WOLVES

Spirit of the Wild

WOLVES

Spirit of the Wild

TODD K. FULLER

CHARTWELL
BOOKS

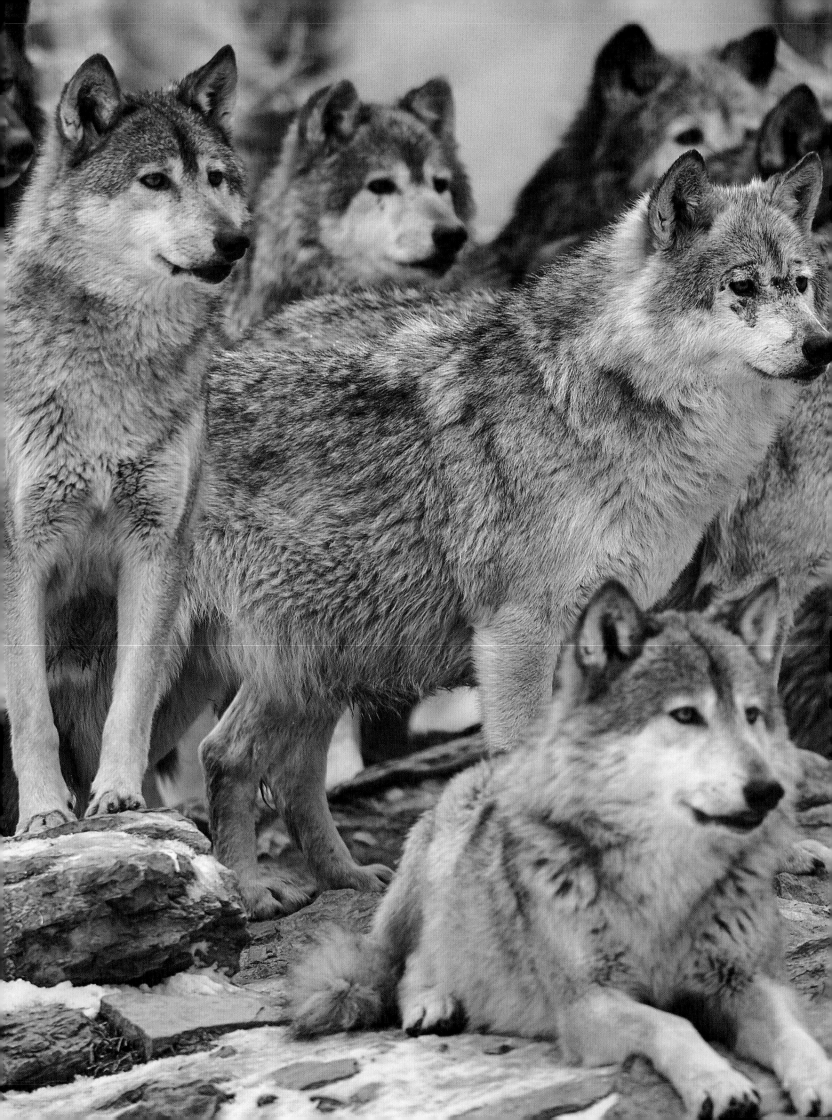

Table of Contents

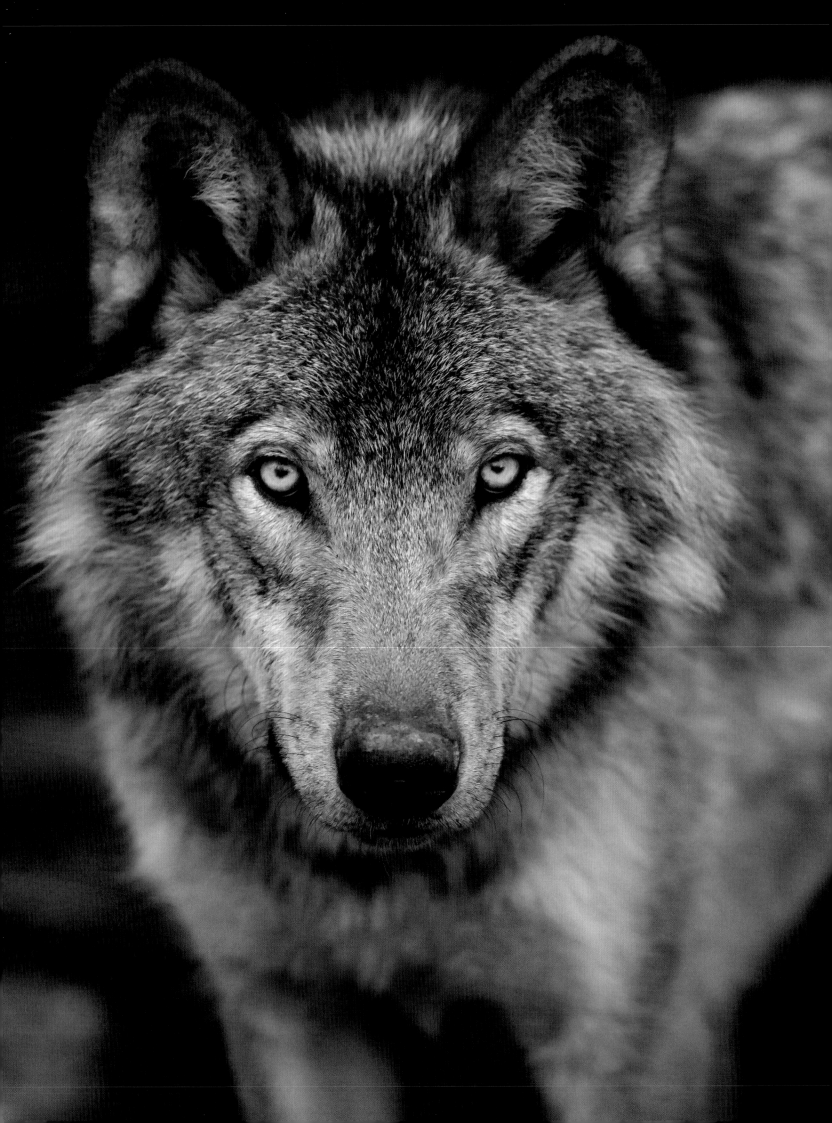

The Natural and Cultural History of Wolves

When most of us imagine a wolf, we think of the large, dog-like animal that lives throughout the Northern Hemisphere and often travels in a pack. They are locally called gray wolves, timber wolves, steppe wolves, and sometimes Arctic or tundra wolves, but they are all the same species. Scientists and ordinary people alike recognized the close affinity of wolves and domestic dogs; thus the Latin name, *Canis lupus*, which appropriately enough means "wolf dog."

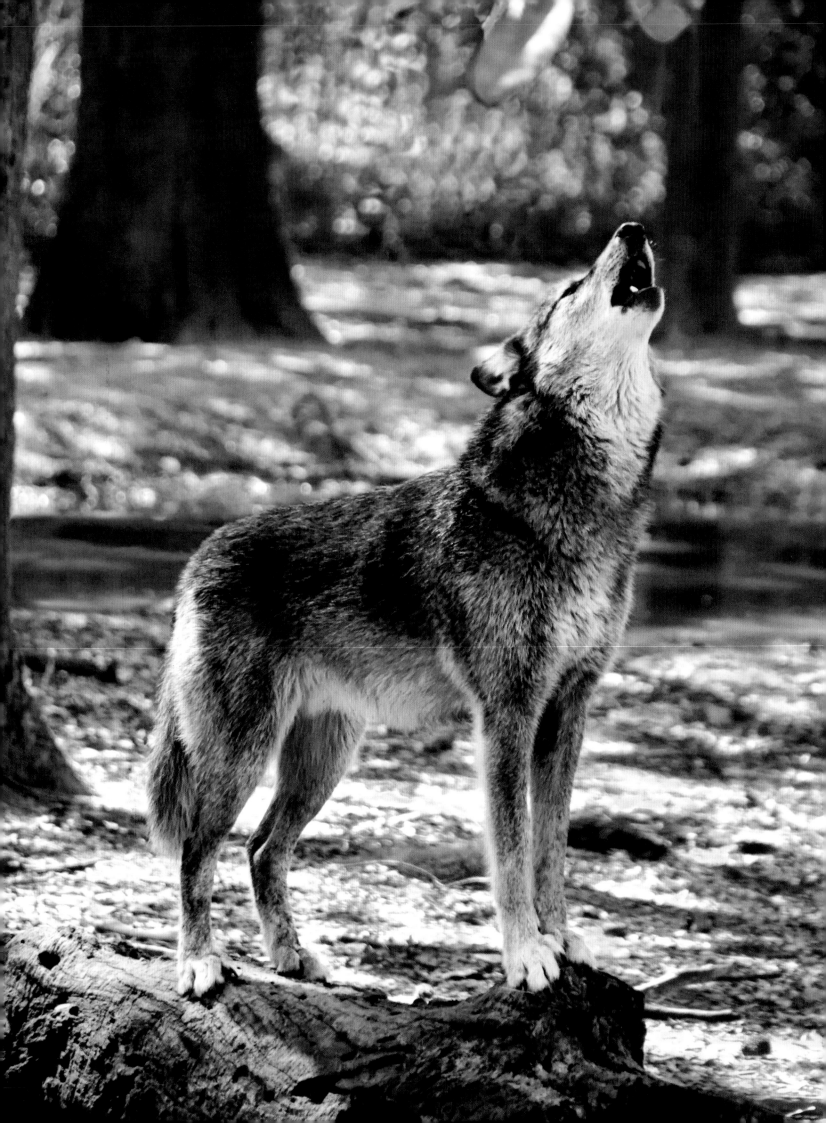

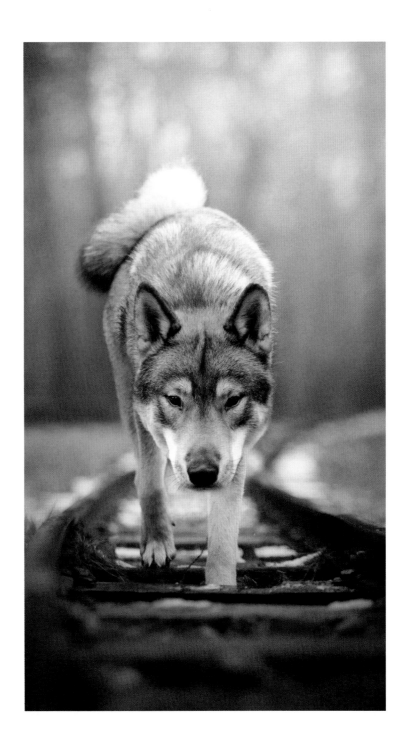

Wolf Ancestry

So how did wolves come to be? Fossils indicate that wolves first developed about six million years ago. Their evolution started with small forms something like jackals, and by three million years ago they occurred in the Old World and North America, with a separate group evolving in South America. By about two million years ago, some of these groups split into more wolf-like and more coyote-like animals. The wolf-like animals became larger about 800,000 years ago and split again into two groups, one of which became the most widely known extinct wolf, the dire wolf; the other group became the wolves we know today.

Modern wolves likely began to develop as a species in North America, but seem to have migrated and then developed most fully in the Old World before reinvading North America in the late Pleistocene era, some 100,000 to 150,000 years ago.

At one time, wolves were, other than human beings, the most widely spread mammal species in the world, with more than a million wolves once roaming the Earth.

They roamed North America from central Mexico north to the Canadian Arctic, hunted in Europe from the Southernmost tip of Italy to northernmost Norway, and denned in Asia from southern India to Japan and Siberia.

It may be difficult to imagine that wolves once thrived on Manhattan Island, now the center of New York City, or trotted along the banks of the River Thames in England, or chased deer through forests that have been turned into the metropolis of Sapporo, Japan. But before humans developed agriculture and settled in villages 10,000 to 15,000 years ago, wolves were to be found throughout the Northern Hemisphere.

Because of this wide range of habitat and climate, wolves proved to be adaptable. Even though they lived among other large carnivores of various kinds, they were able to sustain themselves in a variety of ways and spread across more than half the world.

Though wolves don't live in wet tropical rain forests, they do live in a wide range of environments. In the foothills of Saudi Arabian mountains or the stony plains of the Gobi desert, wolves do just fine in summer temperatures, usually by sleeping during the day, like everything else, and hunting at night. In mid-winter above the Arctic Circle, when temperatures are very cold and the sun never gets above the horizon for weeks at a time, wolves curl up in the snow and have a good sleep when they are not chasing down musk oxen.

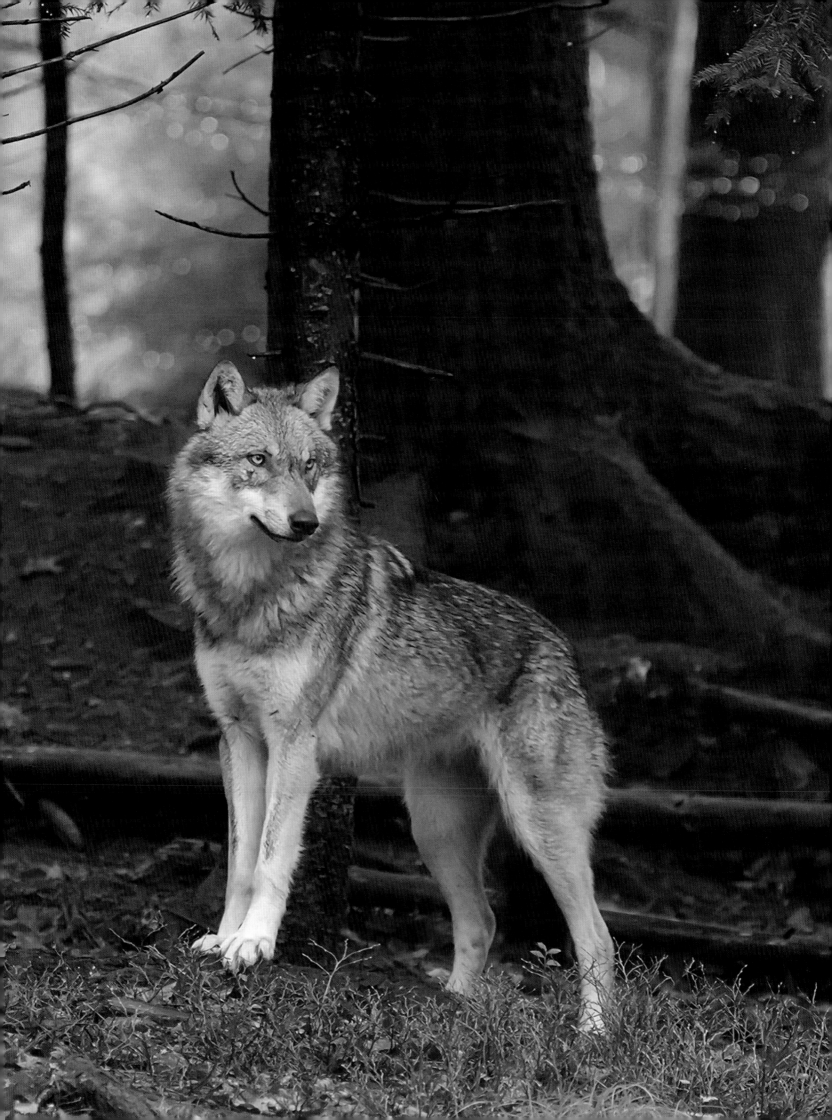

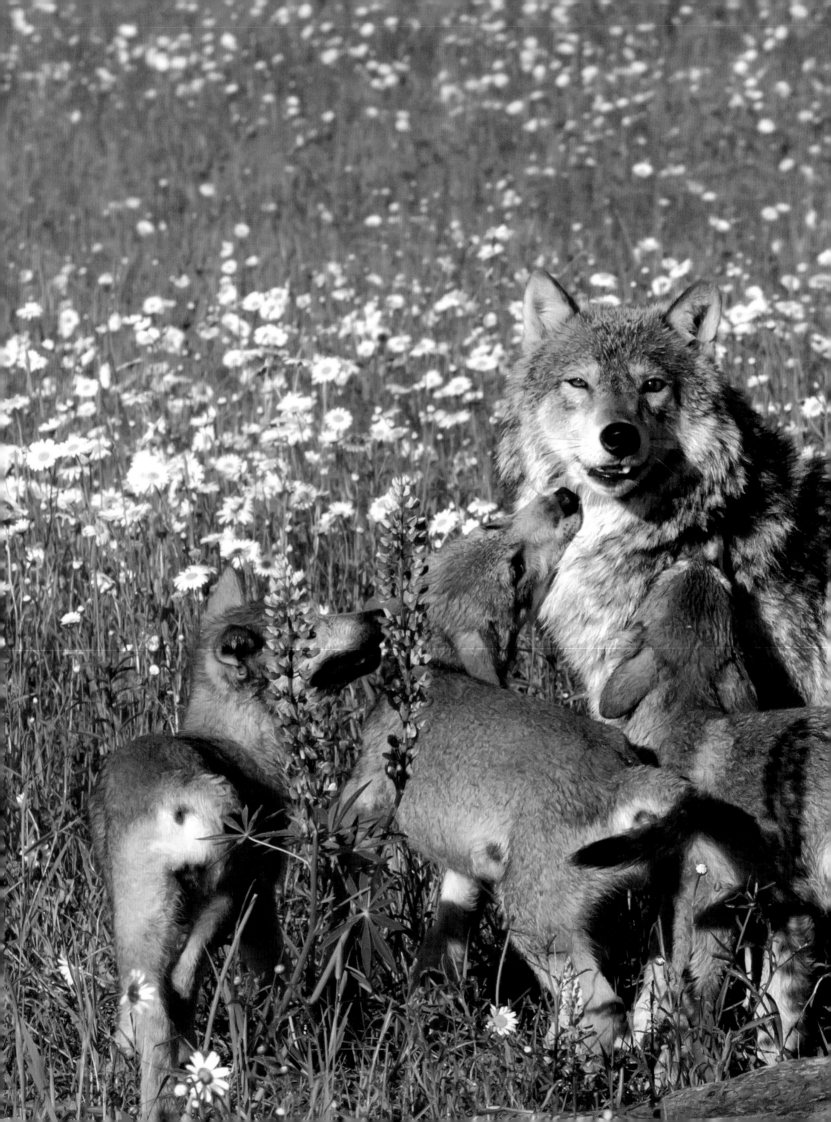

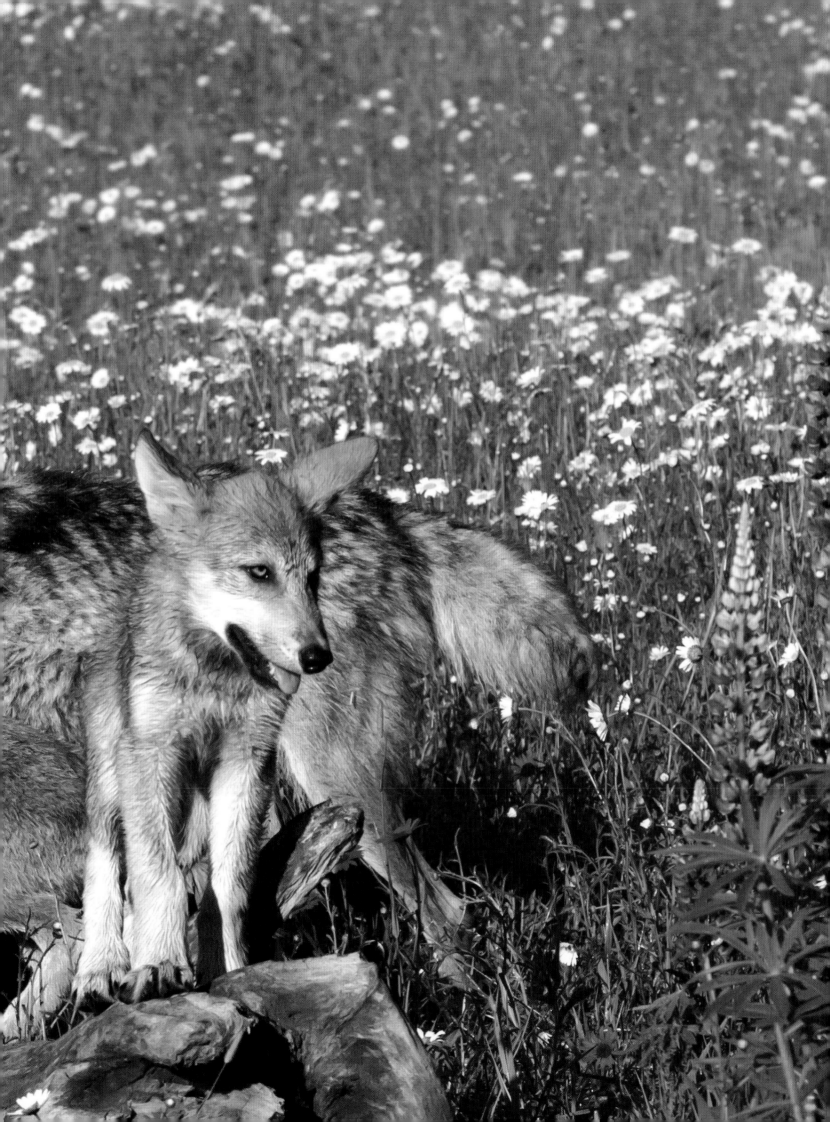

We don't know definitively how dogs evolved, but they are thought to be the product of wolves eventually domesticated by humans, whether for pets, hunting companions, or even "living blankets."

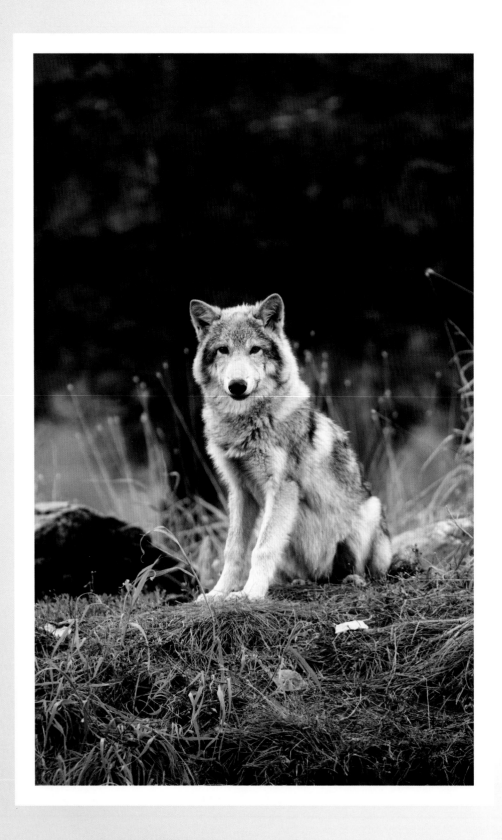

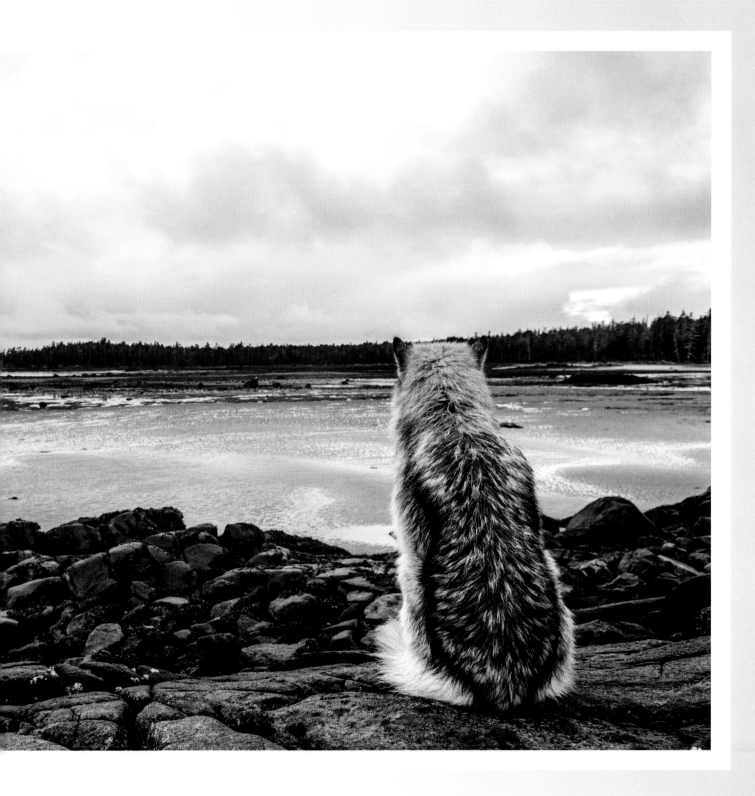

Wolves and Domesticated Dogs

It is also likely that dogs evolved on their own, perhaps 12,000 to 15,000 years ago, when humans settled in villages and created new food sources, such as garbage dumps. Some wolves may have taken advantage of this resource, and those able to tolerate and adapt to the close proximity of humans developed into the dogs we know today. Whether they are a subspecies of wolf or a separately and recently evolved species of their own is still up for debate. Though we think of dogs most often as in the possession of, or at least dependent on, humans, some dogs do thrive completely on their own in the wilds of Australia (dingoes) and New Guinea (singing dogs).

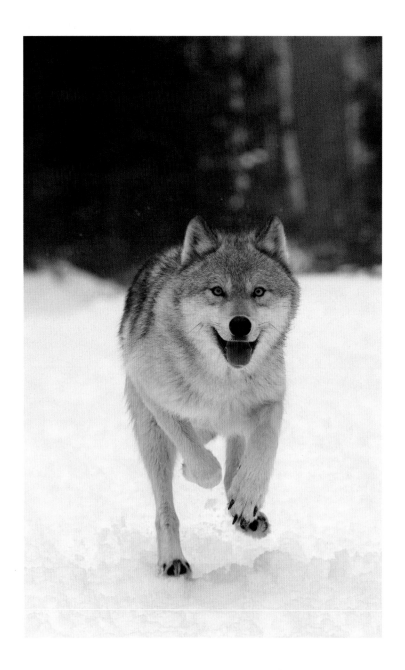

Wolves Today

Today we have about thirteen subspecies of wolves in the world; five in North America and eight in Eurasia. They live everywhere—in the high Arctic, boreal forests, temperate grasslands, and arid subtropical deserts. This wide range of habitats means that like their ancestors, wolves are still a highly mobile species.

Given that wolves inhabit so many different environments, their prey also varies significantly. For the most part, wolves depend on large mammals, particularly hoofed ones, for most of their food. In some areas they prey almost exclusively on small deer or gazelles and in others they kill very large elk, moose, and even bison.

Wolves may have to range far and wide to find vulnerable prey and may even have to migrate with them throughout the year to make sure they have something to eat, but wolves evolved to be excellent travelers. They move easily over flat plains as well as high mountain ranges, through desert sand, marshes, and lichen-covered tundra. They can swim great rivers and climb steep mountains. And they hunt successfully in the thickest forests and the most featureless grasslands.

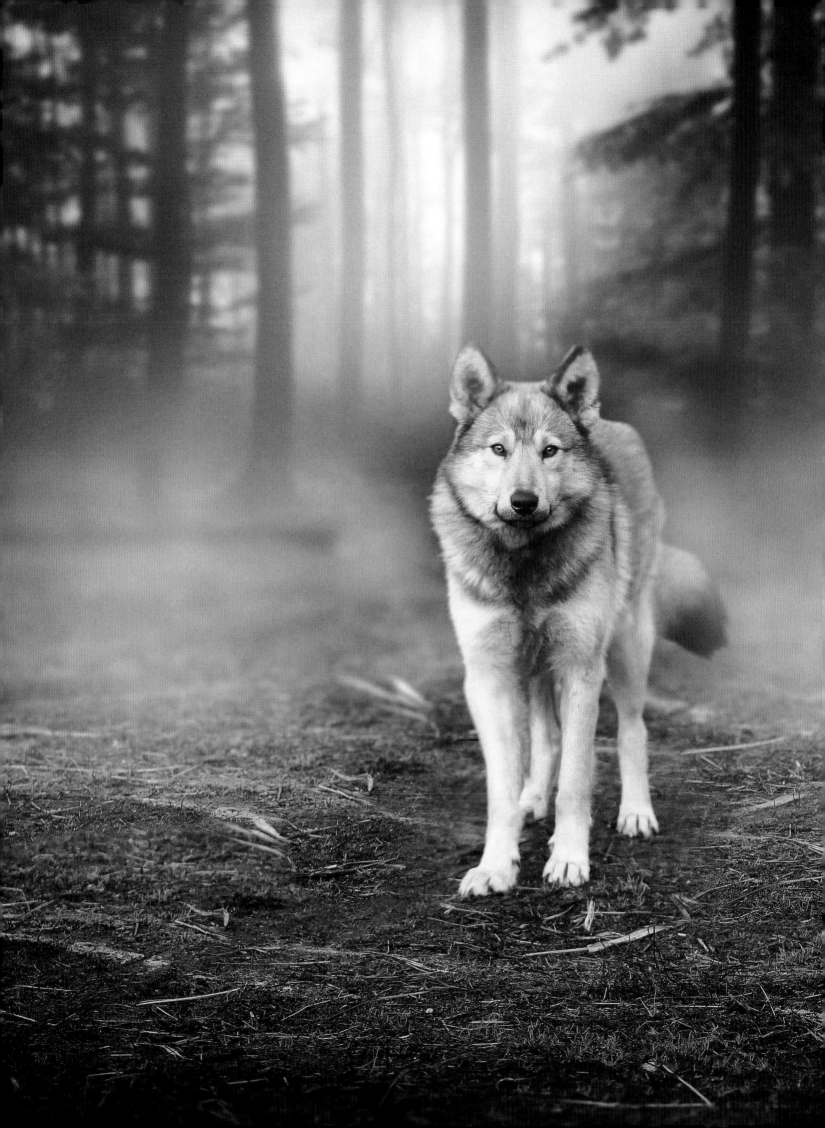

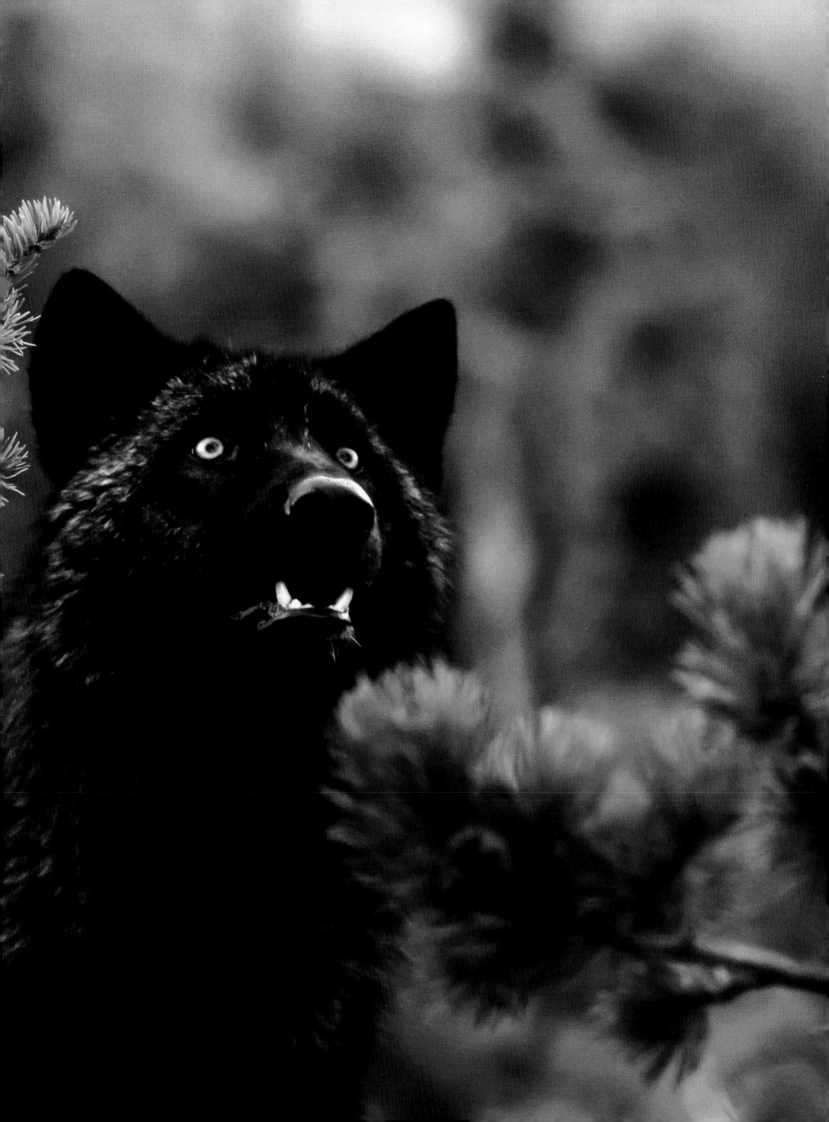

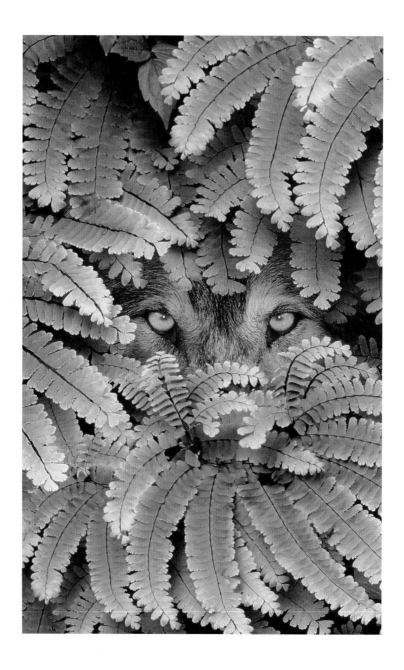

Wolf Legends and Lore

Perhaps because all early peoples in the northern half of the world had to interact with them in some way, wolves have been a rich source of material for myths and legends. Human interactions with wolves make good stories, often so entertaining or fascinating that they have been passed on for generations. Whether truthful or embellished, these stories play an integral part in some cultures. For example, there are several universal images depicting a bitterly cold winter night, with a family thickly bundled under furs in a horse-drawn sled racing across the snow; the mother and children are looking back over their shoulders, terrified, at a huge pack of ravenous wolves relentlessly chasing after them.

Hunting and gathering cultures likely had a healthy admiration for wolves. Wolves are proficient hunters, and thus often became totems, or respected spiritual animal representations, of a family line or clan. Ceremonies intended to maintain group togetherness often involved human portrayals of wolf totems, frequently including the wearing of masks and pelts. Medicine men of a variety of tribes wore wolf skins in order to mimic the powers of wolves.

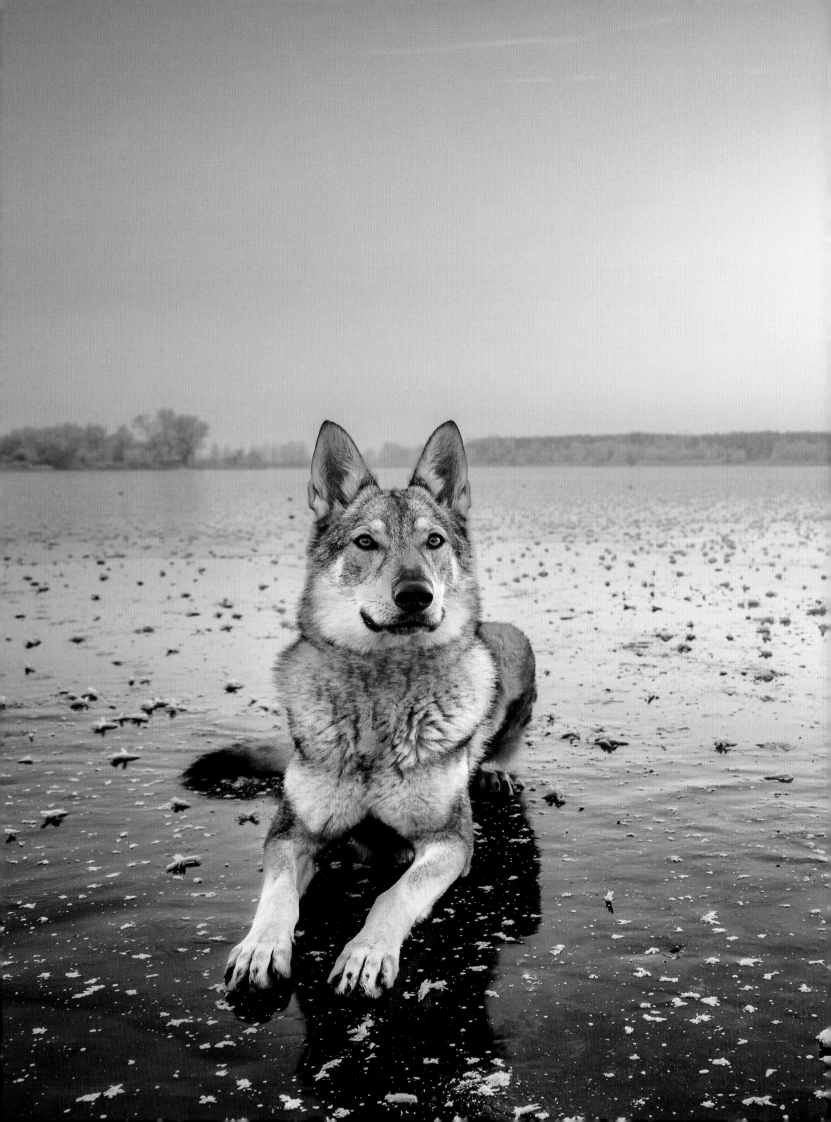

Another universal image is that of a lone wolf on a ridge top, silhouetted by the moon, howling a mournful song.

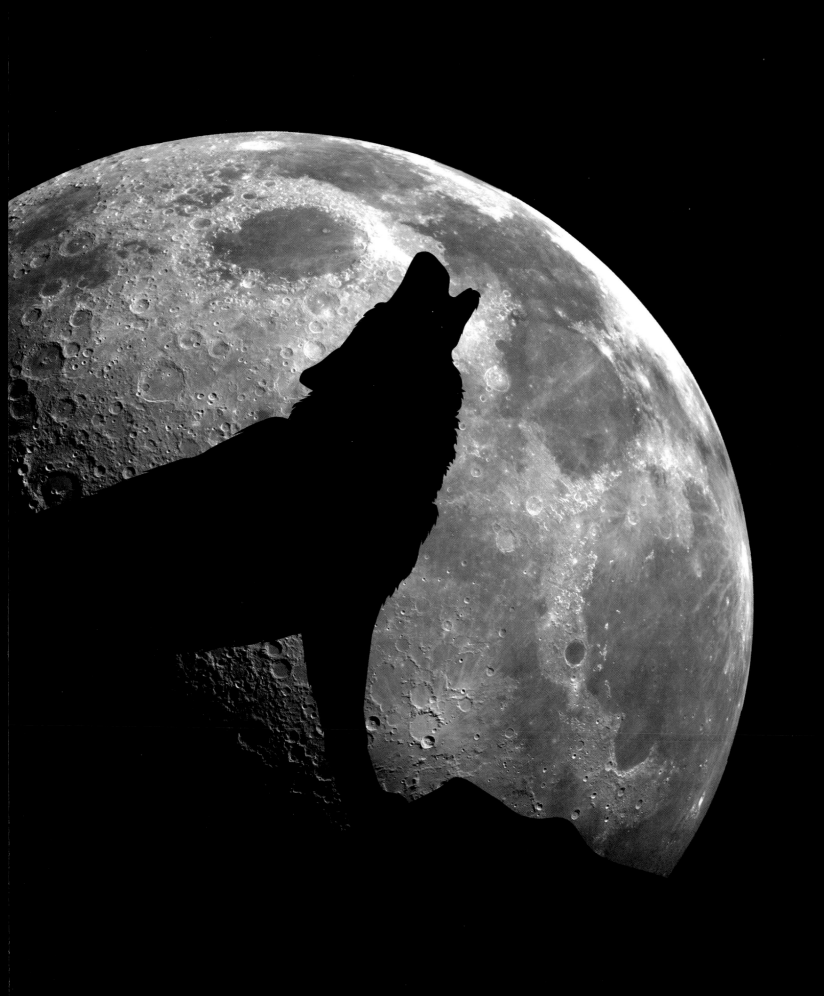

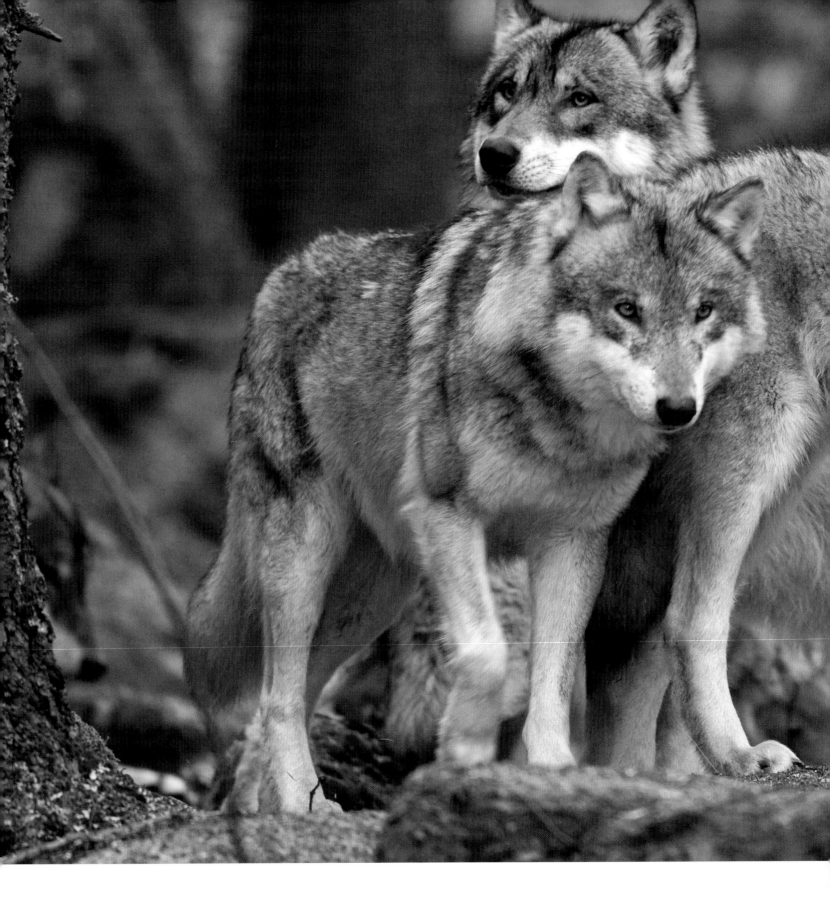

Giant totem "poles" carved from individual trees were often centerpieces of communities.

Warrior peoples associated themselves with admirable characteristics of wolves and portrayed the wolf on battle flags. During the Middle Ages, people also ascribed magical powers to wolves: birth pains could be eased with powdered wolf liver, and a wolf's paw tied around the neck could relieve a sore throat. In some cultures, wolves were portrayed as collectors and distributors of information and knowledge; in others, they were known as fertility gods. One of the best-known legends related to wolf fertility is that of Romulus and Remus, twin sons of a Vestal Virgin, who were banished to the wilderness.

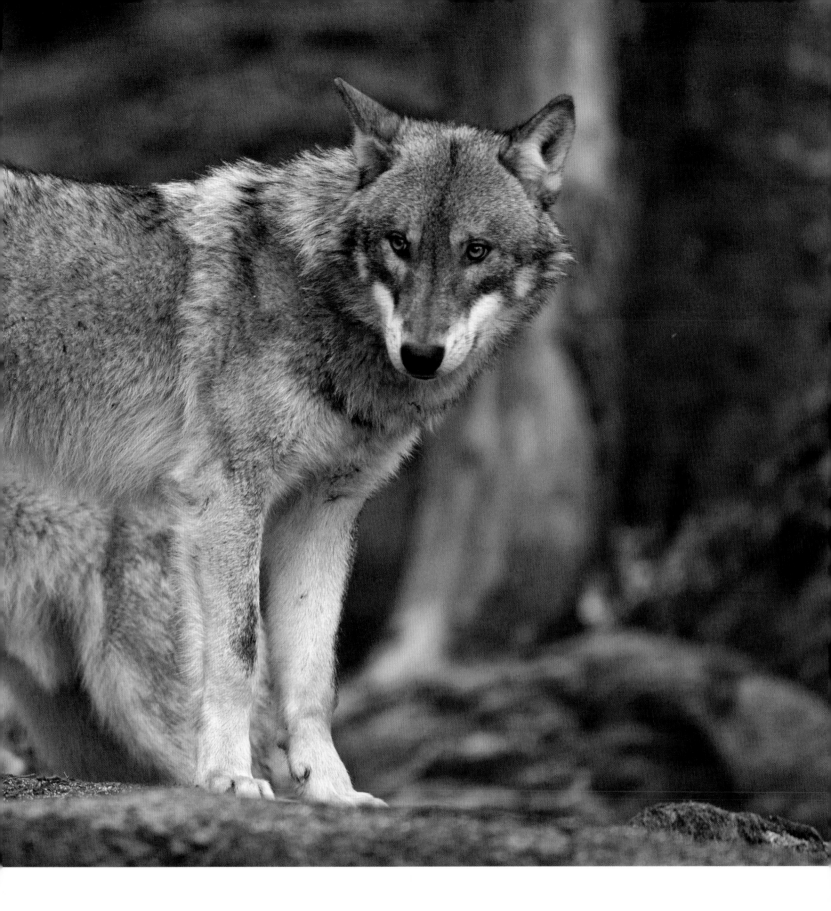

They were raised by wolves before being rescued and going on to become the legendary founders of Rome.

The advent of Christianity gave rise to the notion of humans as masters and not part of the natural world. In the Bible, wolves are portrayed only as symbols of greed, depravity, cunning, and deceit, and came to be viewed as evil and threatening. The subsequent legends of werewolves, in particular, reinforced fearful views of wolves.

Depicted as ferocious and sly, wolves were often used in folk tales to teach a moral lesson. The story of the *Three Little Pigs* seems to suggest that adequately preparing for hard times is a good idea. In *Little Red Riding Hood*, keeping to the path and

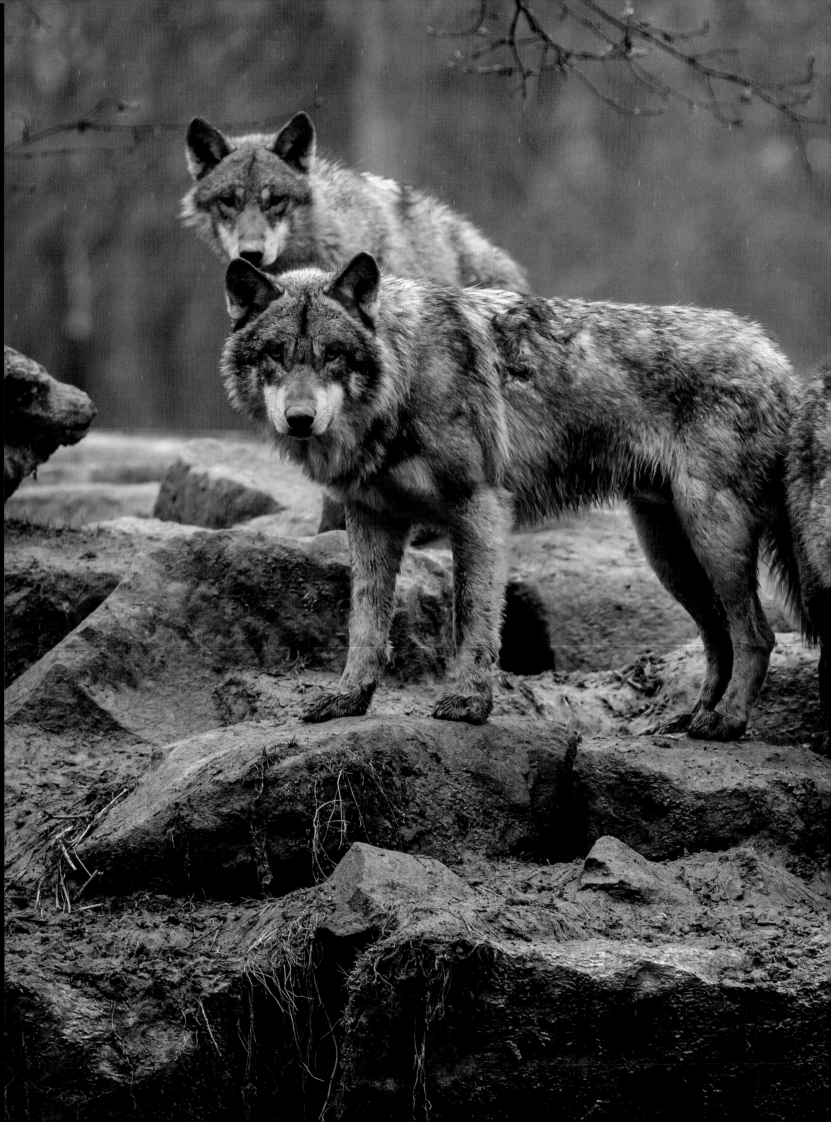

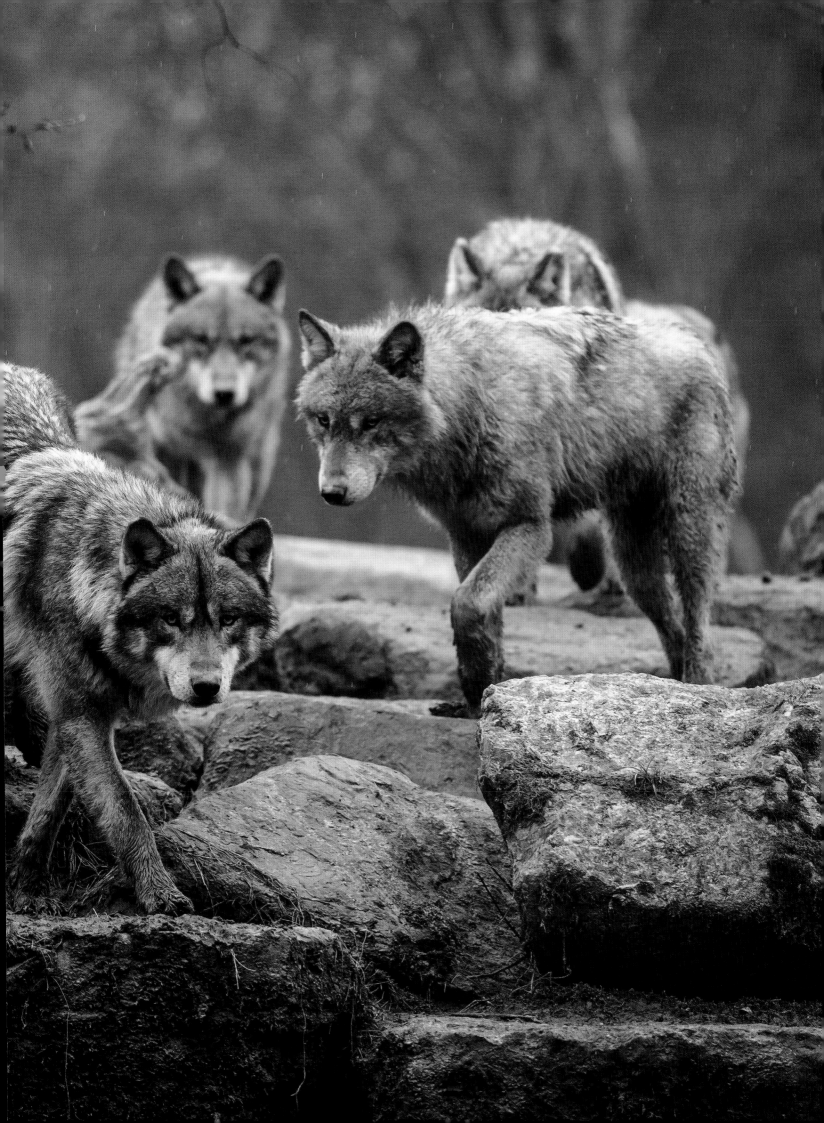

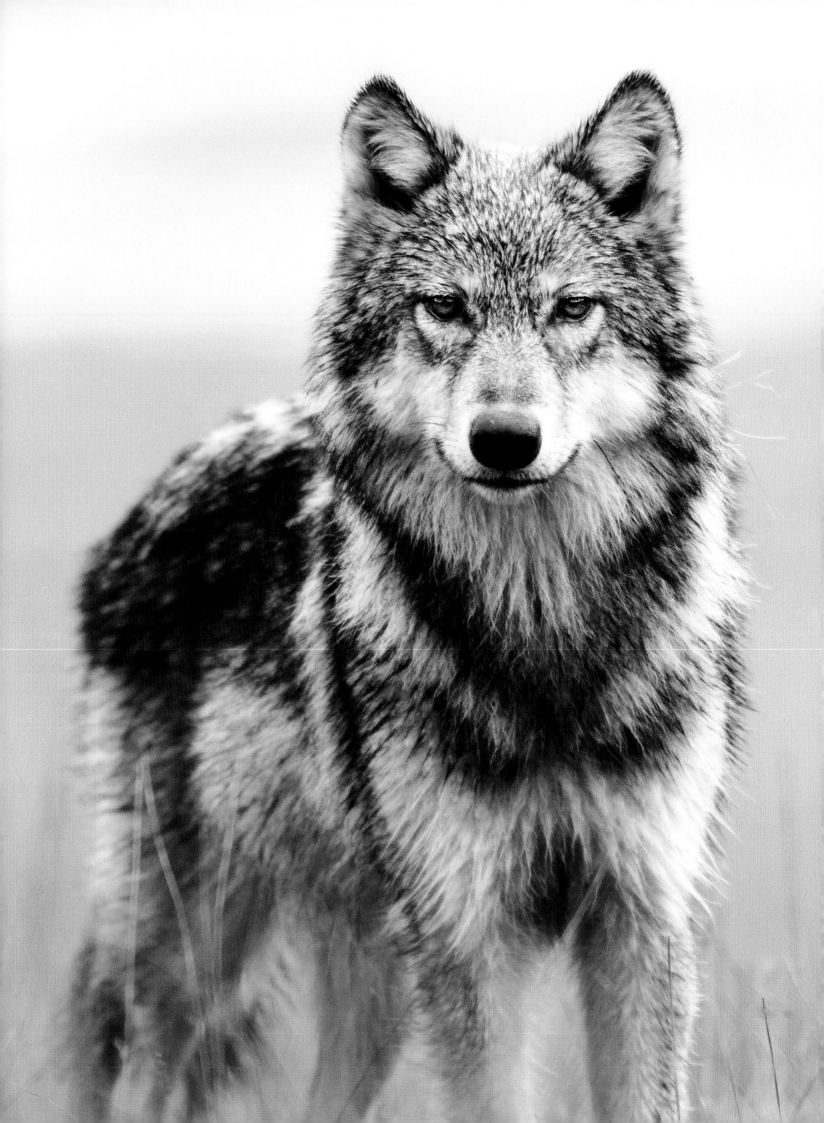

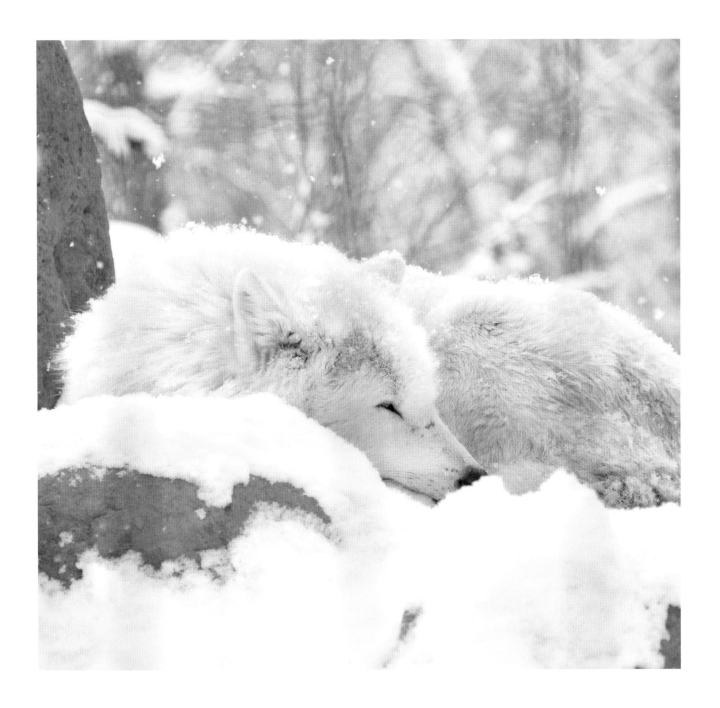

Numerous other stories of "wolf children" have been recorded over the centuries, including Rudyard Kipling's Mowgli.

never being distracted from accomplishing one's task will probably result in coming to no harm. Finally, St. Francis's taming of the terrorizing Wolf of Gubbio demonstrated to the local people the power and providence of the living God.

So what about the wolf chases, or wolves howling at the moon? Are these, and other wolf stories, based on true depictions of wolf behavior, or are they simply distorted human ideas? Wolves certainly do chase and kill large

mammals, sometimes even people, but only rabid wolves would probably pursue a sled, and such an occurrence would have been rather rare.

All in all, many of these myths and legends are probably based in part on real attributes of wolves, but most certainly have been interwoven with human characteristics, both good and bad, that make us feel even more connected to this powerful and remarkable animal.

Wolves do howl at night,
but no more so during the full moon
than at other times of the month.

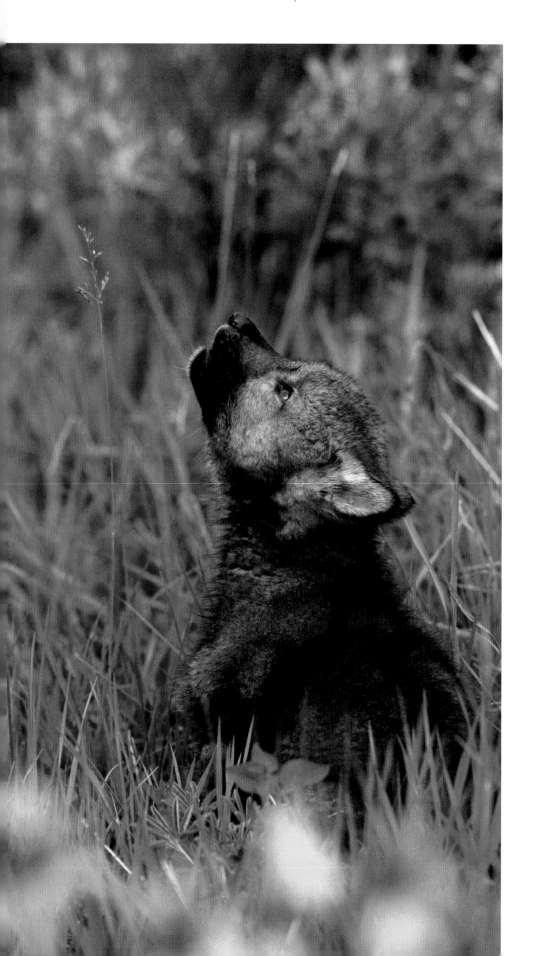

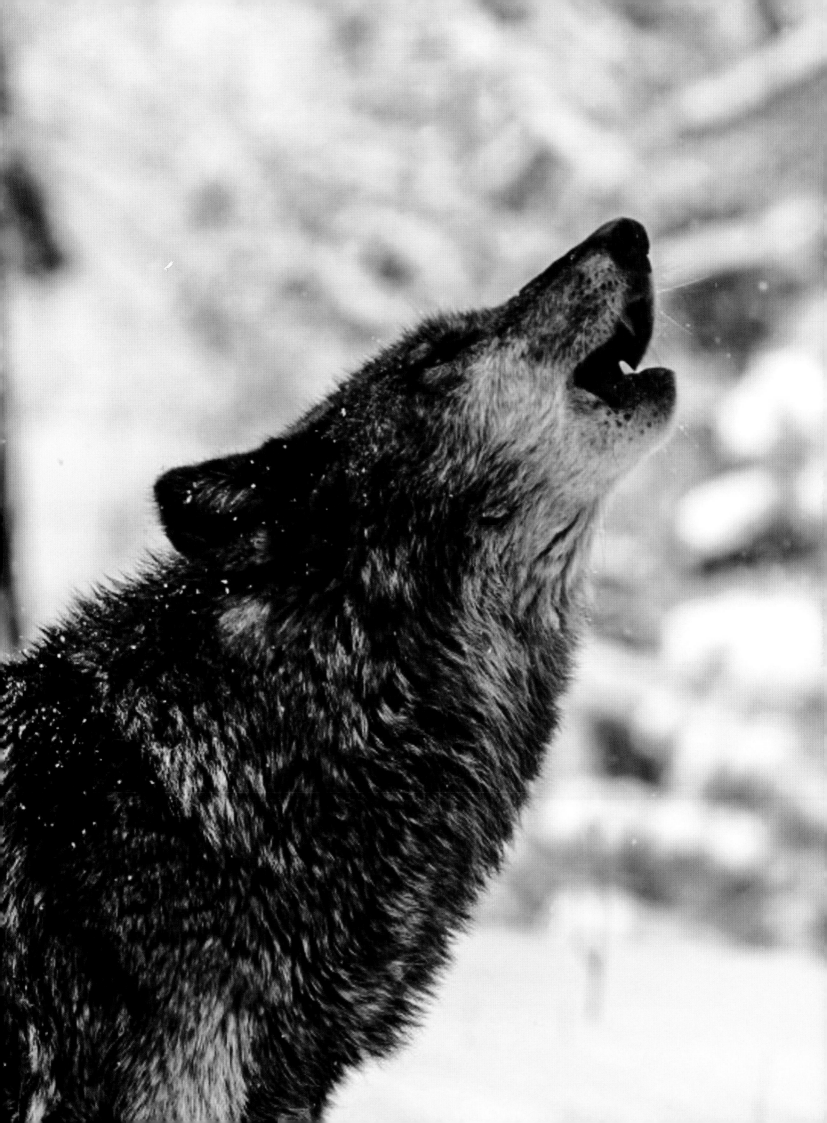

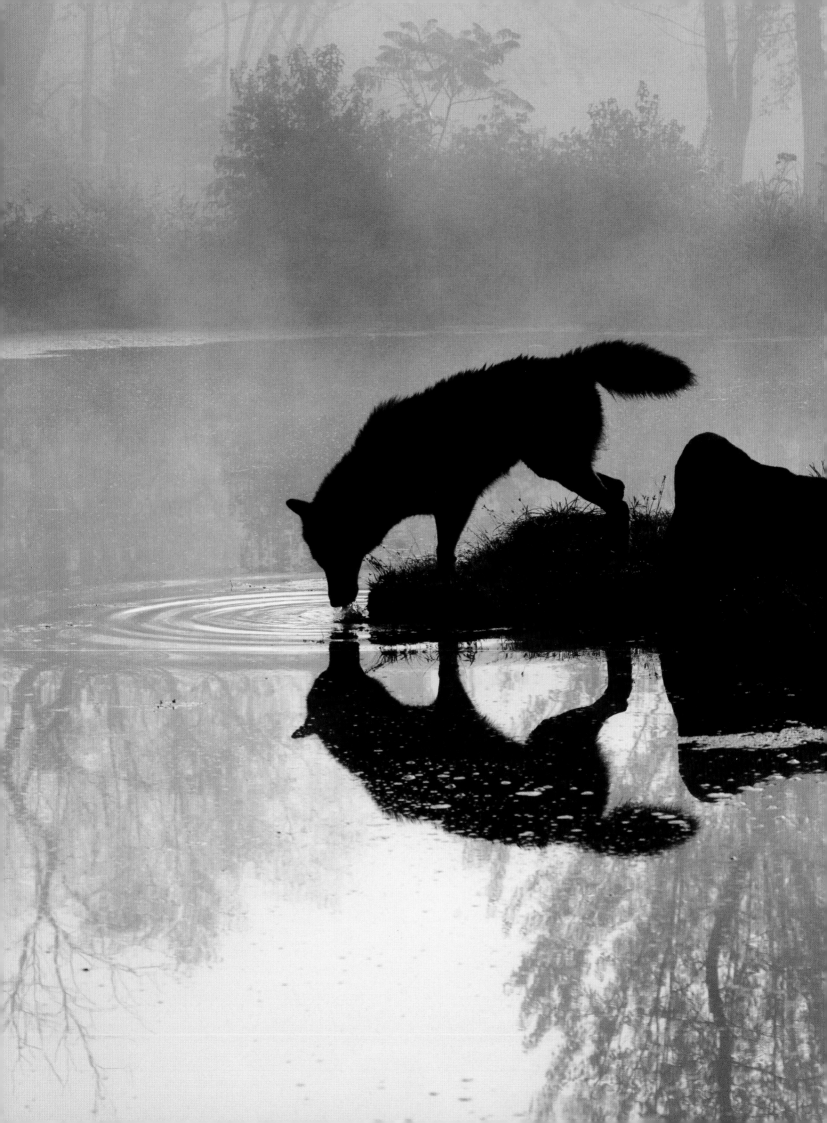

Physical Characteristics and Adaptation for Survival

Although all wolves have a distinct appearance, they differ greatly in size and color. As with body size, wolf weights can vary considerably between areas, and may even vary within an area depending on environmental conditions. There is a great variation between wolves in the Northern latitudes versus those in the lower latitudes that is related both to the physics of keeping warm or cool, as well as average prey size. It is easier for large wolves to retain body heat, and for small wolves to get rid of excess heat. Also, large wolves are likely to be more successful in killing very large prey such as moose or bison than are small wolves.

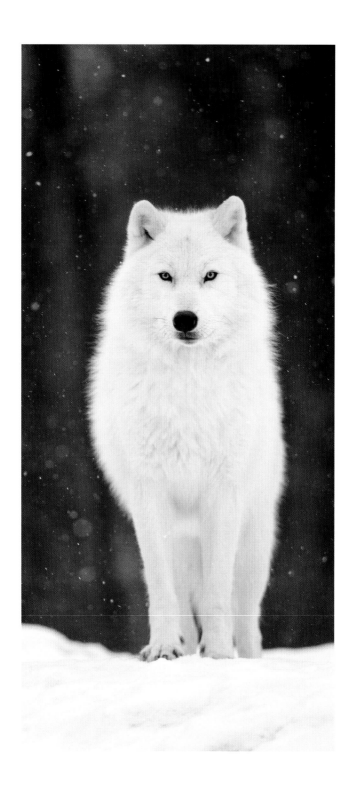

Physical Features

SIZE

A newborn wolf pup would fit in your cupped hands; it weighs only about a pound (500 g) and is darkly, finely furred.

By one year of age, most wolves have reached adult size and weight. Males are about 20 percent larger than females. On average, adult male wolves weigh 95 to 105 pounds (43 to 48 kg) and females weigh 80 to 90 pounds (36 to 42 kg). In general, wolves in lower latitudes, especially those living in dry, desert regions such as in India and Saudi Arabia, are smaller than those farther north.

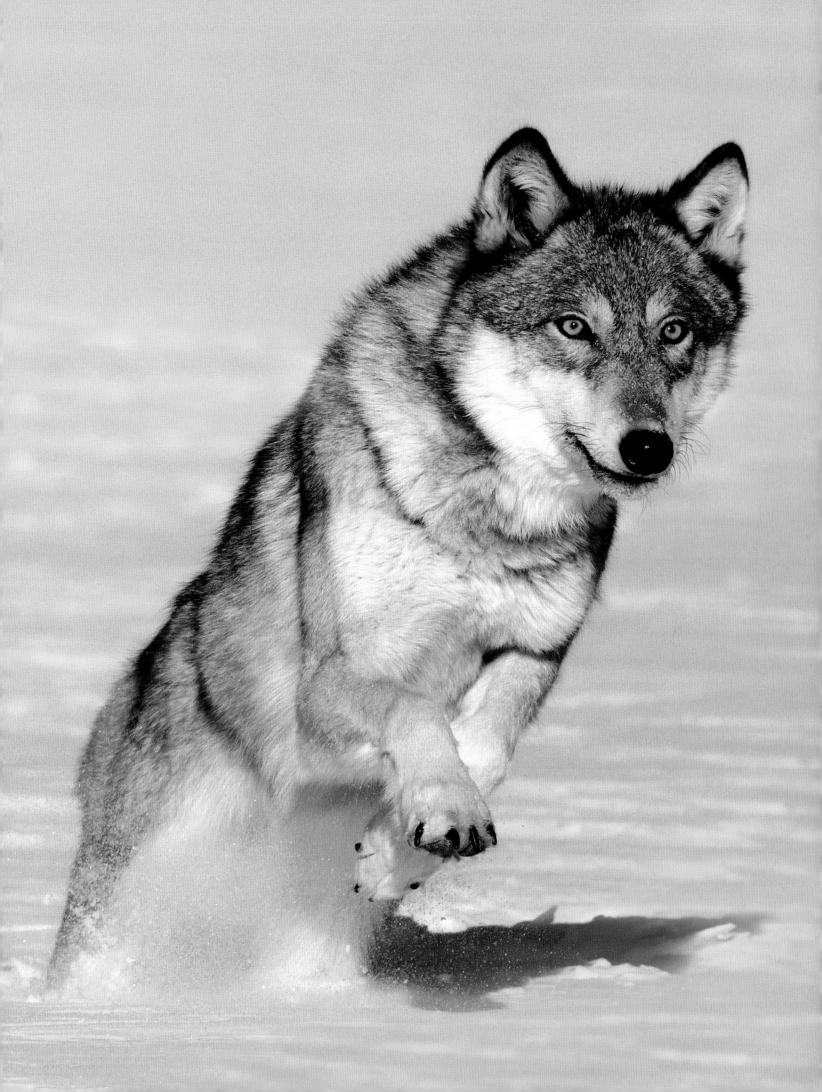

COLOR

Wolves are among the most variably colored mammal species. Their coat colors include white, cream, tawny, reddish brown, steely gray, salt-and-pepper mottled, and jet black. Even a single individual may have white, black, brown, and gray hairs intermingled.

For example, black wolves sometimes change over their lifetimes to bluish silver, silver, or even white. Gray-colored wolves may change to cream-colored or white over time.

In North America, few wolves are white, but their proportion in the population increases as

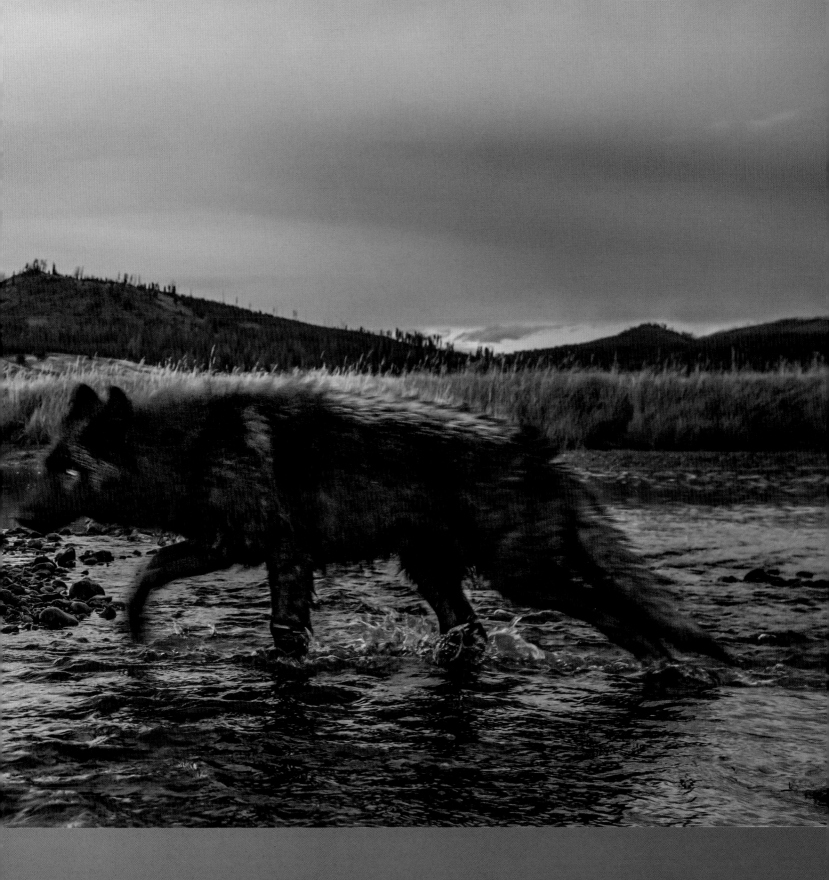

they get closer to the high Arctic of Canada and Greenland. There, the majority of wolves are white. Perhaps blending in with the snowy landscape gives them an advantage when it comes to stalking prey.

White wolves remain white throughout their adult lives, but this is not necessarily true for other colors of wolves.

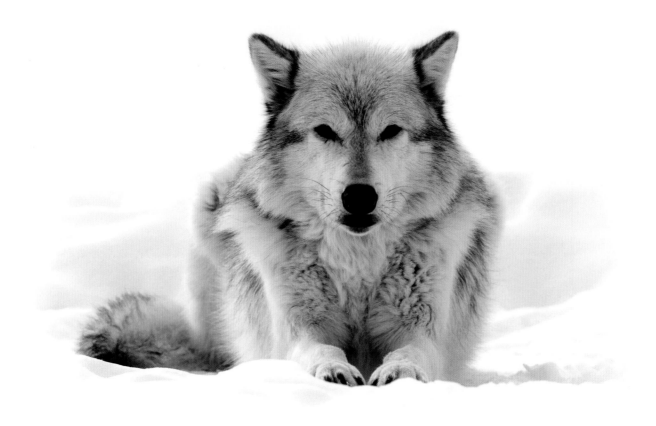

Built for Survival

COAT

Not only is a wolf's coat colorful, but it is also fully functional. It is comprised of stiff, long, outer (or guard) hairs that give the wolf its color, as well as a shorter, finer layer of hair called the underfur. The guard hairs cover the underfur and provide protection from the elements and the wear and tear of traveling over scrubby vegetation, while the underfur provides insulation for the body. Given this insulating purpose, it logically follows that wolves from more northerly latitudes and colder temperatures have much longer and denser fur than those from southern areas.

SKELETON

Wolves, more so than any of the other carnivores, are adapted for traveling. And whether just exploring or hunting, wolves are widely known for their ability to trot or run for long periods of time. In fact, an old Russian proverb relates that a wolf is kept fed by its feet.

It is not surprising, then, that the wolf skeleton is "built" for travel. The large chest of a wolf is rather narrow, and its legs are positioned tight to the body with the toes turned outward. This allows a wolf to swing its legs easily and, in snow, to place its hind foot in the print made by the front

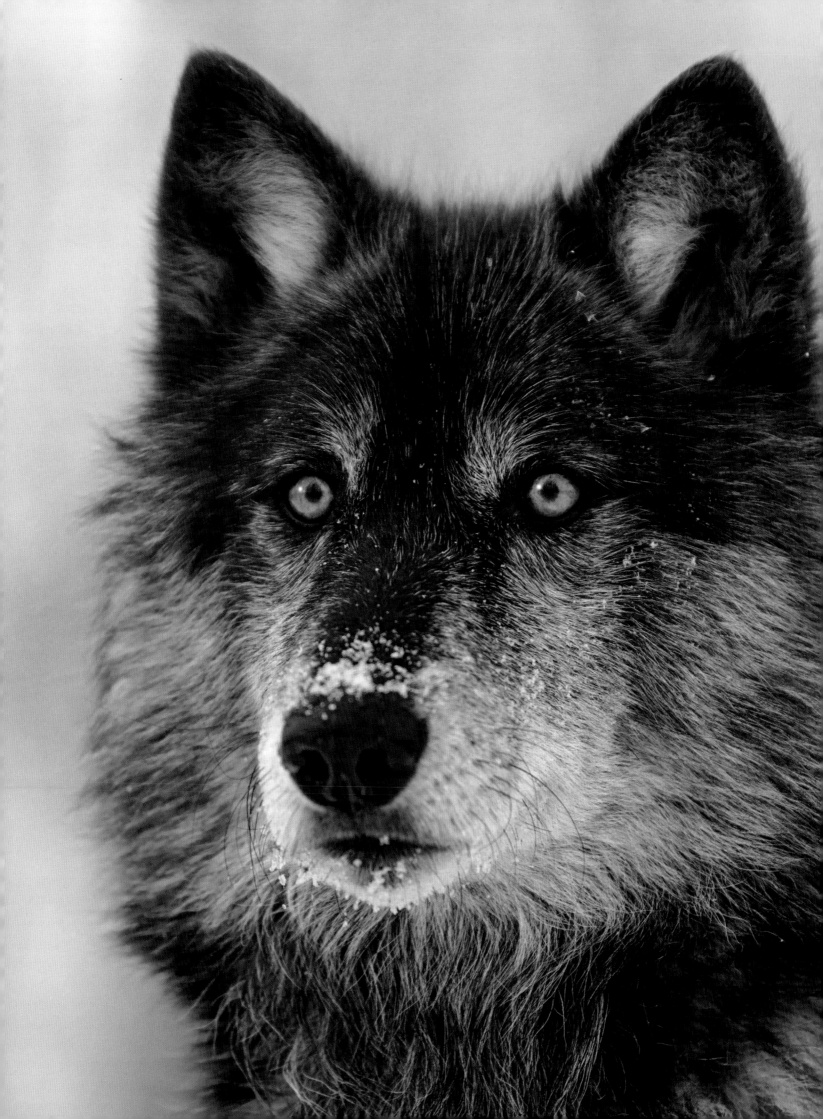

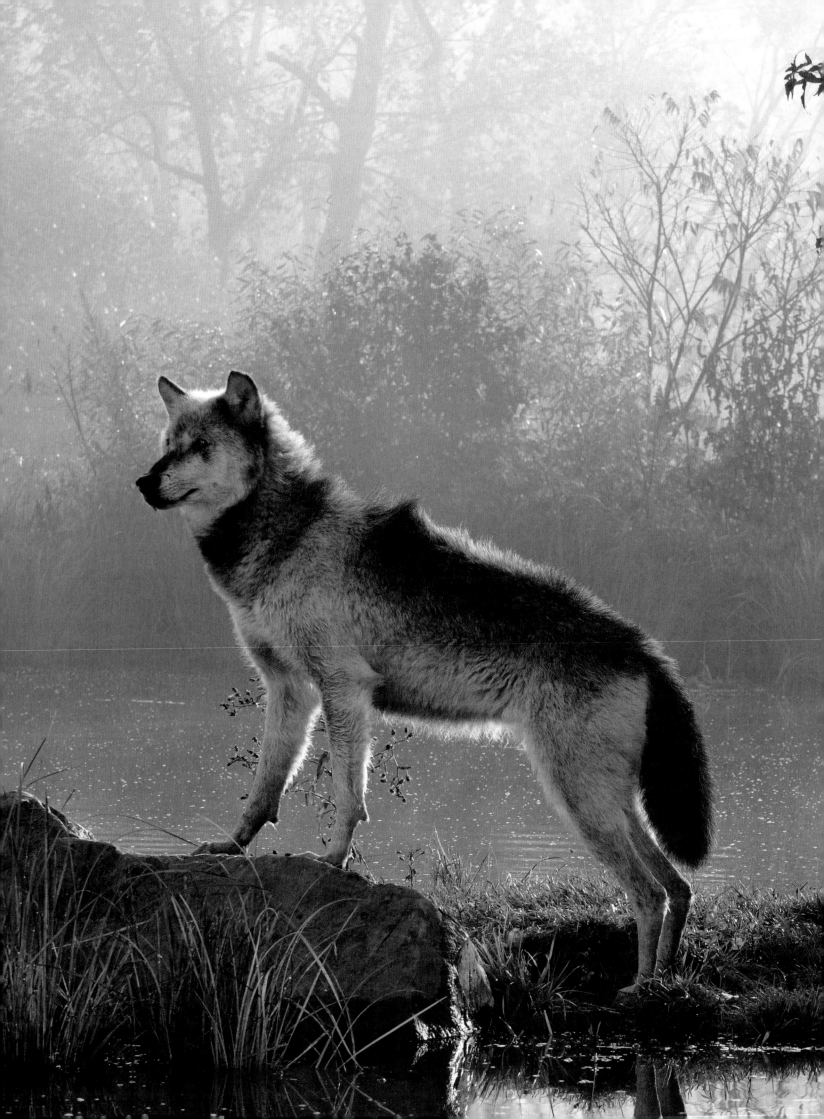

foot (unlike dogs, which often put their hind feet next to the front footprints). Another feature that allows wolves to do well in snow is their long, thin legs. All canids walk on their toe tips, but wolves' legs are relatively longer than those of their other close relations and thus are better able to get around in deeper snow. Also, a pack traveling through deep snow usually follows one after the other; the tracks and trails made by pack members reduce the energy needed to travel. However, wolves' relatively large feet also allow them to travel on top of crusted snow that may not support the narrow, sharp hooves of deer, moose, or elk. This allows them to move more quickly and be more efficient hunters.

Thin legs not only go through snow more easily than thick ones, but they are also easier to move and can therefore be swung more quickly, allowing for rapid, long-distance, and seemingly tireless movement. Walking wolves routinely travel at 4 to 6 miles per hour (6 to 10 km per hour), or twice the regular speed of a walking human. Maximum speeds can reach 35 to 40 miles per hour (55 to 65 km per hour), again nearly twice the maximum speed of a human. Long-distance travels are also routine for wolves, and they have been known to travel more than 31 miles (50 km) in a day. This allows wolves in the desert, for instance, to seek out necessary drinking water that might be available only at a few sites located at great distances from one another.

SKULL

Although a wolf's speed and agility may help it overtake large prey during the hunt, the process

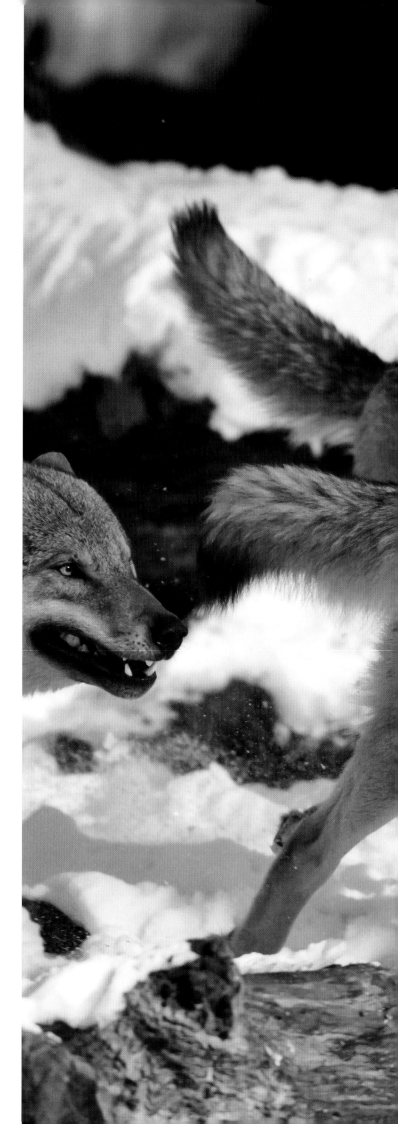

Wolves, more so than any of the other carnivores, are adapted for traveling.

of killing and eating such an animal might seem to present some challenges. However, the wolf's skull is ingeniously designed for exactly this purpose.

A wolf's skull is long and tapers toward the front, forming the relatively long "nose" (compared to other carnivores). Importantly, the lower jaw is large and strong to provide space for the teeth and the attachment of massive jaw muscles. The jaw is well anchored to the skull to handle the stress and strain it undergoes when holding on to struggling prey, and it is well proportioned in length relative to skull width so that it can safely open quite wide.

Wolves possess forty-two teeth as adults. The largest and most notable of these are the canine teeth, which are used to hold on to prey. The small front incisor teeth are also used to hold on to prey, especially when large animals twist their heads back and forth, often "picking up" wolves off the ground. These small teeth are also used for more delicate tasks, such as capturing small mammals, removing bits of meat from bones, and picking berries off of branches.

Some teeth are relatively enlarged and have shearing edges. When the jaws close, these blades shear past one another, trapping and cutting the food. These edges are also self-sharpening, thus providing lifelong "meat scissors." Other teeth serve as crushing and grinding surfaces.

BODY

Wolves store a very large portion of food in their stomach and then process it rapidly so they can eat even more food, as the "feast-or-famine" nature of their diet means they rarely eat at their leisure or in predictable intervals. Prey animals are usually very difficult to capture, and some wolves may go for several weeks in winter without making a kill. Thus wolves have to eat all they can whenever they can. Wolves in packs usually kill a large ungulate or hoofed mammal every couple of days, but none likely eat fresh meat every day. As a result, wolves

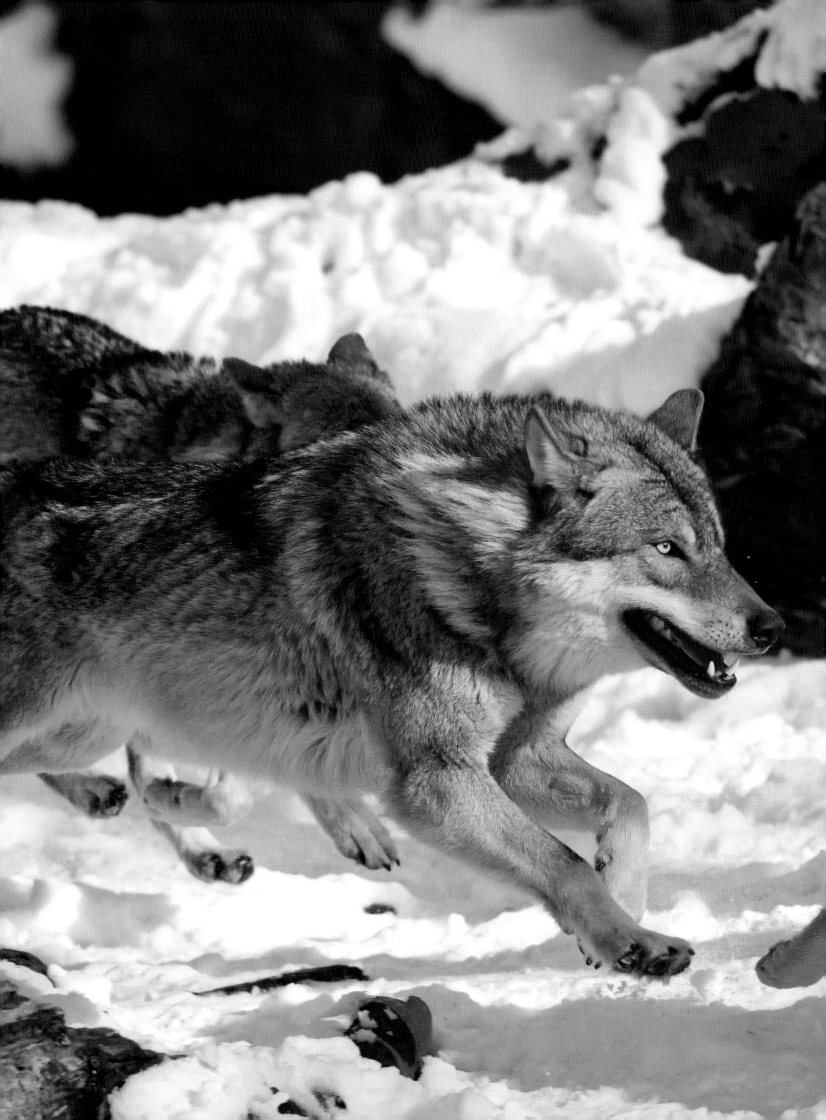

The wolf's efficient shearing and grinding teeth give it the ability to quickly consume large chunks of meat.

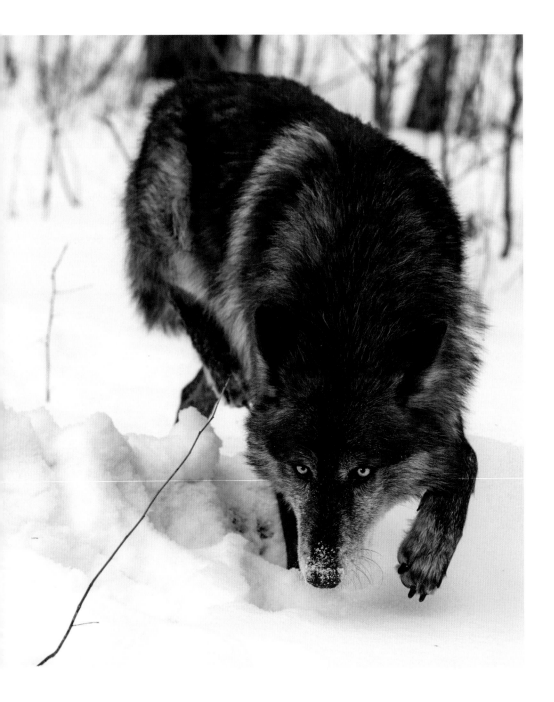

typically lose and gain significant amount of weight on a regular basis.

EYES, EARS, AND NOSE

The eyes of wolves can function during both day and night, although their vision is not nearly as good as that of cats. Wolves have a relatively wide view of their surroundings and do slightly better than dogs in using both eyes to focus, but it is nowhere near the ability of humans. Dogs, and probably wolves too, seem to be quite sensitive to motion and apparently see shades of gray better than humans can, but they have very poor color discrimination.

Dogs, and hence probably wolves, seem to have relatively ordinary hearing abilities for carnivores, but certainly can hear some things better than humans.

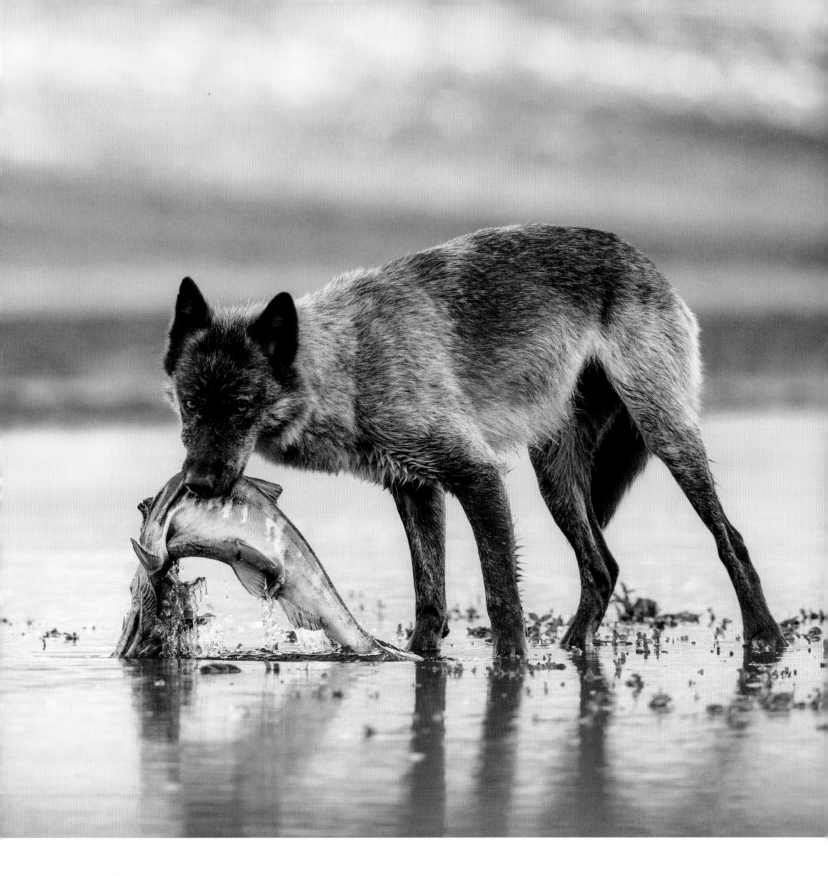

Wolves use their sensitive noses for communication and for hunting. Their long "nose" enhances their sense of smell and makes them hundreds of times more sensitive to odors than humans are. This is vital to their survival, as they use their sense of smell to find much of their food, the topic of the next chapter.

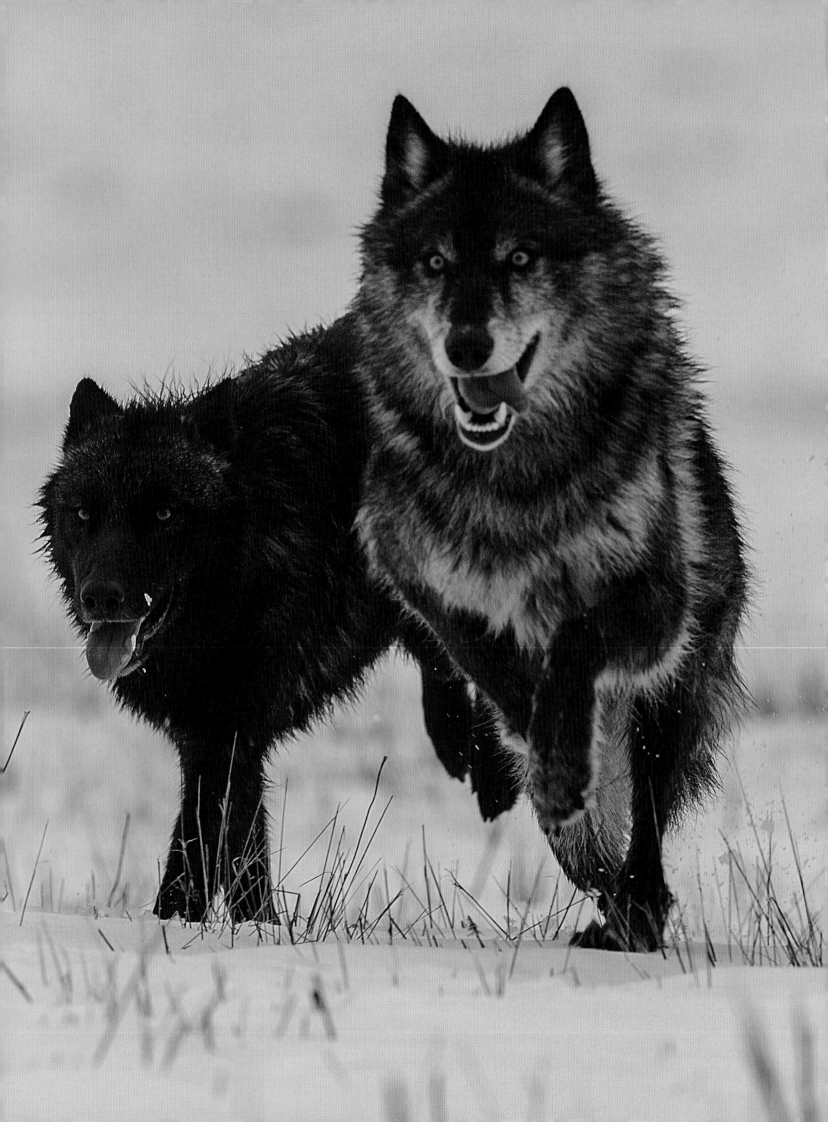

WHAT WOLVES EAT

Not surprisingly, wolves everywhere eat a range of animals and a fair amount of plants, limited in variety only by what is present at a given time or place. The ability of wolves to live in all kinds of places is related to their diet and their tolerance of diverse climatic conditions. Wolves can eat just about anything we humans can eat, plus a bit more that few of us find either nutritious or palatable.

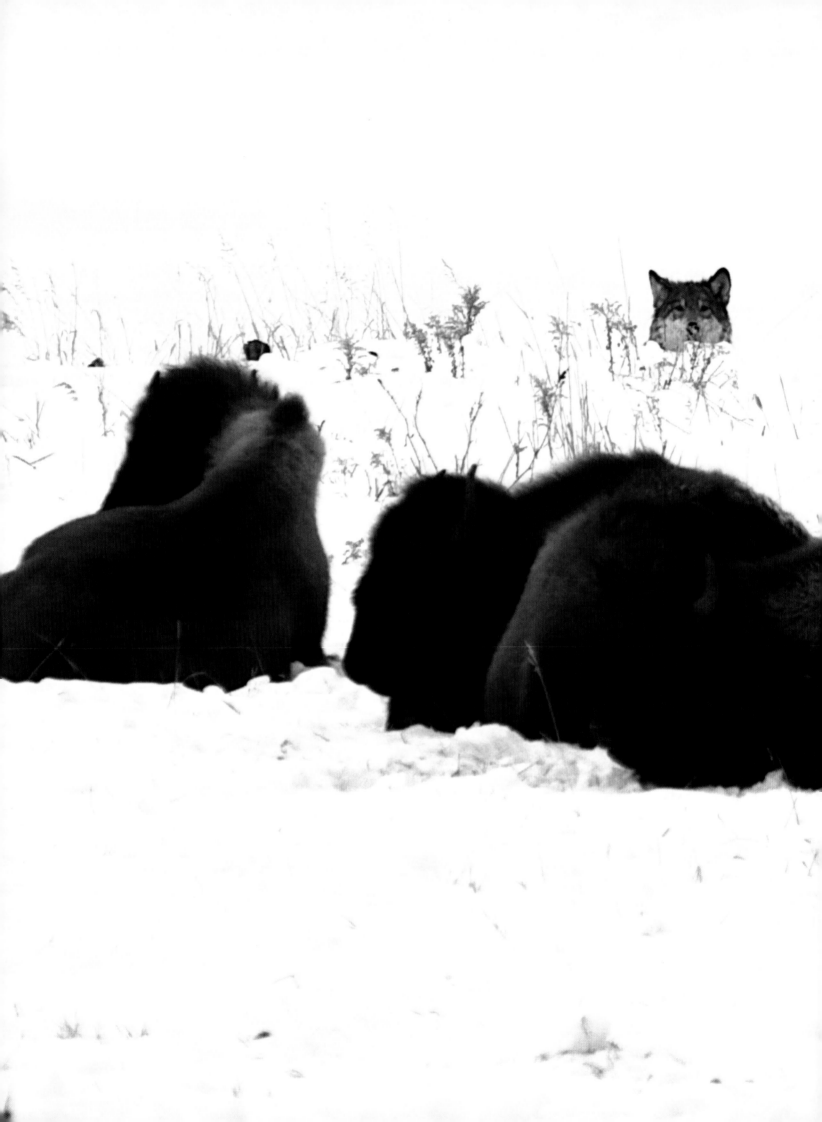

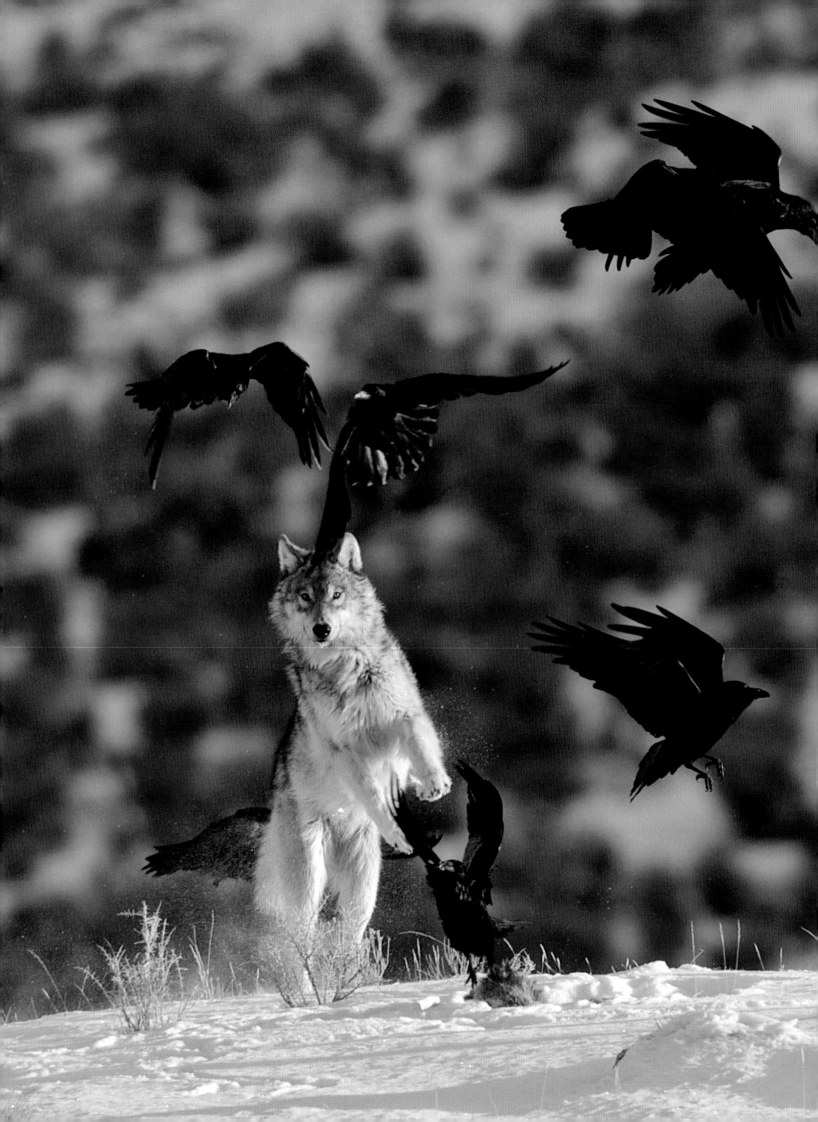

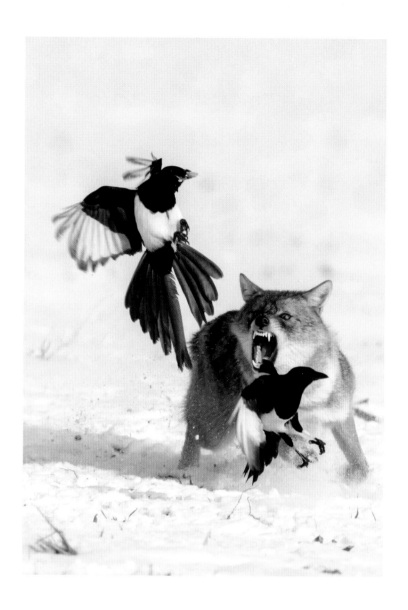

Food Choices

Wolves are opportunistic foragers. This means they are experts at taking advantage of whatever circumstances they encounter to get something useful to eat. The key, however, is getting something that is "worthwhile." Despite claims in the famous book and movie *Never Cry Wolf,* wolves cannot make a living by just eating mice. In the long run, it just costs wolves too much energy to catch enough mice to survive on. Because of the wolf's relatively large body size, and despite the dangers in trying to catch and kill a moose, it is still "easier" and more efficient for a wolf to catch a moose than to catch a moose's weight in rodents.

Wolves will attempt to capture any large prey present in a given area. In any particular region

there is one large species that is both common and abundant, and this is the one wolves consume most often.

In areas where these wild game have been eliminated from the landscape by humans, wolves have developed a taste for domesticated species, including horses, donkeys, cows, sheep, goats, pigs, llamas, yaks, reindeer, and camels. Wolves also kill and sometimes consume domestic dogs, and most likely domestic cats and rabbits, too.

Even where ungulate prey is very scarce or even absent, wolves are able to survive by eating other kinds of prey. In both North America and Eurasia, beavers are commonly consumed when they become most available. Usually this is in

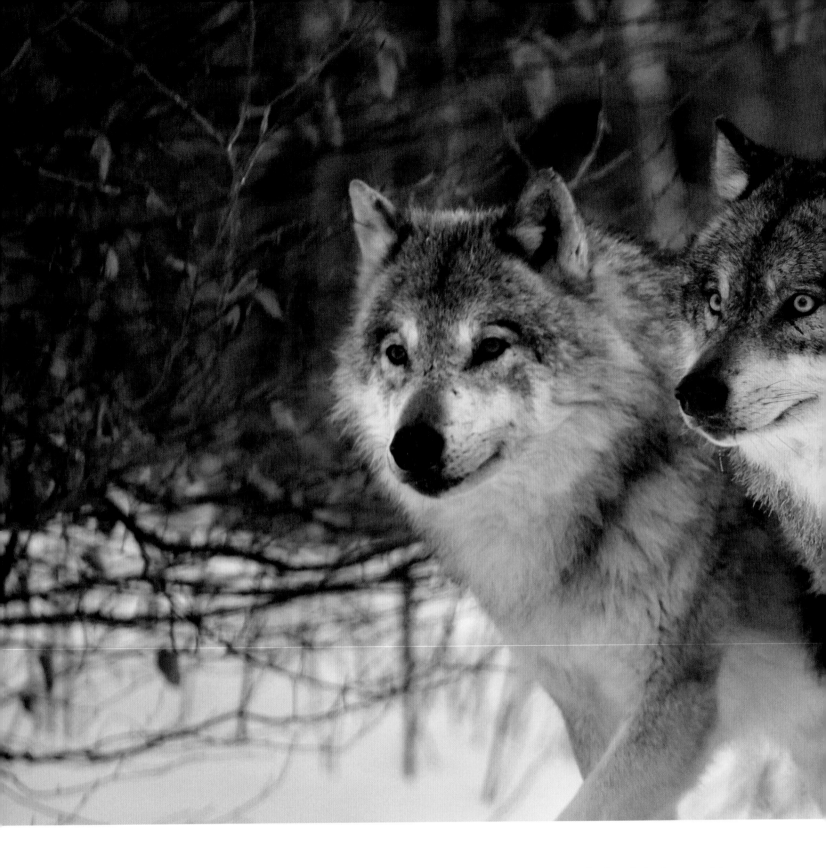

spring, when their winter food cache is exhausted and beavers begin foraging on land, or in the fall when yearling and two-year-old beavers disperse from their streams and ponds to find new areas in which to settle. Hares of a variety of species are sometimes an important component of wolves' diets, too. In addition, wolves have been observed catching live fish at coastal streams where salmon spawn. They can catch fish at the rate of twenty per hour, and seem to eat just the heads before catching a new fish.

Other prey species are eaten whenever it is relatively easy to catch them. Wolves probably don't go out of their way to catch mice and voles, marmots and woodchucks, ruffed and black grouse, or grasshoppers, but they do feed on them given the opportunity. Bird eggs and nestlings are likely consumed when encountered, as well.

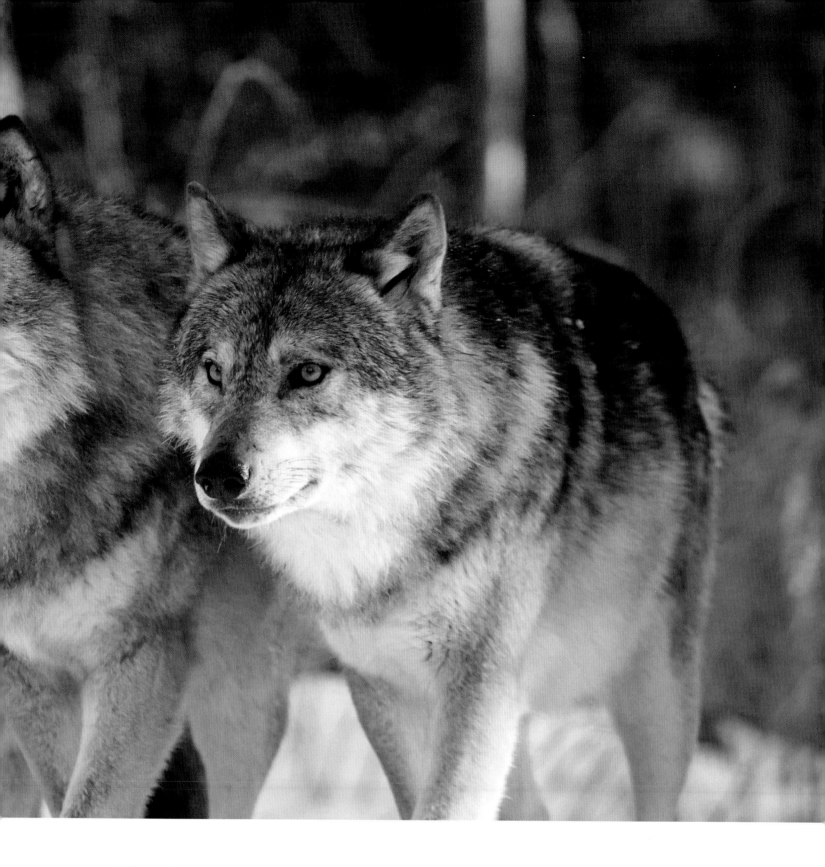

Wolves also eat fruit when it is available. They eat blueberries and raspberries in North America. Wolves in Italy spend time in mature vineyards, and elsewhere in Europe they commonly eat cherries, berries, apples, pears, figs, and melons. Wolves sometimes eat grass, and though it may provide some vitamins, they probably eat it to provoke vomiting to get rid of intestinal parasites or long guard hairs. Overall, wolves eat such a varied array of food items that, given enough of whatever is available, wolves can survive almost anywhere.

They mostly depend on large
hoofed mammals, called
ungulates, including deer, elk,
moose, wild horses, wild sheep
and goats, wild boar, gazelles,
musk oxen, and bison.

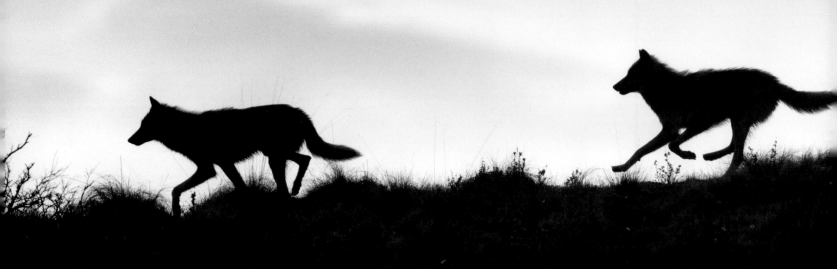

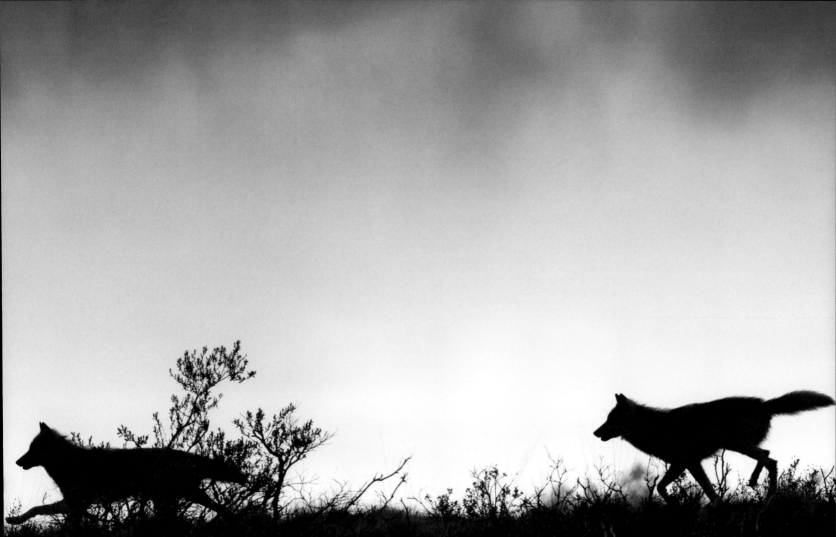

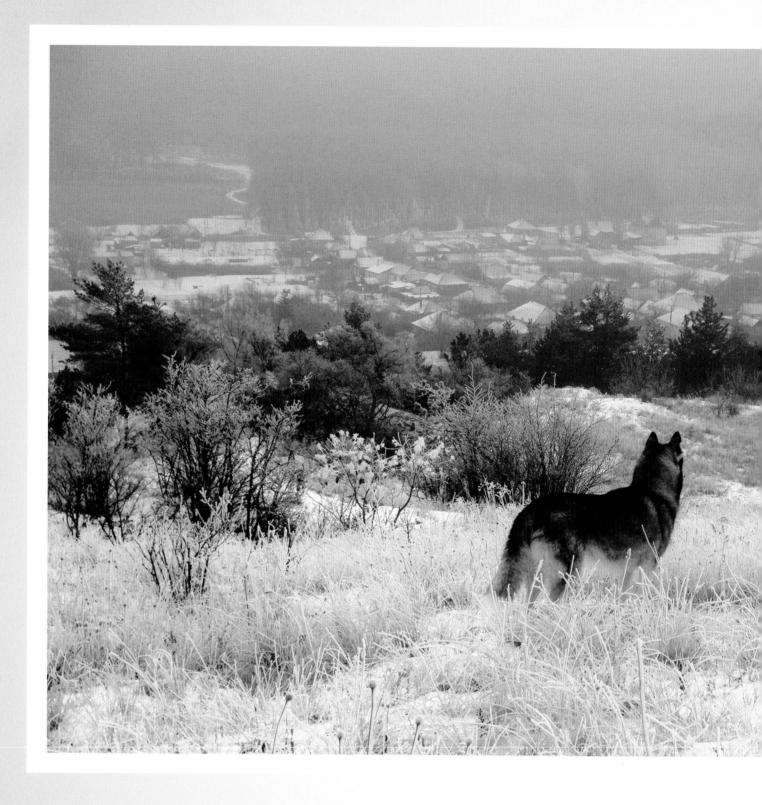

Scavenging Behavior

They will feed on carcasses of animals that died of other than being hunted by them and "steal" carcasses from other carnivores, such as bears, and eat the remains of prey that they or other species killed days, weeks, or months earlier. They will also visit human garbage sites. There, wolves find the remains of domestic animals as well as human meals of meat, fruit, and vegetables, and even pasta. Often wolves feeding at dumps ingest non-food garbage, too, including human hair, plastic, tin foil, cigarettes, matches, and glass.

Wolves are notorious scavengers.

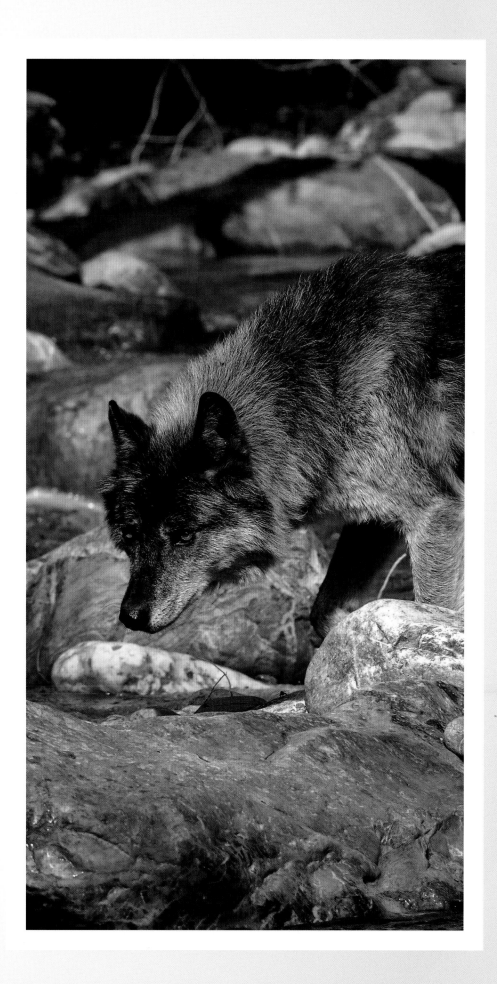

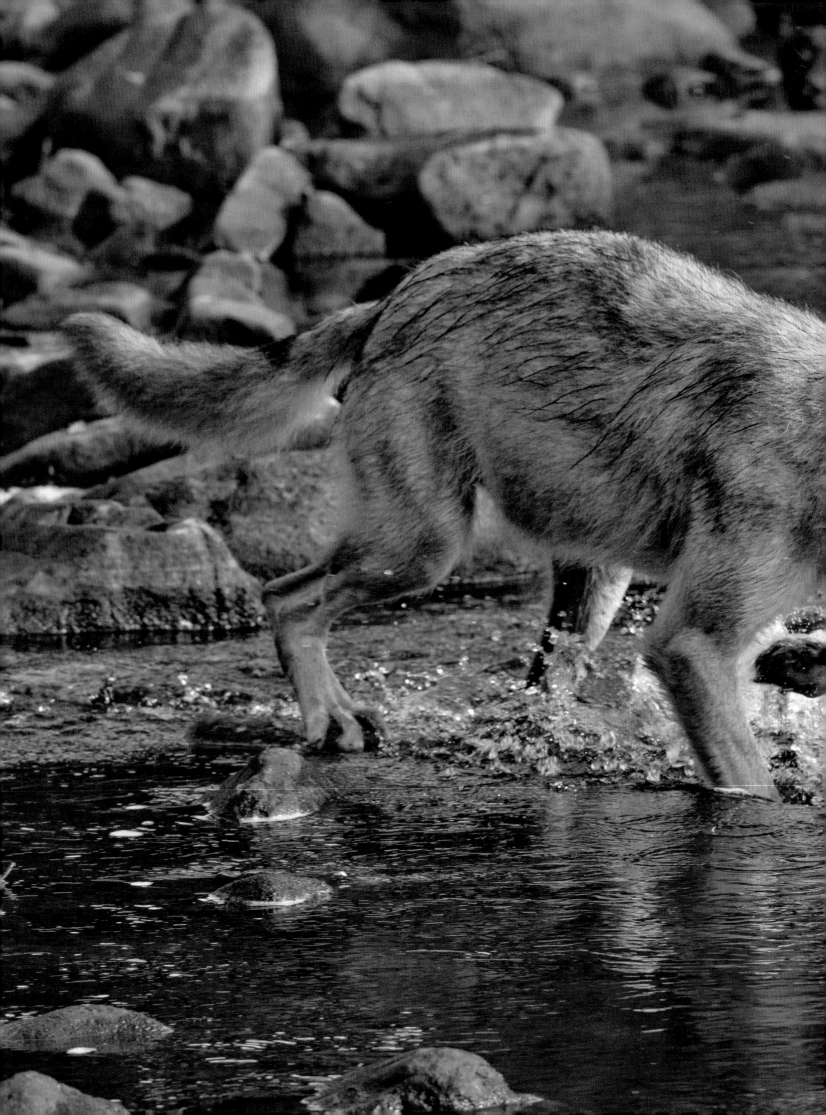

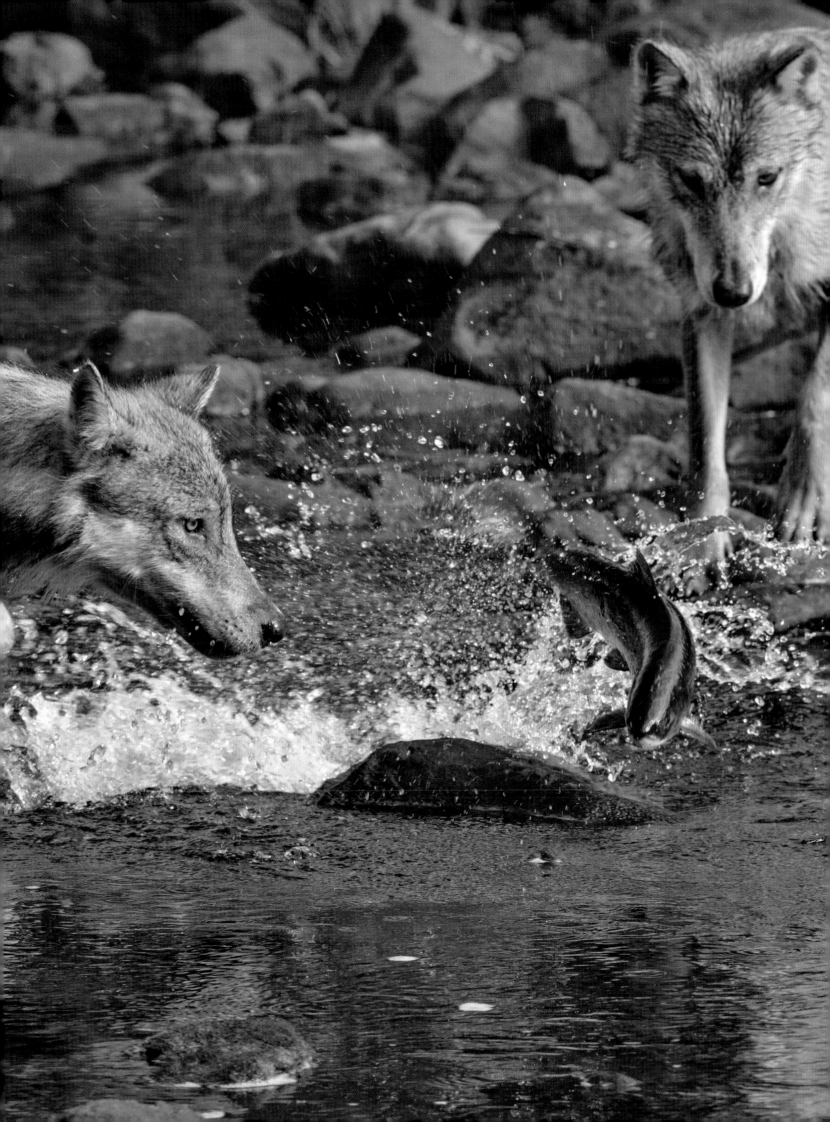

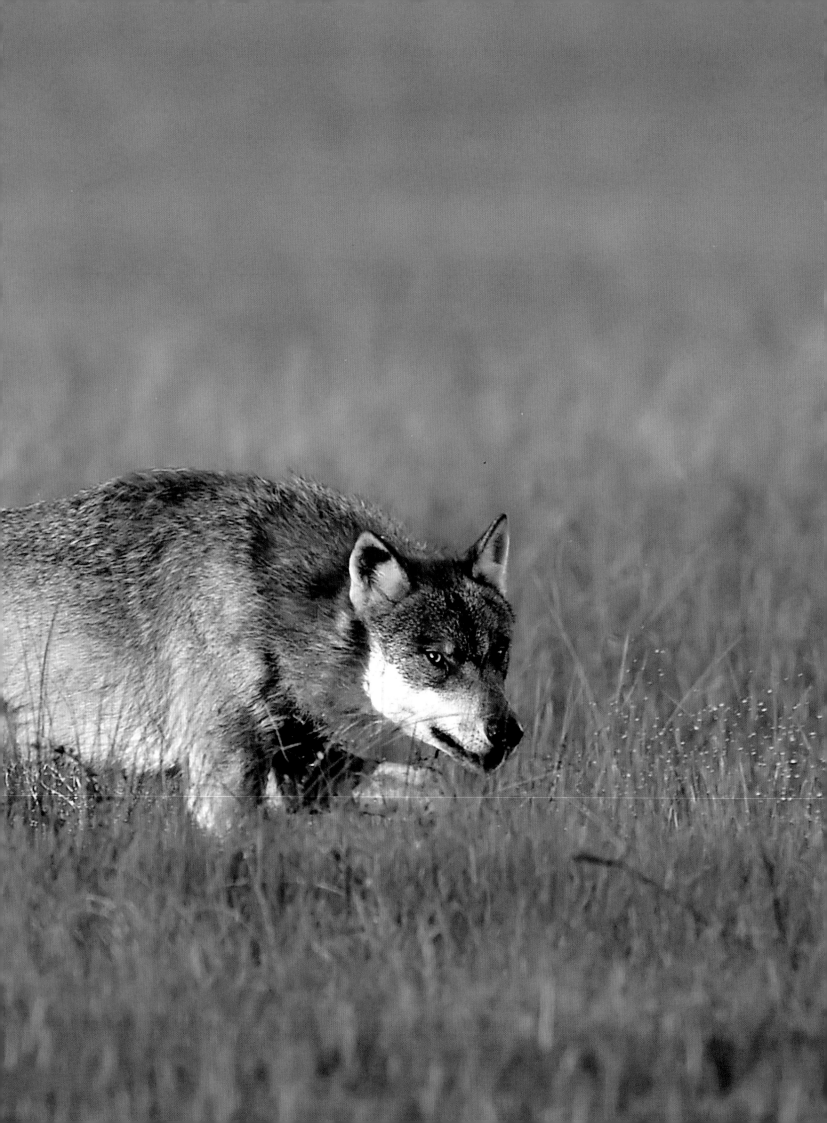

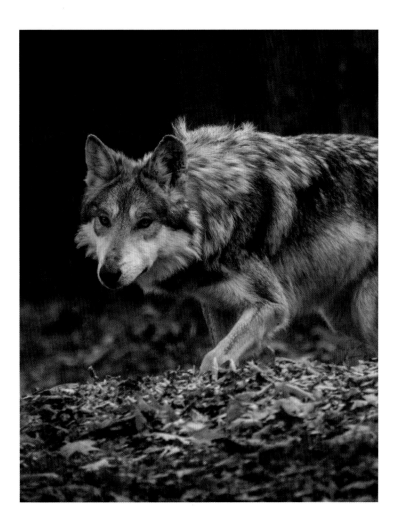

Hunting Behavior

Endurance, aggressiveness, and experience are probably the traits that make a wolf a good hunter. It must take a combination of boldness and confidence for a wolf to tackle a moose or bison, and a lot of experience to know when to abandon the attempt.

FINDING PREY

The first part of a hunt obviously involves finding the prey, which requires significant travel. Most prey animals are mobile and relatively scarce, so the distances wolves travel is necessarily large. Wolves can run up to 35 miles per hour (60 km per hour) for several minutes and can continue to run fast for more than 20 minutes while on the trail of prey. When they find it, it is most often bigger than the wolf, sometimes ten times bigger and more.

Prey animals are detected by sight and/or smell, most often in chance encounters, but probably in areas where wolves have had some previous success. Wolves select their prey by observing which animals are the most vulnerable. Young animals are smaller, slower, and less experienced than older animals, and so are easier to catch. Older animals are more likely to be in poor health and slower than younger ones. Animals that show some abnormal behavior might stand out and be a focus of hunting wolves. For example, an elk or a red deer that has become lame due to an arthritic knee joint might be a step slower, show an awkward gait going uphill, or not be able to turn as well as a healthy animal. Wolves key in on such behavior and pursue these animals more frequently.

STALKING PREY

Wolves will stalk an animal to get as close as possible. They seem to remain restrained but

excited and make use of uneven terrain to get close. If the prey animal initially runs, or when stalking wolves are detected and the prey runs, wolves immediately give chase. If the prey is small and alone, such as hares, deer, or caribou calves, wolves seem to try to catch it as quickly as they can because no matter the species, it is likely that the wolf can kill it.

Wolves will run along with large prey animals for a bit, seeming to evaluate which one might be most vulnerable and easiest to kill.

This testing seems to work; large prey animals killed by wolves are generally inexperienced or injured. Sometimes when prey animals detect wolves, they actually move toward the wolves or stand their ground. This behavior is most common in larger prey such as moose, bison, and musk ox. In these cases, wolves approach the prey animals but wait until the animal runs before getting close enough to grab it. If the prey stands its ground for a long enough time, the wolves usually give up and move on.

THE CHASE

It seems logical that a pair of wolves would be more efficient hunters than a single wolf. A pair could maneuver better, keep up with running prey, and one wolf could distract the prey animal while another attacks. Lions are known to hunt strategically and cooperatively, chasing into an ambush, heading off fleeing prey, or taking turns chasing prey, so why not wolves?

Wolf pairs do hunt sheep successfully, but only when they can get above them and thus chase them downhill; such sheep can easily outrun wolves going uphill. And when involved in long, strung-out chases on open ground (such as caribou on the tundra), the slower of a pair will "cut corners" and thus get closer to prey animals. But it turns out that wolves are rarely observed to actually cooperate much when chasing prey. This may be because wolves don't really stay long in packs, and with relatively high mortality rates, even pairs aren't together for many years. It may be, too, that long-distance chases are just not very conducive to tactical or strategic hunts, and wolves seem to survive just fine without such cooperation.

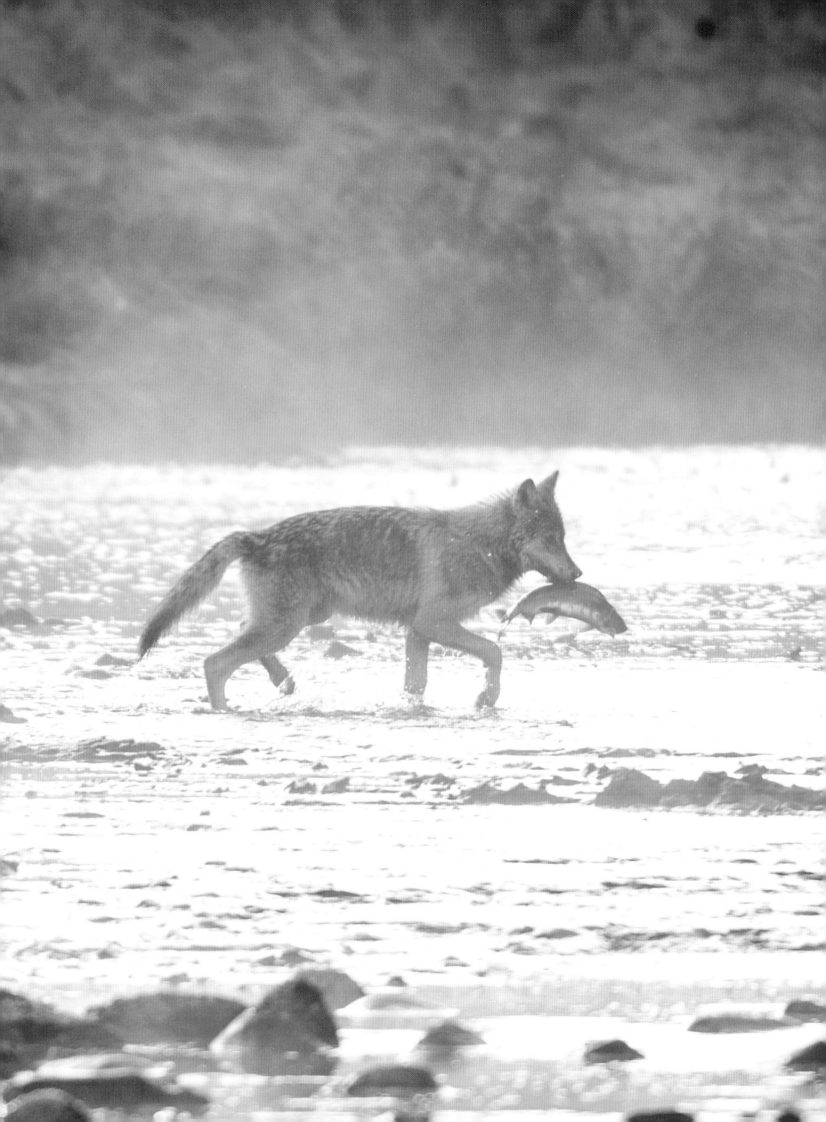

THE KILL

There does seem to be some cooperation, or at least diversified help, when wolves actually grab onto a prey animal and kill it.

When some packs kill a moose, a single wolf will grab onto the very large nose and pull at it with all its might.

On rare occasions wolves do what is termed "surplus killing." They kill repeatedly over a short period of time and eat little or none of the carcasses. This usually occurs only when prey is both abundant and highly vulnerable. It usually involves newborn or older animals and is most common with herds of domestic animals lacking normal defenses against wolves.

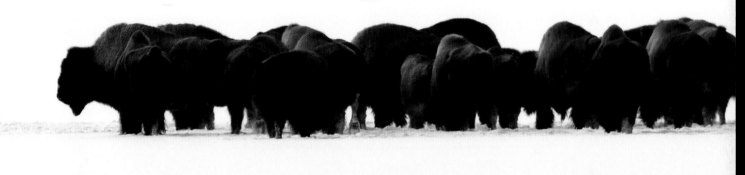

Although wolves are big
carnivores that can chase down
the swiftest of prey, they are
also able to take advantage of
the widest variety of food types.

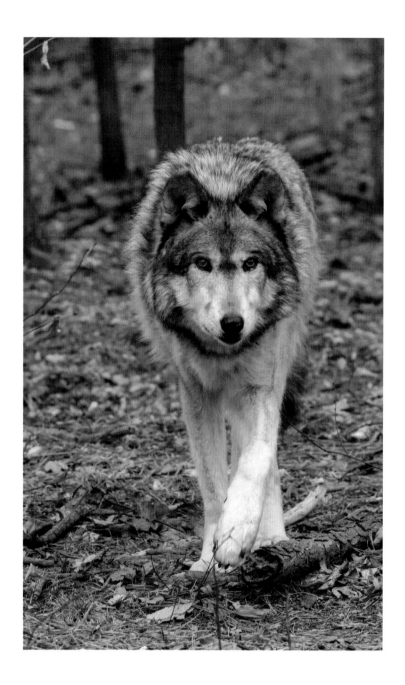

Feeding Behavior

There is a reason for the expression "wolfing down" your food; wolves are voracious eaters. An adult beaver, a deer fawn, or a yearling caribou can all be consumed by a pack of wolves within an hour or two. Even a 330-pound (150-kg) moose calf can be eaten so quickly and completely that nothing but a mat of hair remains.

One of the reasons wolves eat their prey so quickly is to keep scavenger animals away from the best meat. Some species make a living by paying attention to where wolves go and what they kill.

Anything that remains after the wolves' first feeding is available for smaller animals to take. The other reason for speed feeding is probably that the wolves are so hungry. It could be several days since their last meal, and the best survival strategy may be to eat as much as possible as fast as possible.

Usually the most dominant "alpha" male and female wolves get to eat first. This may be because they often are the breeding adults and thus parents to the rest of the pack, but also because they often do most of the actual killing. Sometimes they rest

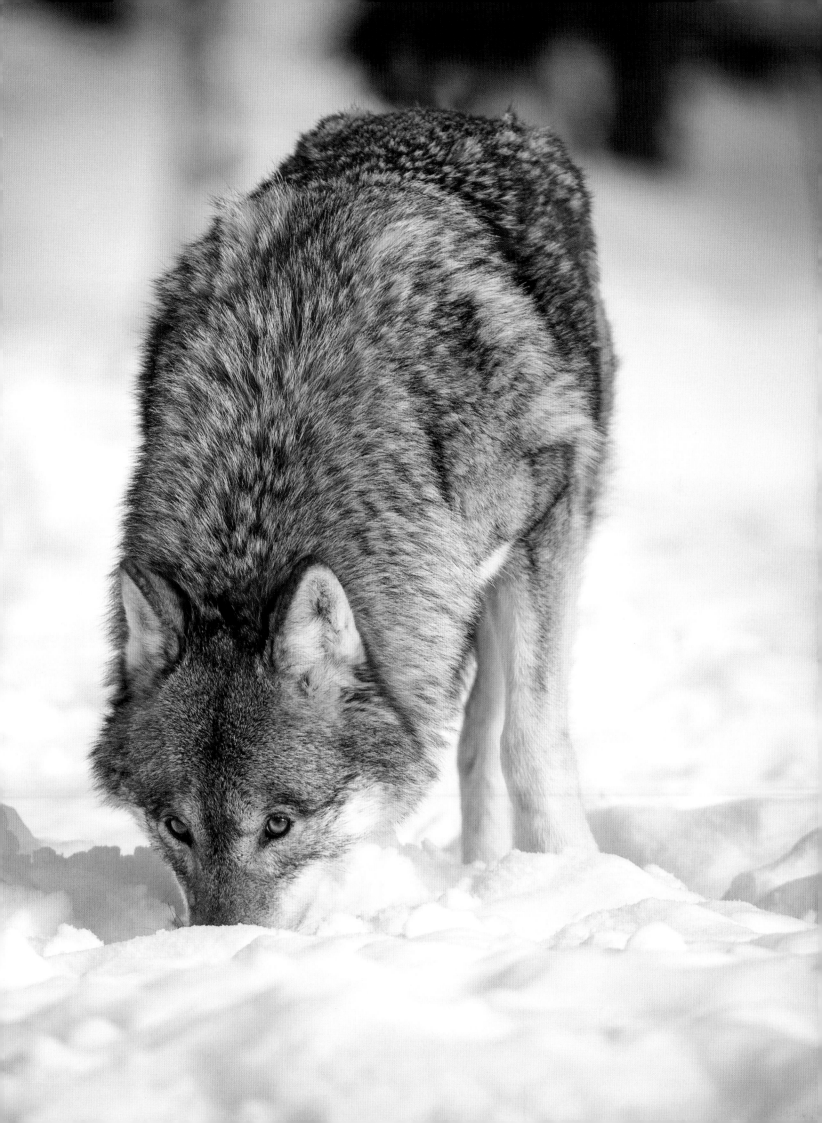

just after making a kill, however, and other pack members begin feeding first.

The first parts of a carcass that are consumed are often the large internal organs (lungs, heart, and liver). Then they consume the stomach and intestine, along with smaller organs such as the kidneys and spleen. At the same time, some wolves may be eating skin, back muscles, leg muscles, and meat from the ribs.

Well-fed wolves have stomachs so distended that they often can only sleep on their side, not curled up. They may rest for five to six hours before feeding again, eating whatever meat and skin they can find and crunching up bones.

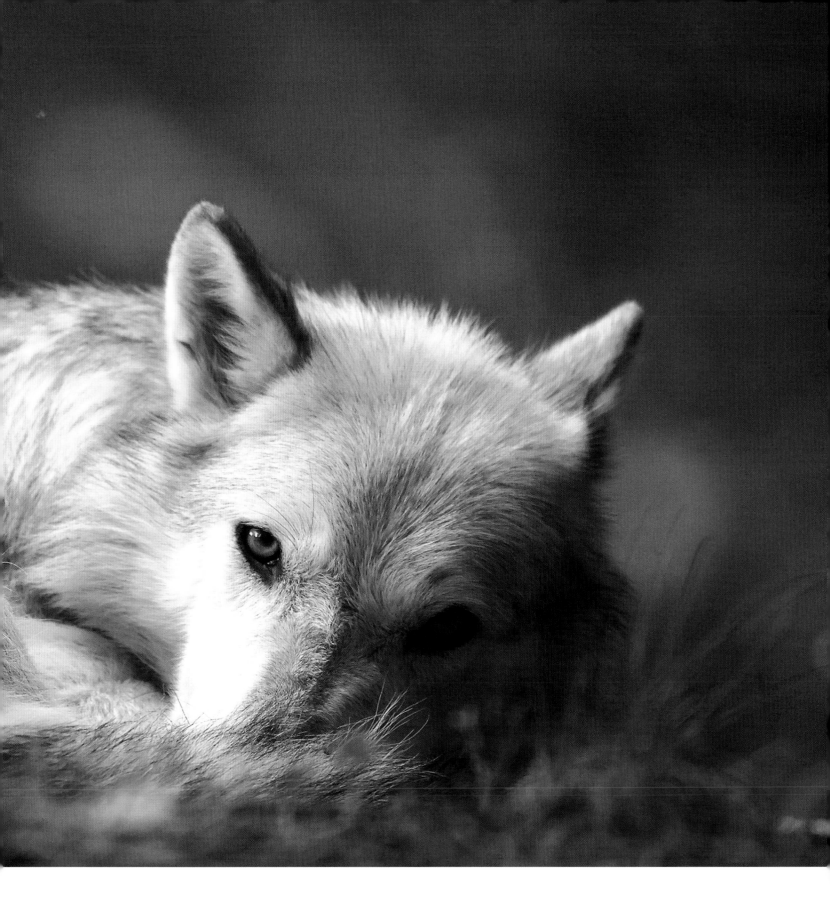

When wolves are full and can't eat any more, they hide, or cache, food.

Caches may contain a few chunks of regurgitated meat or a whole hare or caribou calf. Caching usually happens in the spring or summer when wolves hunt singly or in pairs, and thus any kill they make likely has more meat on it than can be eaten in one sitting.

Caching protects food from scavengers and provides future meals if nobody else raids the hideaway.

All of this coordinated hunting and feeding behavior requires sophisticated communication skills among wolves, the subject of the next chapter.

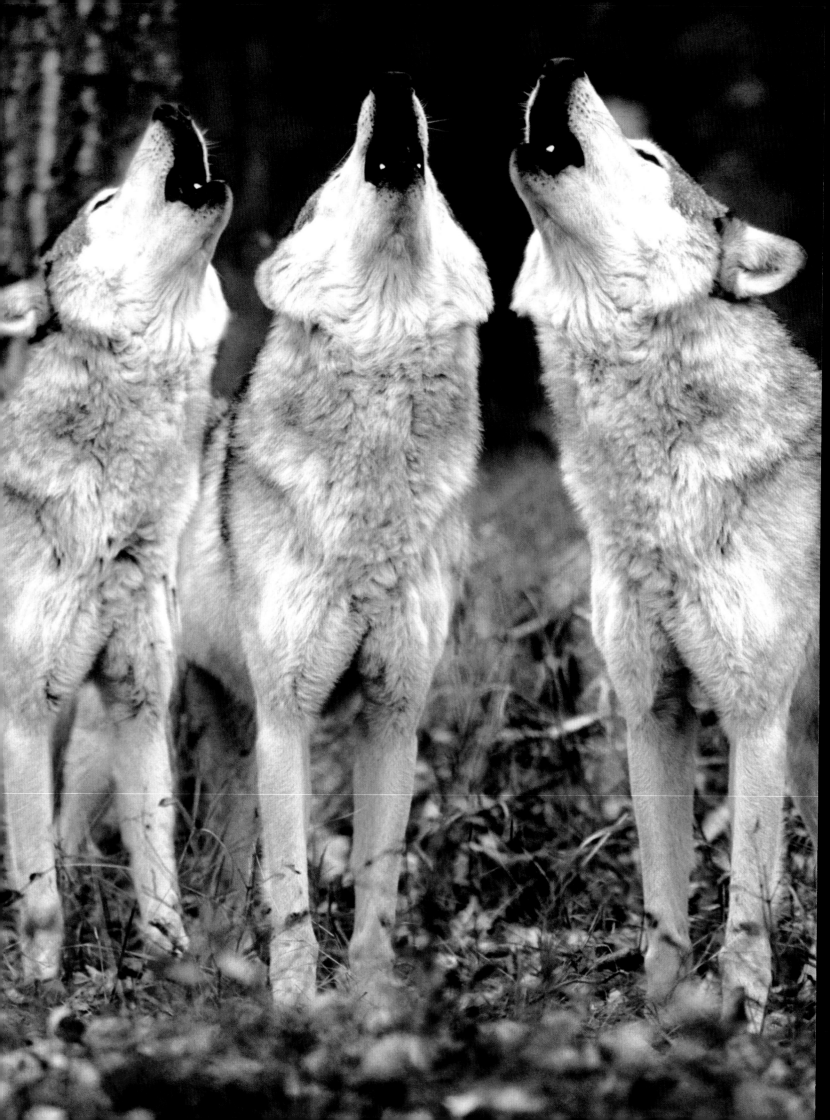

How Wolves Communicate

Wolf senses, like those of dogs, are highly tuned. Every dog that sniffs intently and then lifts its leg on a bush or howls and barks at a passing siren gives us a good idea of the ways in which wolves likely communicate. Dog owners are attuned to the body and facial expressions of their own and other dogs. Similarly, wolves use signals that are obvious to us humans, but also use much more subtle but equally informative signals to send messages to other wolves. These signals can either involve nearby pack mates or neighboring and even unknown wolves across the landscape. This communication spans all the senses and includes sound, scent, body language, and touch.

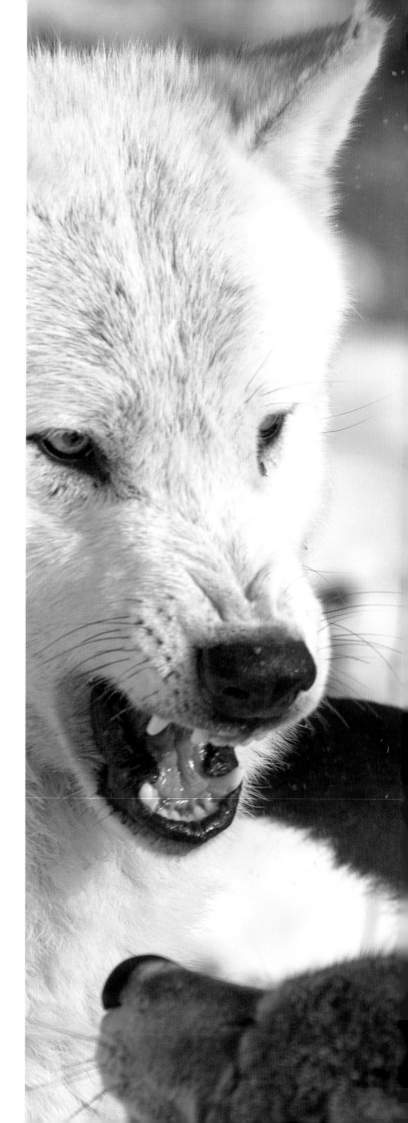

Wolf skin glands produce substances with distinct odors, which wolves can deposit as they roam.

SOUND

Adult wolves generally make two types of sounds: friendly and unfriendly. Friendly sounds include whines, whimpers, and yelps, and are used in greeting and when trying to appease another wolf. Unfriendly sounds, on the other hand, include growls, snarls, woofs, and barks and are used in aggressive and dominant situations, such as during an attack or as a warning.

But the sound that most often comes to mind when we think of wolves is the howl.

First, wolves may howl to reunite. Second, wolves may howl to strengthen social bonds. "Chorus" howls, where many wolves howl together, are highly contagious. There is vigorous social activity such as sniffing, rubbing, and licking among pack mates before, during, and after chorus howls. Third, howling may reinforce a wolf's territory, such as at fresh kill sites where a carcass is an important resource to defend or, similarly, if wolves are traveling with pups. Howling provides a way for wolves to avoid one another if they choose to do so. Finally, wolves may howl to find mates, especially during the breeding season.

SCENT

If a human could be a wolf for a day, it is likely that the biggest difference in life would concern odors. A wolf's sense of smell is so much more rich and varied and hidden than what we humans can perceive, that perhaps only our own ability to communicate through language rivals the scent messages of wolves.

These scent messages contain information on species, individual identity, age, gender, rank within the pack, state of aggression or fear, and mating status.

Wolves also urinate frequently to mark their territory, especially along regular pathways and at

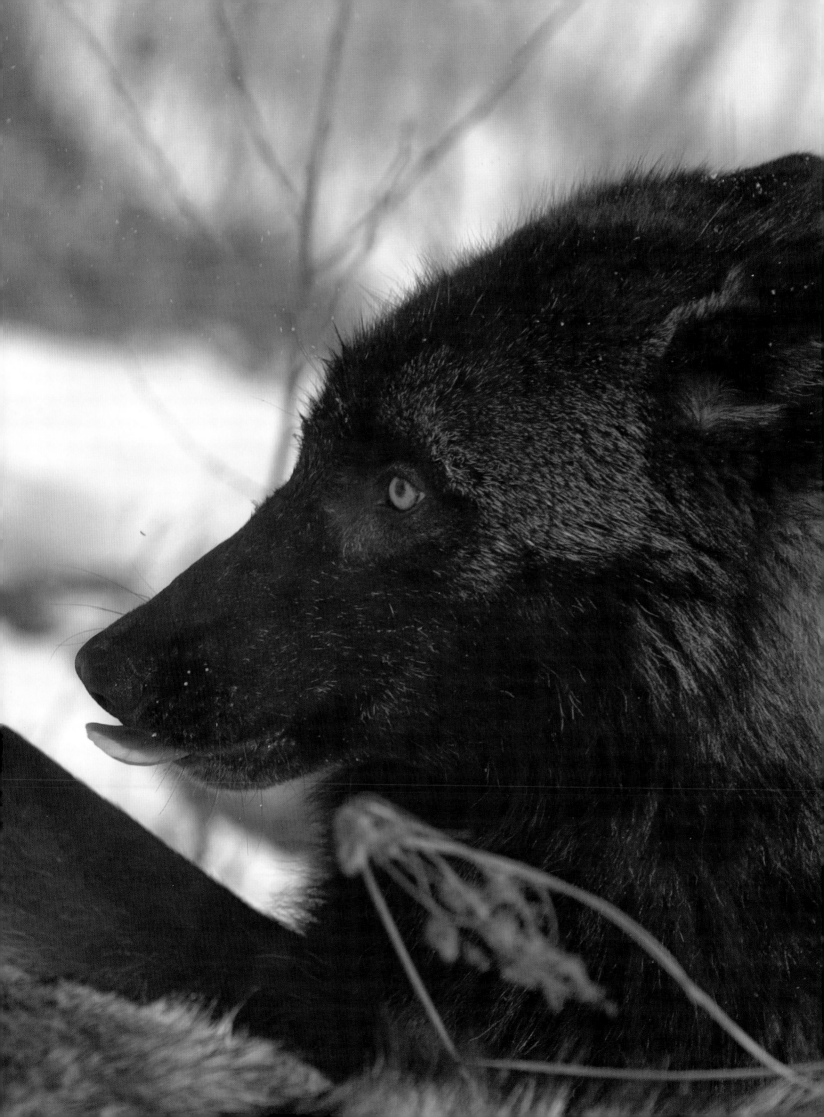

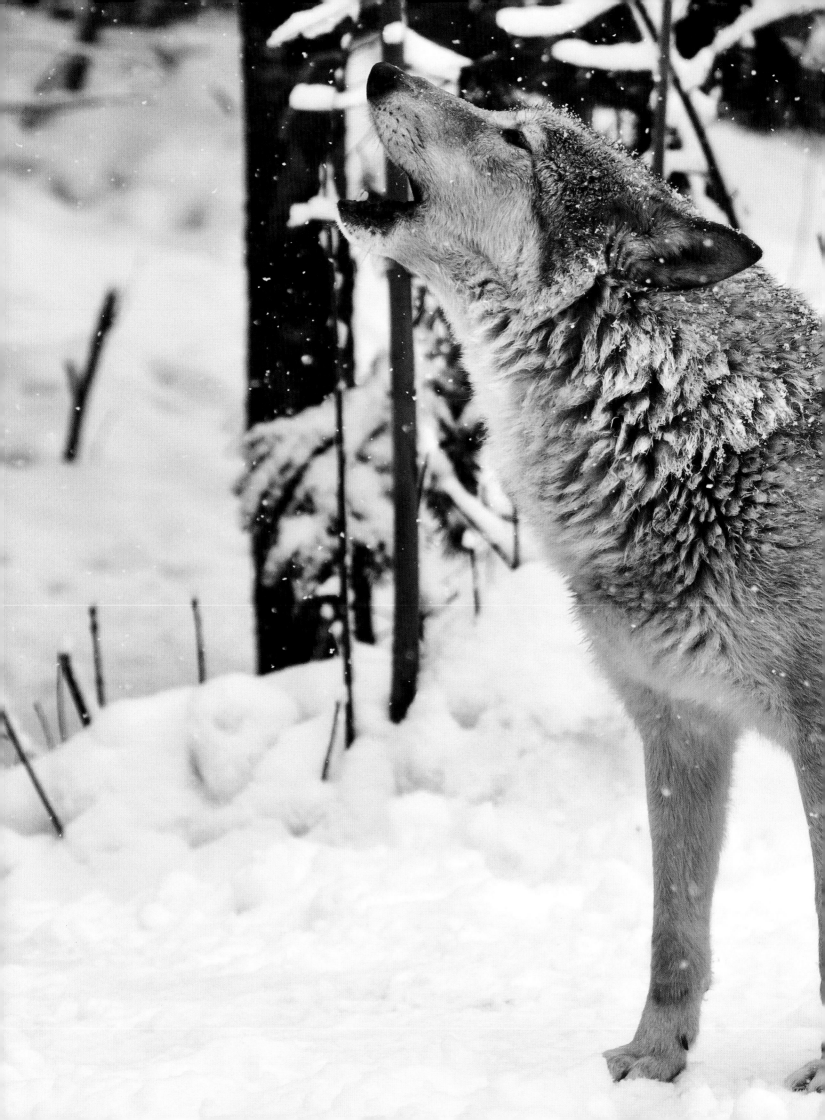

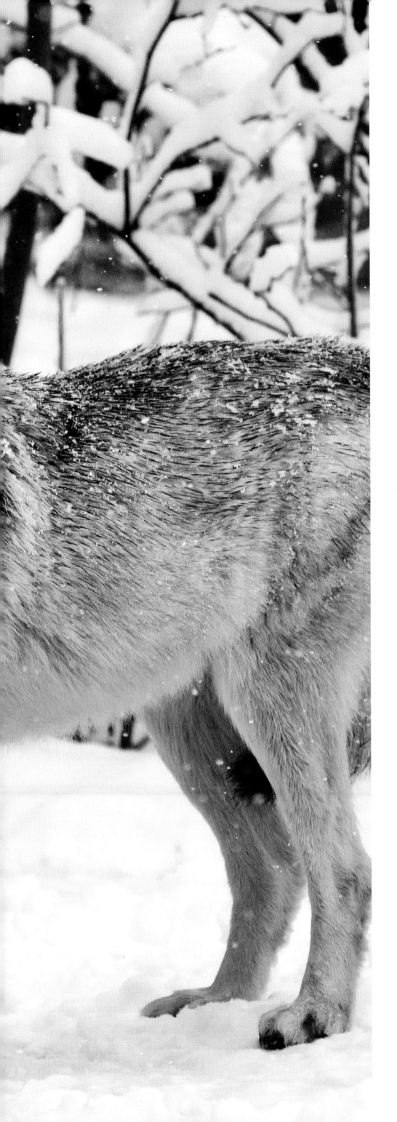

trail junctions, and to let other wolves know of their presence. Males urine-mark more than females, and both males and females, particularly dominant ones, urine-mark more during the breeding season. Urine marks of paired males and females are often deposited on top of one another to reinforce their attachment. Finally, wolves urine-mark food caches that have been emptied, thus keeping track of the status of stored food so they don't waste their time foraging at that site.

BODY LANGUAGE

Postures and expressions are perhaps the easiest wolf communication modes for us humans to recognize, again because of our close relationship to dogs. A crouching wolf with tucked tail seems to tell us something very different than one with bared teeth and raised hair along the neck and back, or another with an upright head, a wide grin, and a wagging tail. Just as we interpret human gestures and facial cues as important forms of communication, so do wolves.

In general, these signals reflect one continuum of expression from submissive to dominant and another, simultaneously, from playful to serious. For example, when a single, dominant wolf returns to a den from a hunt, any other wolf will likely run to greet it. This greeting wolf might approach in a low posture with a slightly crouched body, ears back and close to its head, and a wagging tail. It will likely nuzzle and lick the mouth and face of the returning wolf that, in response, stands erect with head up and tail flying high. The somewhat playful but actively submissive greeter exchanges information with the dominant, somewhat serious returnee.

Similarly, confrontational interactions between two wolves often lead to one wolf on its side and back, tail curled between its legs and ears flat and

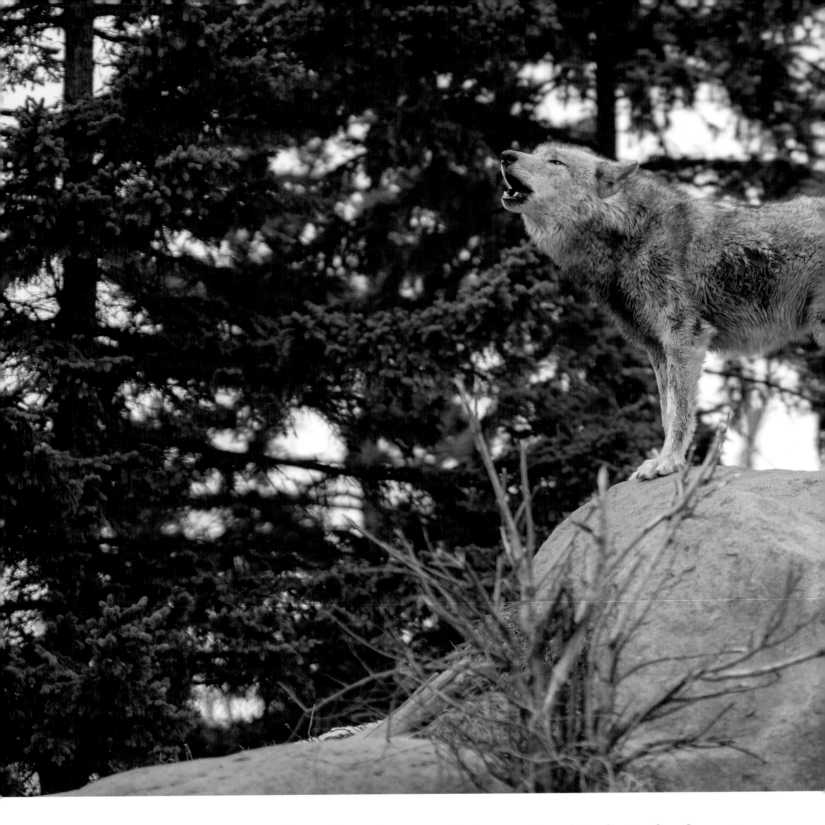

directed backward, and the other wolf standing over it with teeth bared, hair raised, and ears erect. The passively submissive wolf and the actively dominant wolf are both quite serious, and social order is maintained.

TOUCH

Tactile communication in newborn, blind pups is evident in their efforts to nurse and huddle together to keep warm.

As they get older, their play involves frequent body contact, and their food-begging behavior involves licking and other direct contact with food-providing adults.

For adults, much of their body contact occurs in friendly situations, such as group greetings and during courtship and play, which may reduce stress and strengthen social bonds. This anxiety-reducing behavior has been shown in studies of humans and their pet dogs, and certainly wolf pups seem reassured when physically comforted by their

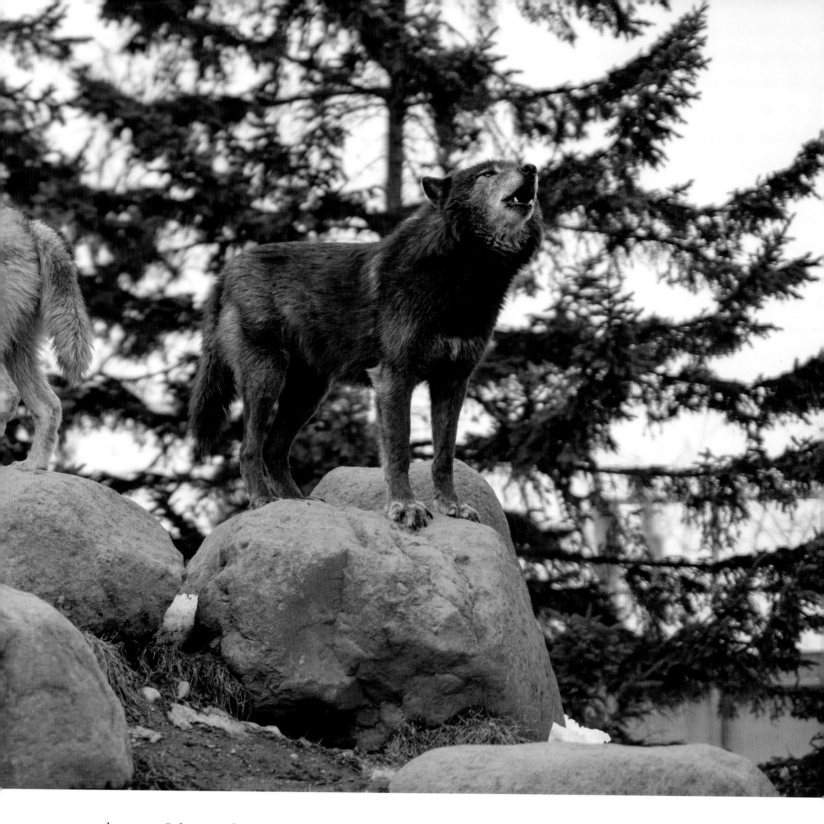

pack mates. Other tactile communication, such as shoving and nipping, may occur during aggressive encounters, which helps wolves assess each other's physical strength and skill.

All of these modes of communication help wolves find mates, breed new pups, and establish family bonds, as we will see in the next chapter.

Wolves communicate via signals from the ears, eyes, lips, teeth, nose, and forehead; changes in body posture; the position of the tail; and the hair, which can stand on end.

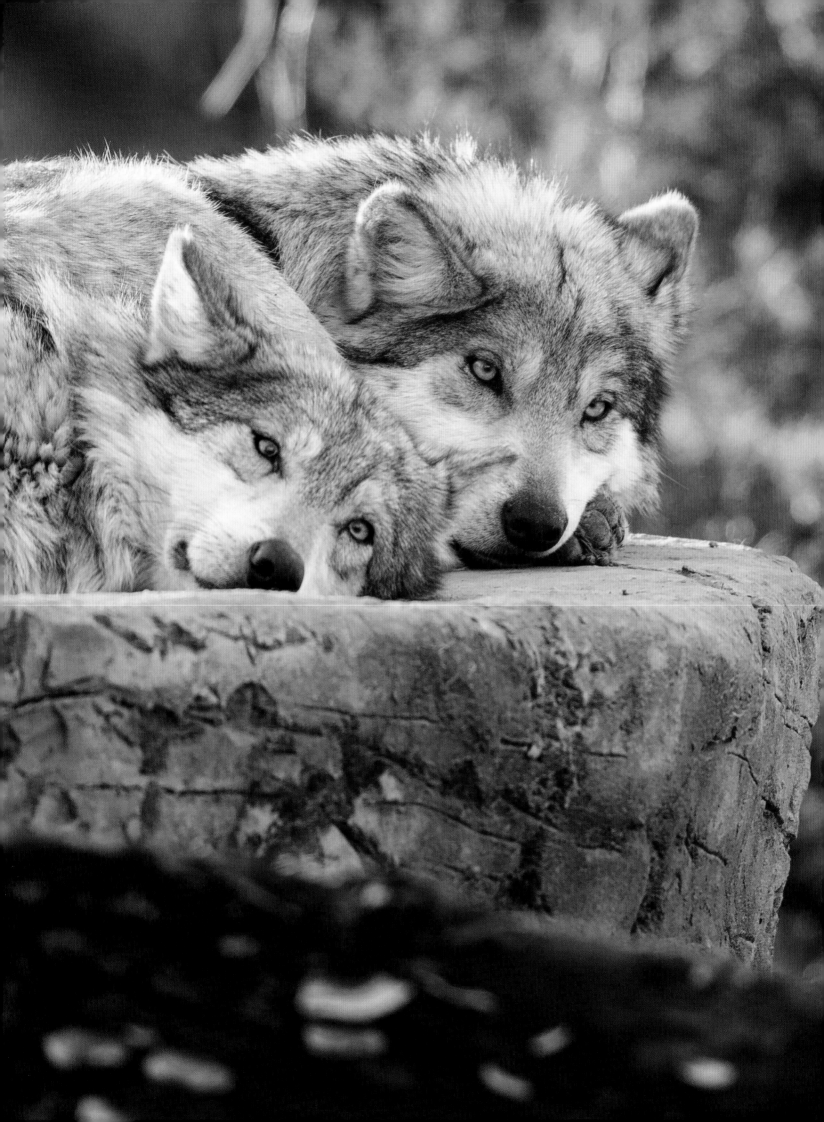

WOLF FAMILIES

One of the things that drives people's fascination with wolves is their social behavior. We know that they live in families, with both parents and sometimes older brothers and sisters helping to take care of pups. We have the classic image of a string of wolves traveling through the snow in search of prey; we also know that when they find prey, they work collaboratively in the dangerous job of bringing it down. Wolves play intensively with each other, but they also sometimes fight and even kill one another.

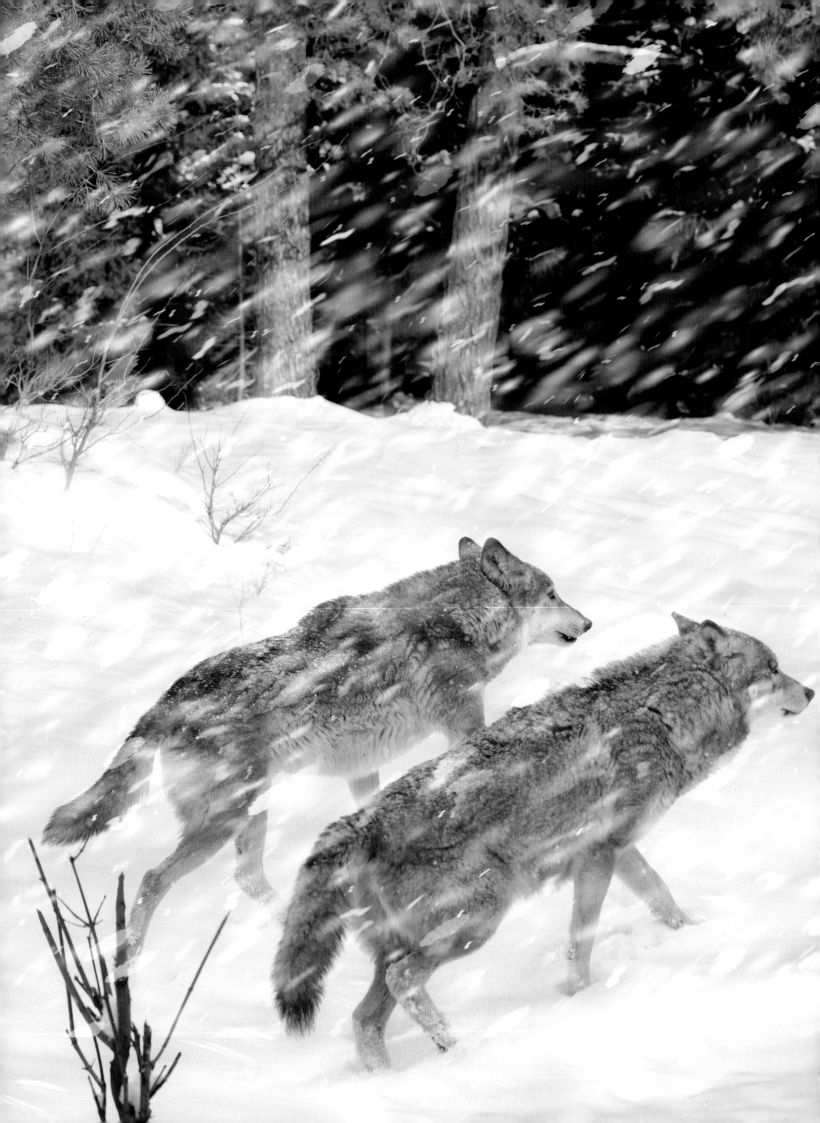

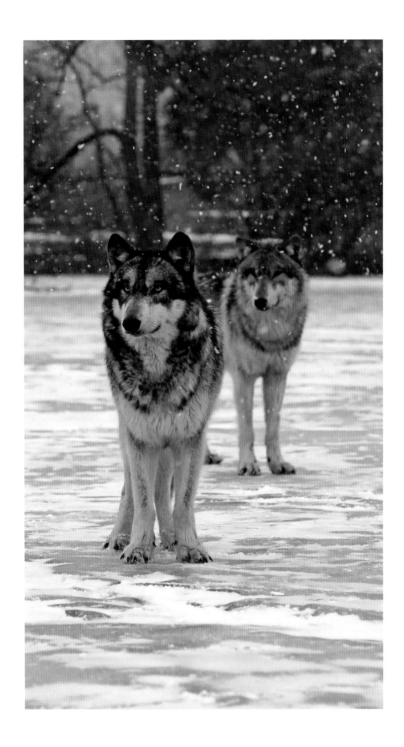

Finding a Mate

They may travel for days or weeks searching for signs of single wolves of the opposite sex. When such signs are found, usually of the scent variety, wolves will trail each other warily, make appropriate sounds, come within sight of a potential mate, and make the appropriate physical gestures indicating nonaggressive attitudes. Intensive scent investigation is undertaken, a bit of playful interaction occurs, and if personalities match, a pair is formed.

Other times a "breeder" is needed in an established pack. This happens when single male or female wolves find, meet up with, and are "adopted" by another family. The single wolf establishes a bond with another "mateless" wolf, and a pair is formed. In other cases, wolves that are already members of a pack will bide their time until an older breeder of the same sex steps aside, leaves the pack, or dies. They then step into the role of breeder.

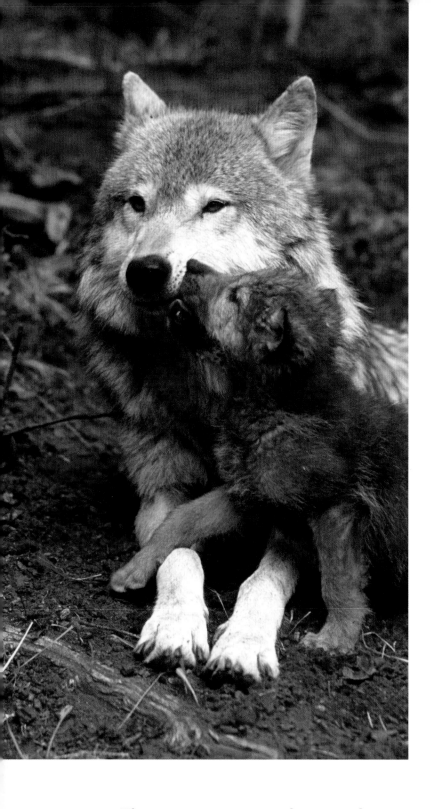

There are circumstances when more than one female in a pack breeds. Usually this occurs when food supplies are high. When multiple breeding pairs of wolves occur in a single pack, the pack may split. This usually happens when pack sizes get quite large (twelve to twenty wolves), and each pair leaves with about half of the pack members. Each new pack takes over a portion of the original range and appears to continue with wolf family life as a pack with a single pair of breeders. When the two packs meet, they sometimes greet each other as family, but then usually go their separate ways.

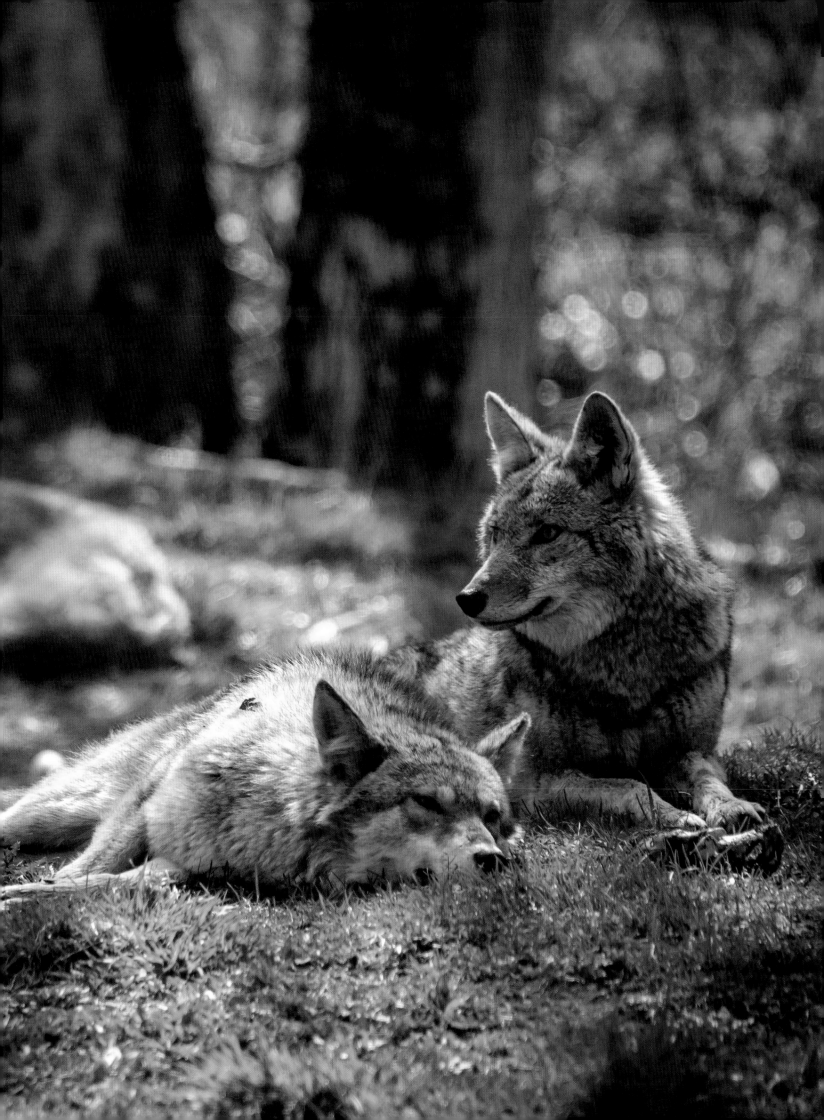

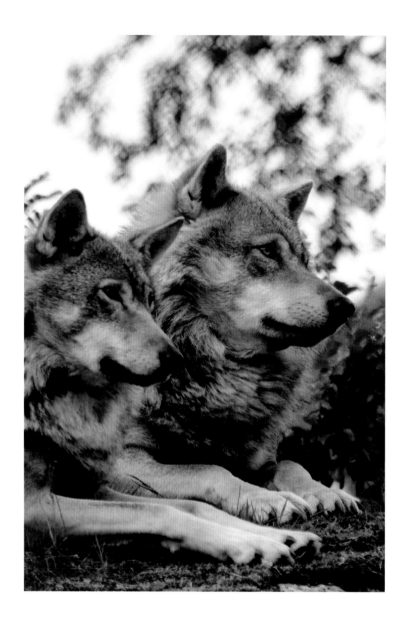

Courtship and Breeding

Courtship and mating behavior occurs in the fall to prepare for the breeding season, which is generally in February. When wolves have mates, or as soon as they find one, they begin to show more interest in them, even if such interest is not returned. Males seem to be a bit more aggressive in this regard.

For the two months prior to actual breeding, paired wolves sleep closer to one another than at other times of the year. Also, the breeding female in each pack is followed more closely by her mate than by other pack members. The paired wolves nuzzle, prance, and sniff each other. New pairs of wolves can form at any time of year, and existing pairs remain together year-round.

Pups are born early in spring, usually early to late April. This timing takes advantage of when other prey species are being born. This new and plentiful supply of helpless newborn prey means that wolf pups have a better chance of eating well and growing quickly before winter sets in and food becomes scarce. Litter size usually averages four to six pups and may be larger if there is a good supply of food for breeding females. While any particular litter can have all males or all females, or any combination thereof, the ratio of the sexes seems to even out to fifty-fifty.

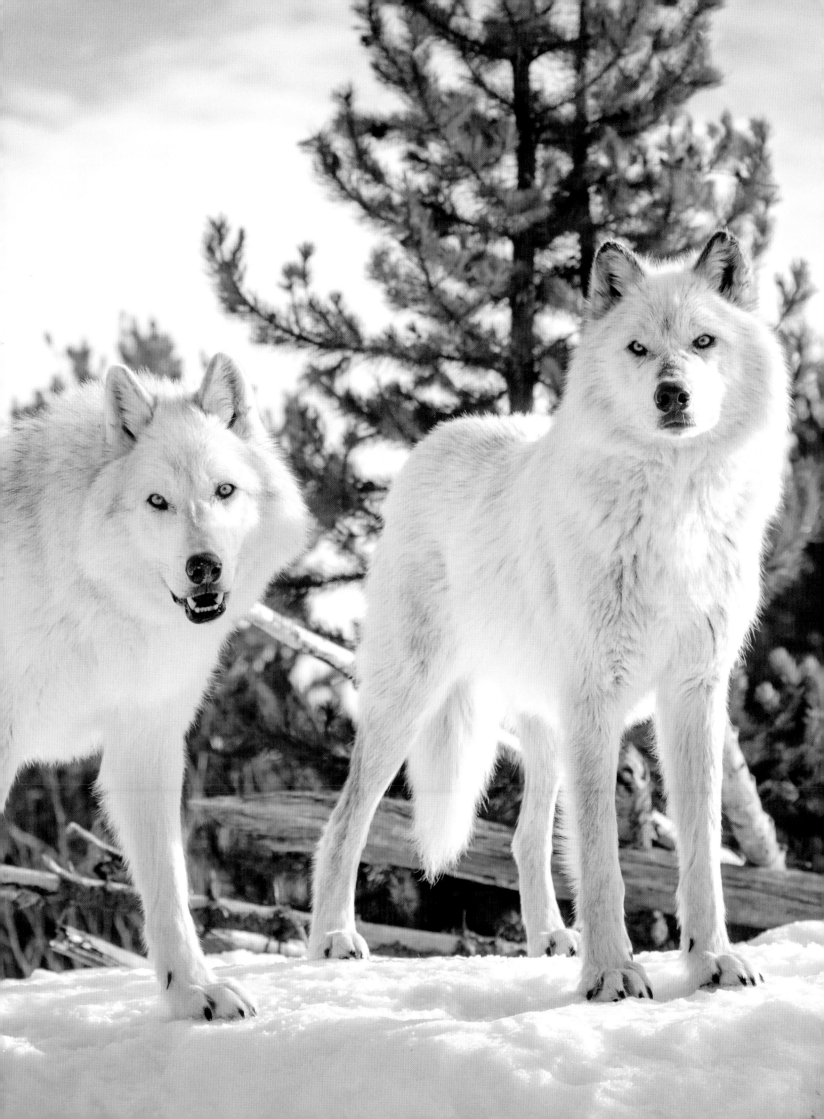

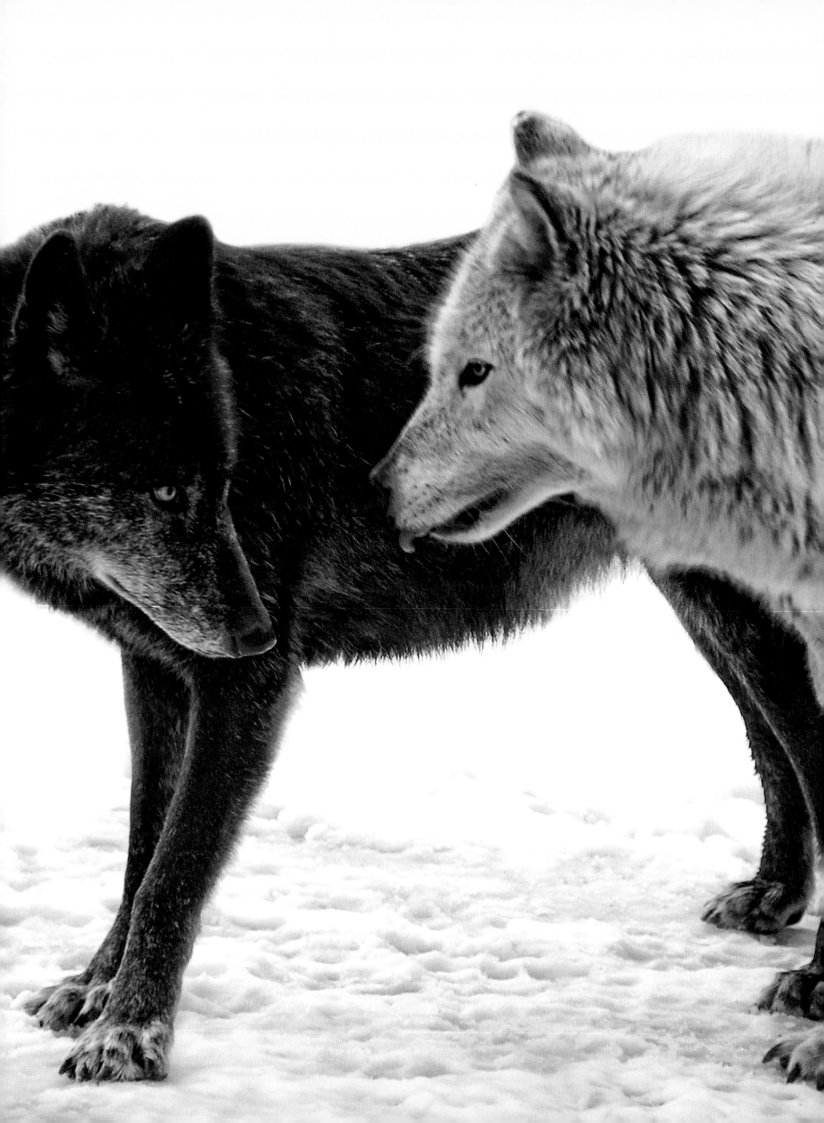

It's usual for the alpha pair to be the only wolves to breed within the pack.

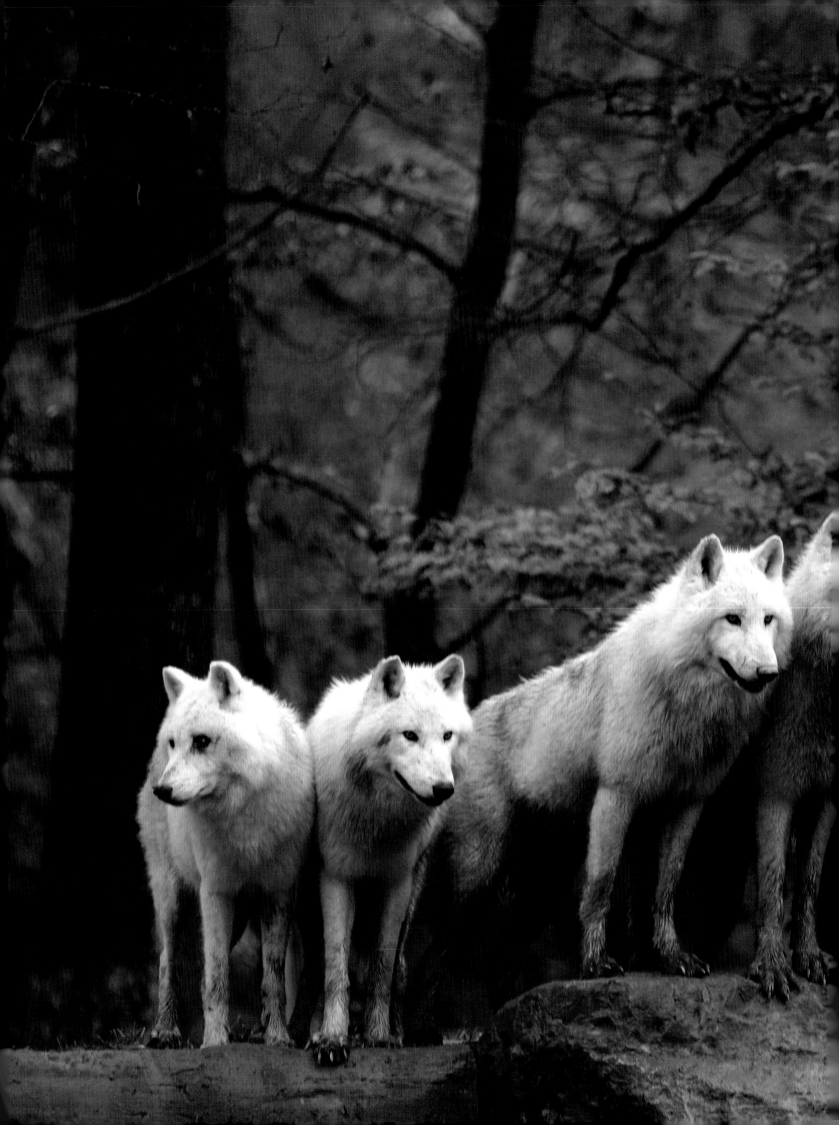

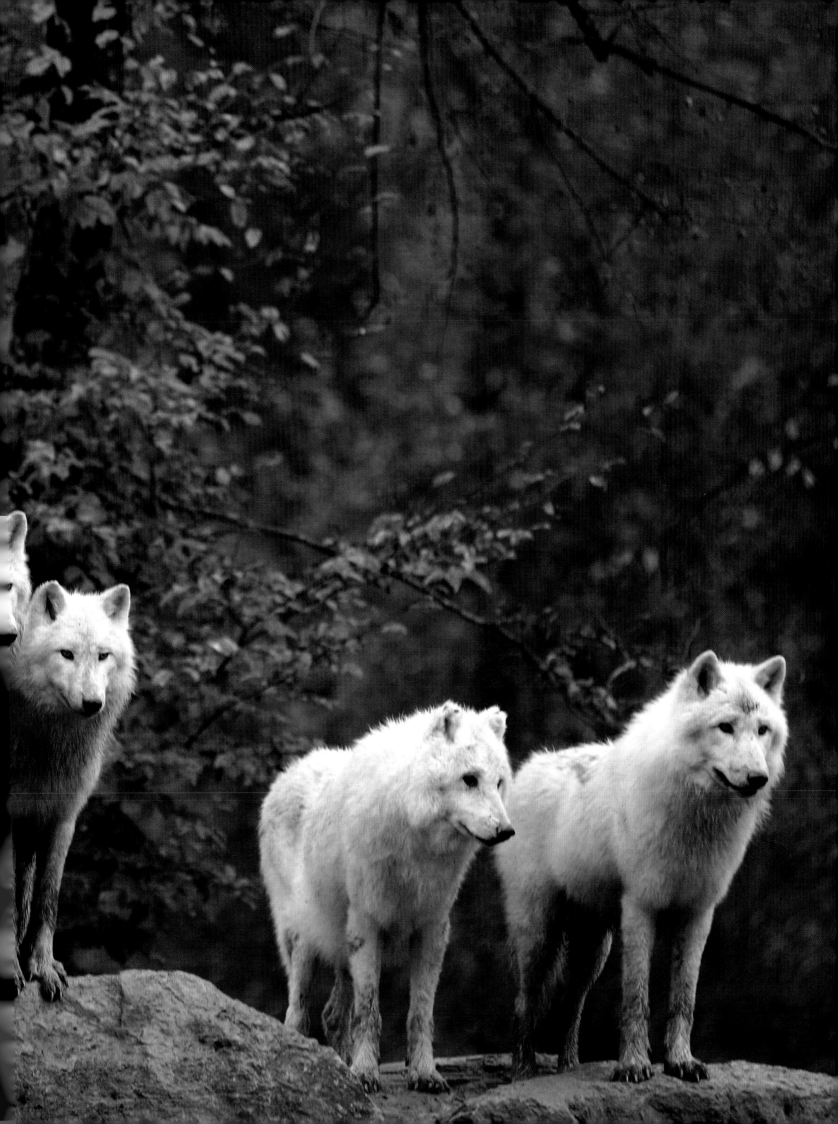

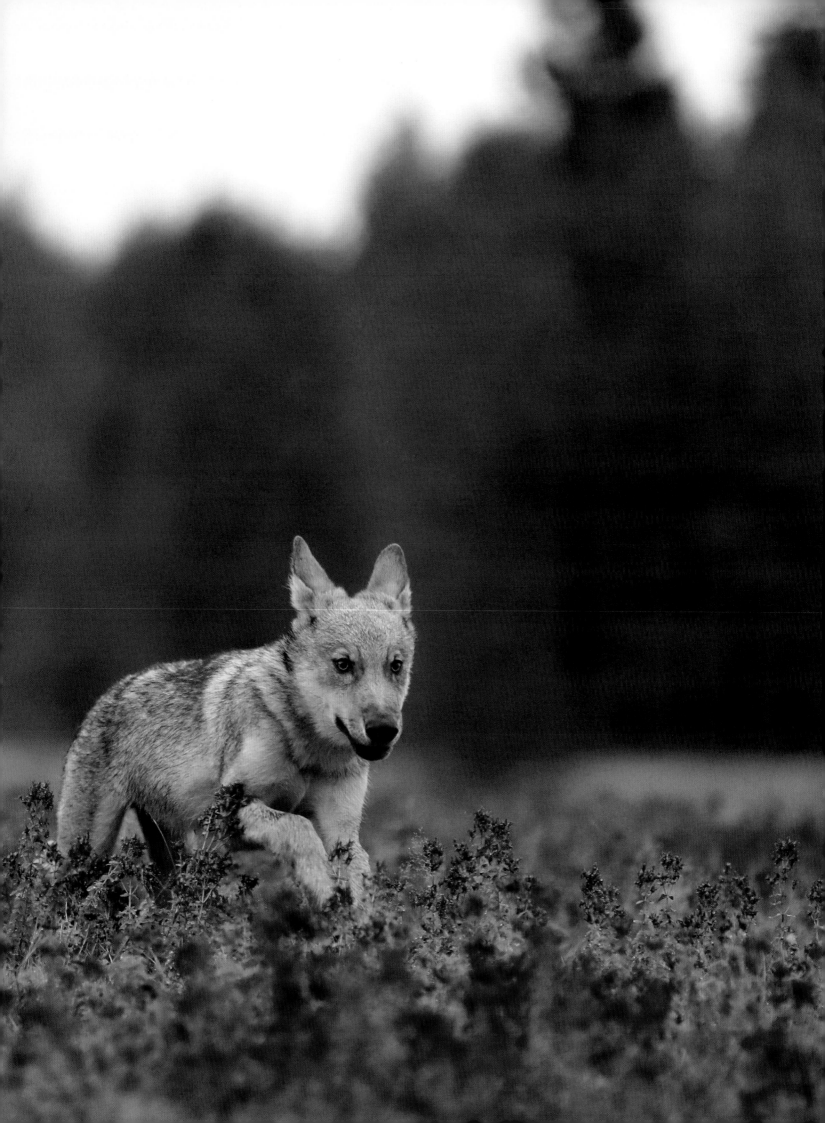

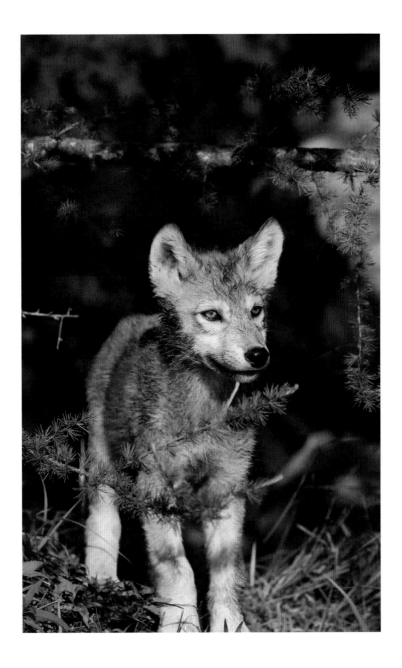

Growing Pups

Family members may begin preparation for pup care even before the pups are born. Both adults and yearlings help with digging a den and providing food for the pregnant female.

Just before the birth, the pregnant female stops foraging for food and settles into the den. Once a pup is born, the female licks it and then nibbles at and consumes the protective membrane surrounding the pup. She noses the pup toward her belly and nipples; pups instinctively suckle within an hour or two of birth.

During the first week to ten days, the tiny pups squirm and crawl on top of each other when they are not suckling, seeking the warmth of their mother, or sleeping. They clumsily roam the den chamber, bumping into the walls and each other before whimpering or crying out. At ten to twelve days of age, the pups are large enough to see and walk to the den entrance, but they usually just scoot right back inside. As a result, no other adults have any real contact with the pups during these first few weeks, except for occasional visits by the father.

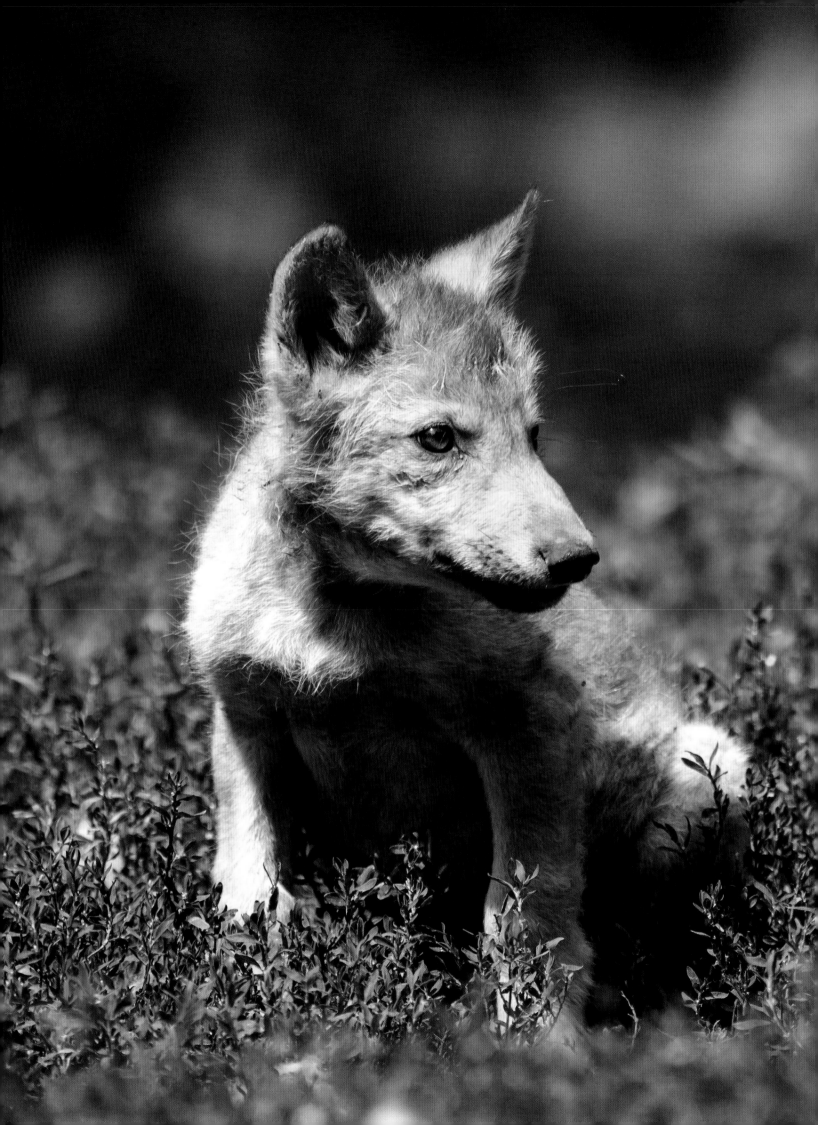

Play is an important component of pup life. When not sleeping or eating, the pups' main interactions with other pups and with older wolves are through play.

The pups continue to get more physically adept, and at about three weeks of age they really begin to experience the outside world by exploring, playing, and lying around in the open near the den entrance. Most importantly, they begin to interact with other pack members. They are still very attached to the actual den and spend significant time there, but they are also able to solicit play and care from older wolves. At this age, pups don't particularly care with whom they interact, as long as it's family. And at any sign of intruders, they dash back into the den for protection. For family members other than the mother, their interactions with pups are key.

During the summer when pups are growing and restricted to home sites, other pack members care for pups by providing defense against predators and by bringing food back not only for the mother wolf, but for the pups, too. Pups are now able to ingest very small pieces of solid food, and a primary interaction of pups with other adults is soliciting food, so it is no wonder that they are extremely excited when an older wolf returns to the den from a hunt. The pups rush over and excitedly poke their muzzles around the adult's mouth. Assuming the wolf's stomach is full, the wolf will regurgitate the food. Pups grab whatever they can as fast as they can, then often scamper off to consume their prize. A large piece of food may end up in a tug-of-war between pups.

When other wolves help the growing pups, they ensure the survival of their family. Helping the pups also strengthens social bonds within the family, ensuring their own survival when they may need help from others, and teaches them how to be parents when the time comes.

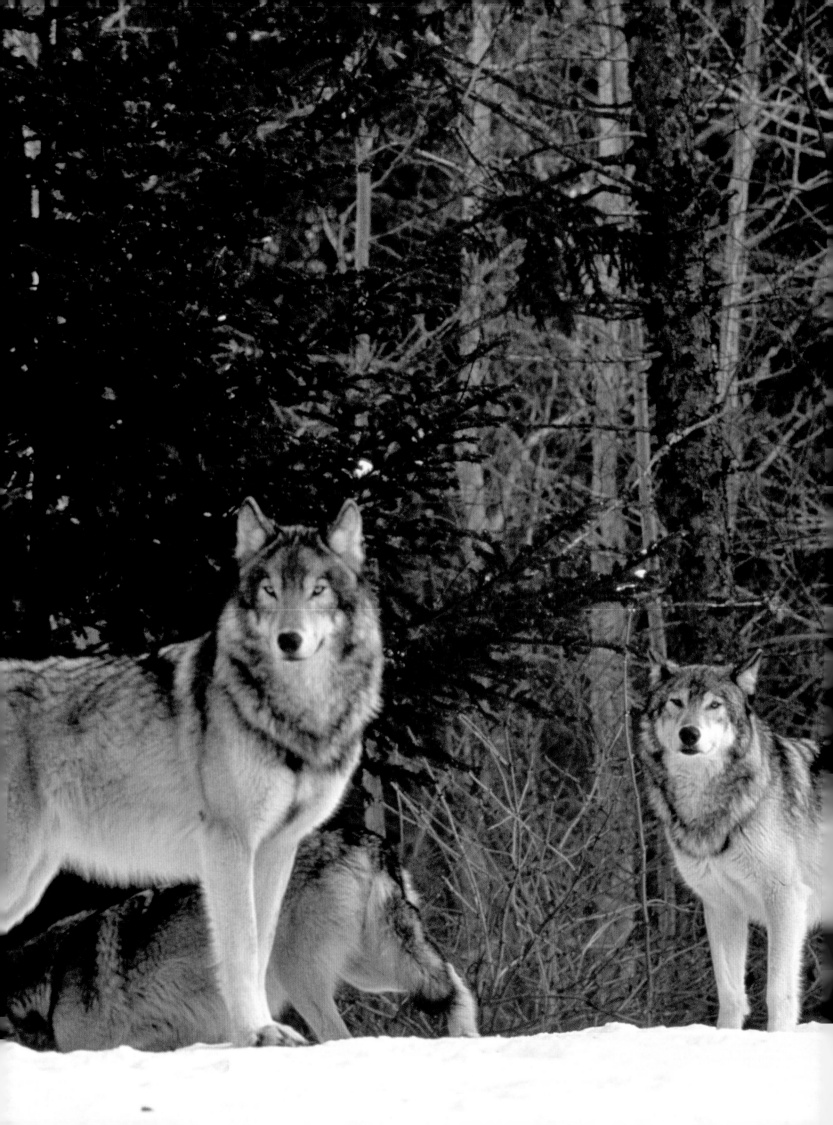

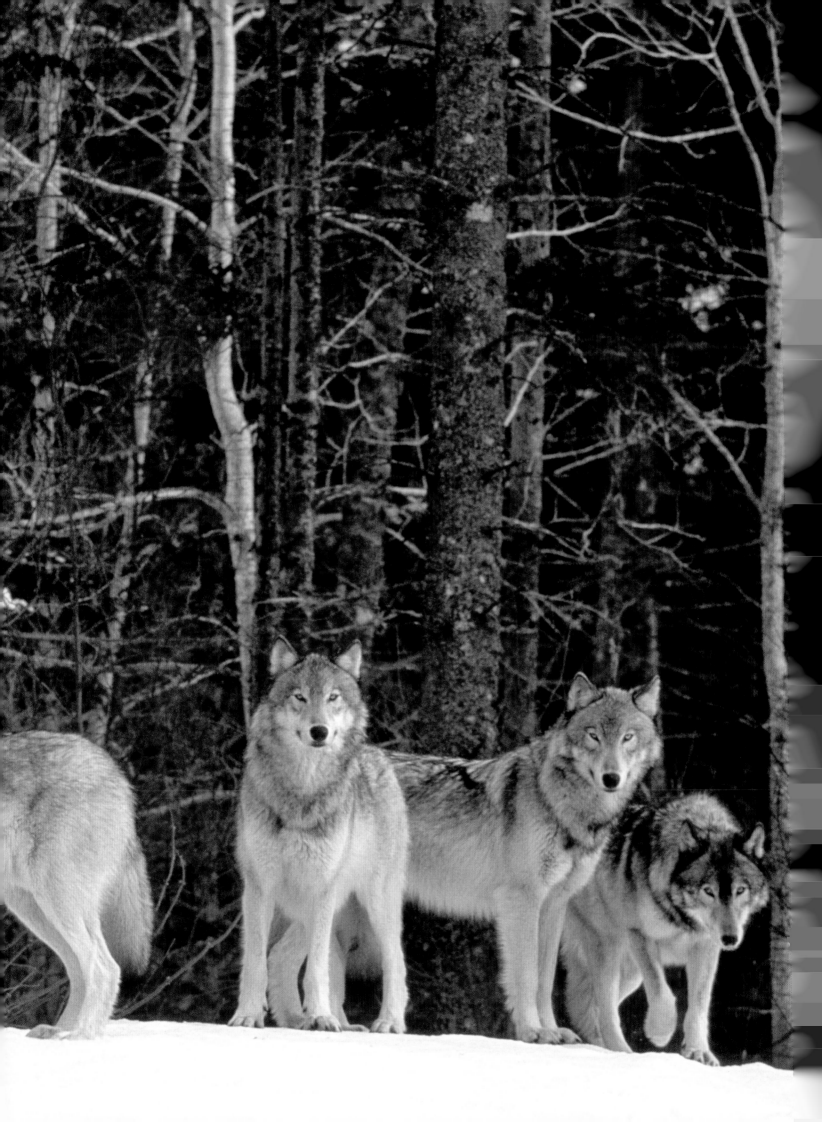

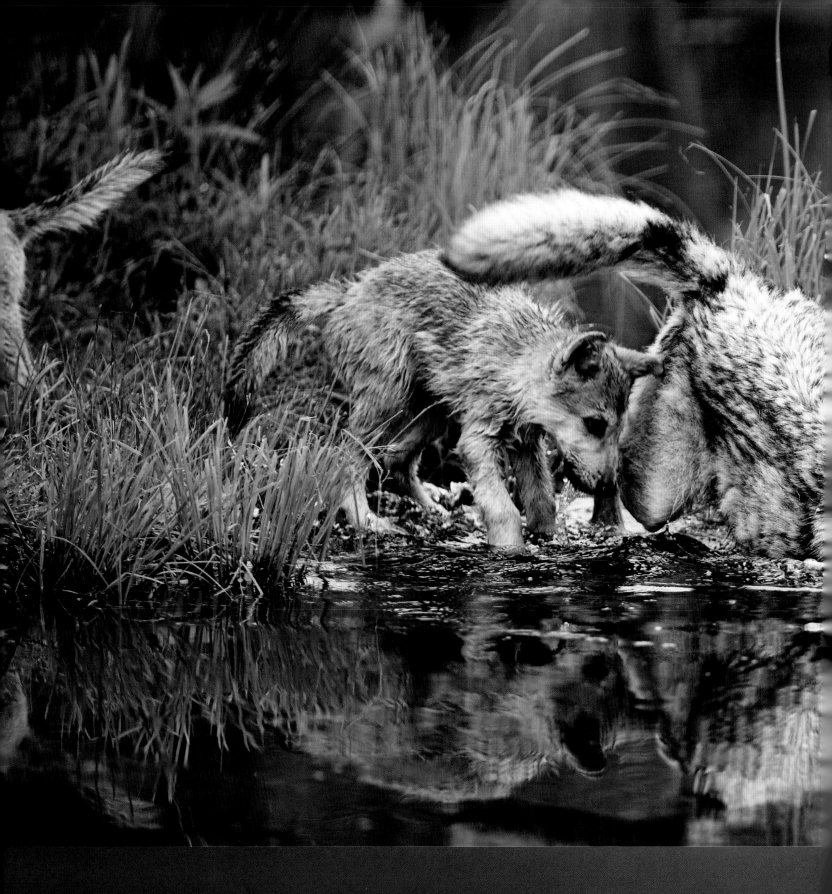

Most play does not result in the kind of dominance interactions that are seen when pups are contesting for food; rather, play enhances social bonds. Play in wolf pups is much of what we see in dogs. They stalk each other, pounce, and chase, skills they will need to master for future hunts. They also bow their front legs, wag their tails, grin, and toss their heads as communication signals. Pups may play tag or keep-away, or may wrestle-tumble for hours on end, and all of it leads to social bonding with pack mates.

Hunting is an important survival skill for growing pups to learn. This includes finding prey and knowing how to kill it safely. Wolf pups are born with the propensity to chase and capture small moving animals, like mice.

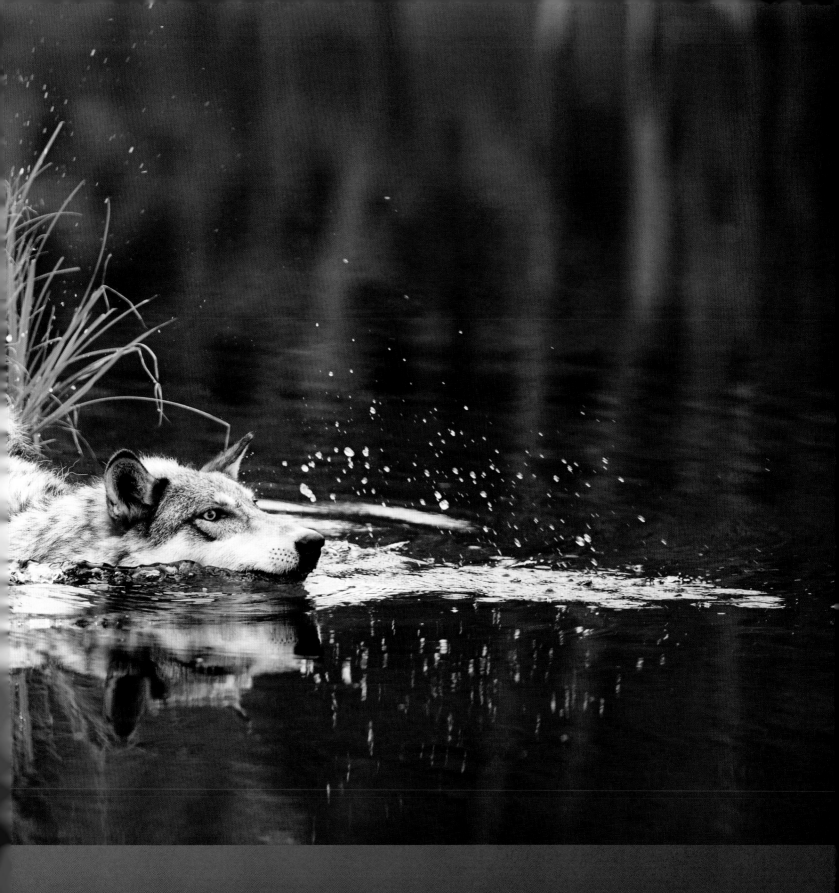

They are ready to learn the finer points of making a living as a wolf, such as how to recognize prey scents, track prey, and join in on chases. They learn with experience how dangerous prey can be, and with each attempt become more knowledgeable about the timing and cooperation needed to kill something as large as a deer or an elk.

By four months, pups can travel longer distances and accompany older wolves on hunts.

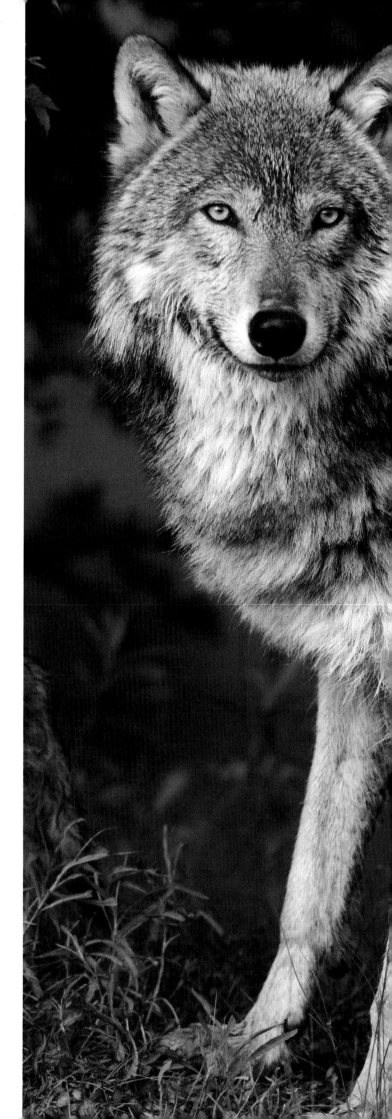

Submission in adult wolves reflects the behaviors they used as pups.

By the time wolf pups are eight months old, they are nearly the size of adults, and at age ten months may be capable of breeding (though they rarely ever do so). For the most part, however, these young wolves have entered into the world of adulthood. Though at times the family may treat them with some forgiveness, most of the time they are required to act their size, if not their age.

ADULT FAMILY MEMBERS

The social relationship among adult wolves is a mix of behaviors reflecting both conflict and cohesion. Given that they must first ensure their own survival, conflicts within a family (or pack) are inevitable. To stay alive, a wolf must secure food resources in the short term and mating opportunities in the long term. When such valuable but often limited resources are up for grabs, physical or emotional battles among wolves are sure to arise. At the same time, most wolves are members of a social group that requires the ability to cooperate, or at least get along well. After all, constant inter-pack conflict would waste precious resources of time and energy that can be better spent hunting for the good of the group.

For example, dominance behavior developed in play-fighting among pups carries over into adult interactions that reduce pack conflict. This group cohesiveness is a hallmark of the wolf species.

The social organization of a wolf family is the result of natural family relationships and age, much like they are in human families. The parents are the biggest for a long while, and they maintain the social hierarchy. Older brothers and sisters also have more experience than younger ones (but not as much as their parents) and it is natural that, up to a point, these older and bigger siblings generally win out over younger ones in social conflicts. The social pecking order within a family is also generally reflected within the larger wolf pack, as we will see in the next chapter.

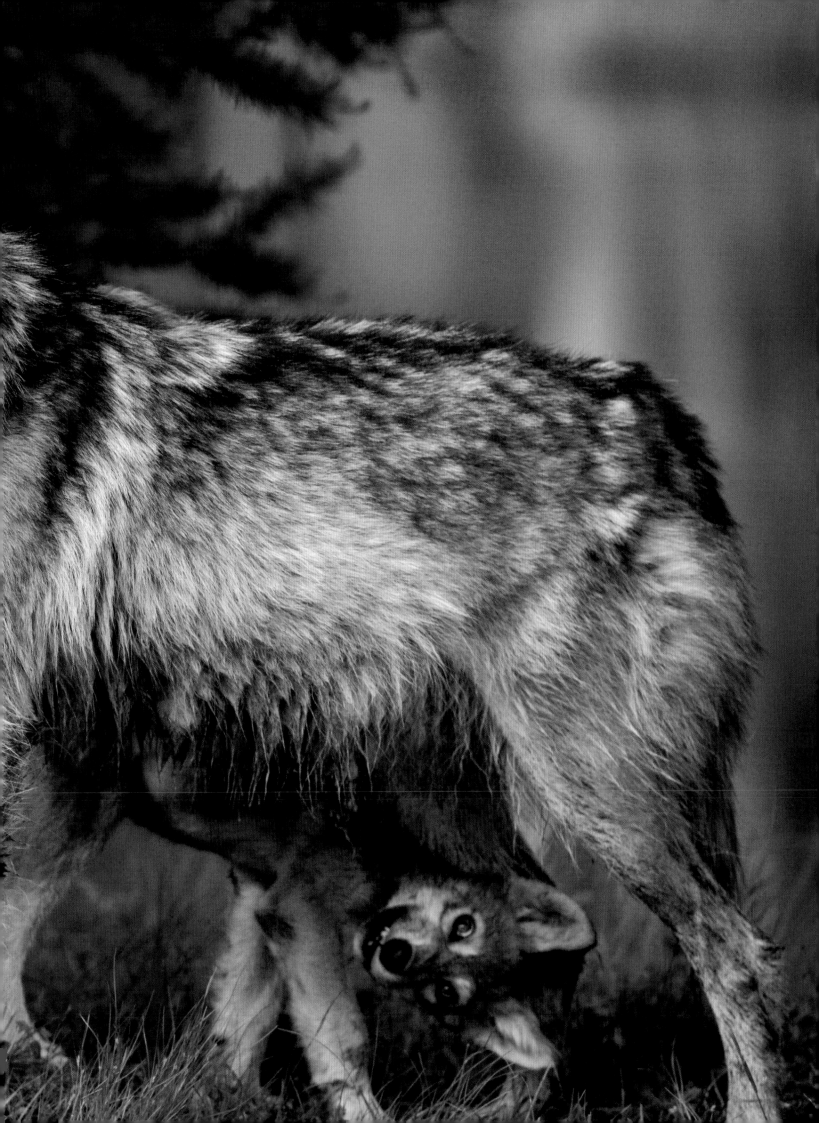

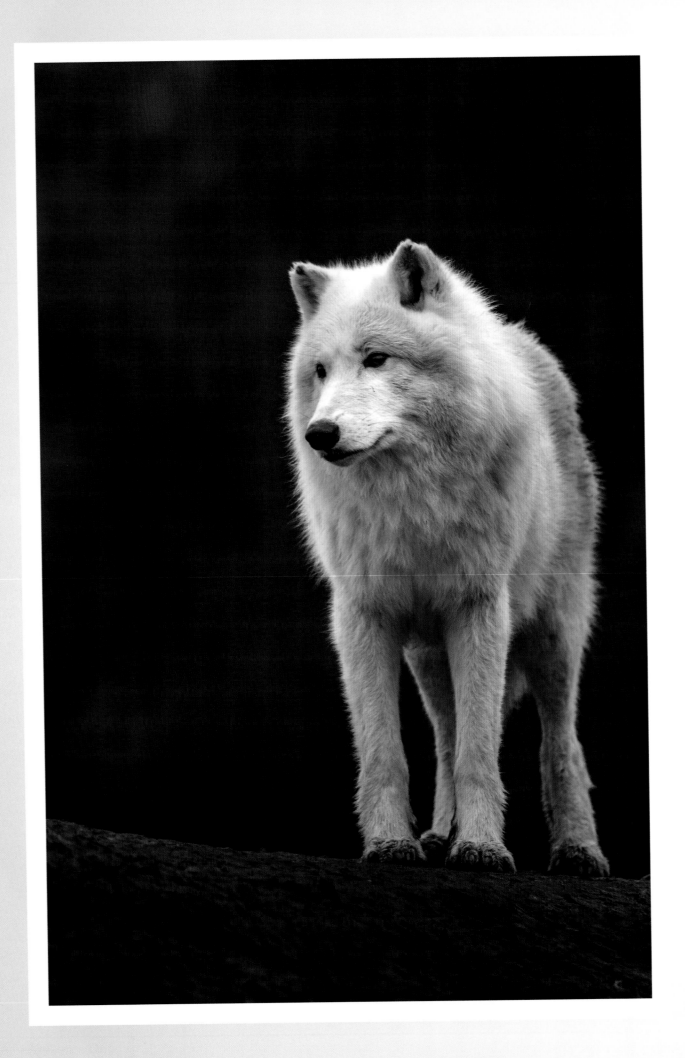

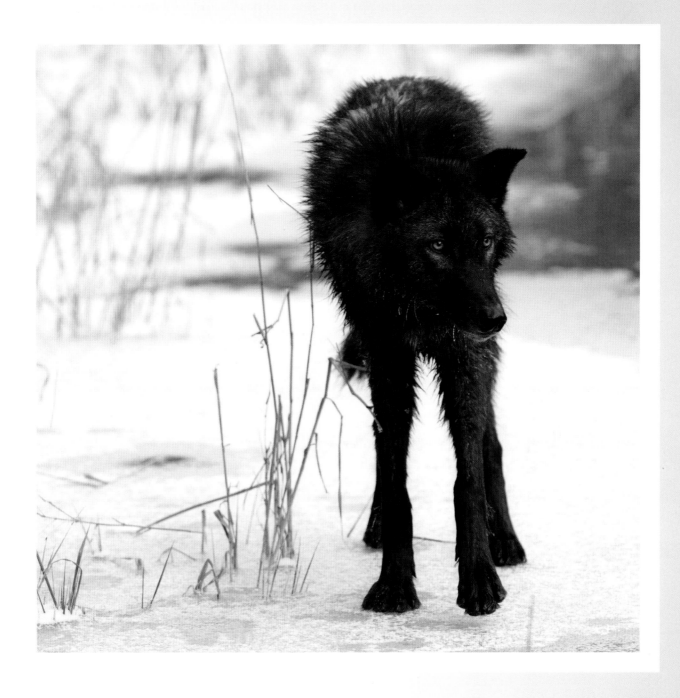

Causes of Death

Wolves die from a variety of natural factors, such as from diseases and parasites. As far as accidents go, adult wolves have gotten fatally kicked in the head or body by deer, moose, and musk ox, and have even been trampled by large prey. They have been known to fall off cliffs while chasing sheep and to die in avalanches in the high mountains. Adult wolves have few natural predators, though brown bears and even black bears probably kill some pups. Starvation mainly affects pups, especially when prey is relatively scarce. Adult wolves also may starve to death, though this is more likely the case for injured wolves that are on their own without pack mates to help them with hunting. A common cause of death, though, is being killed by other wolves. Such deaths occur when prey are hard to find and wolves trespass into other territories in search of food. And then there is hunting by humans—whether legal or illegal—as well as accidents, such as being hit by a car, when wolves venture into places where humans reside.

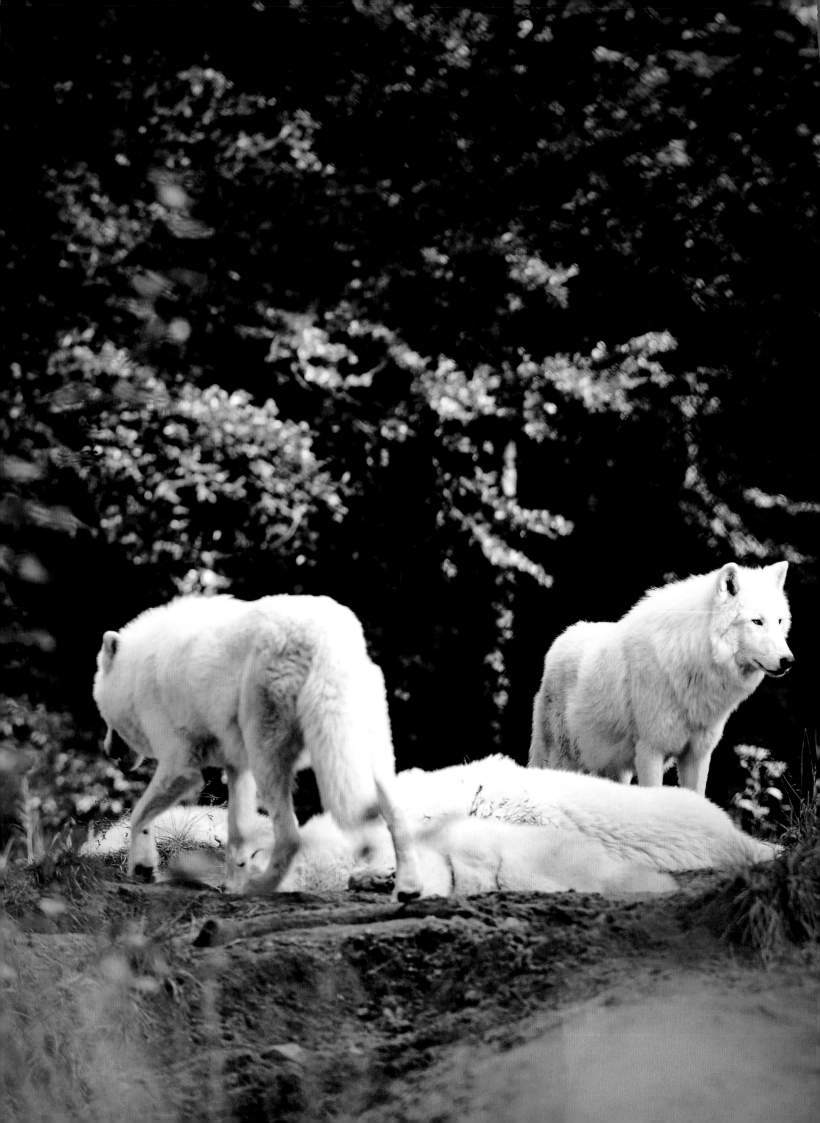

LIVING IN PACKS

All packs are comprised of family groups of wolves, with the average pack size usually between three and eight wolves.

However, variations include an extended family (parents and one or more of their siblings, plus the siblings' offspring), the disrupted family (one or both of the original parents have left the pack or are dead), and the stepfamily (a disrupted family that has accepted an outside wolf to become a breeder).

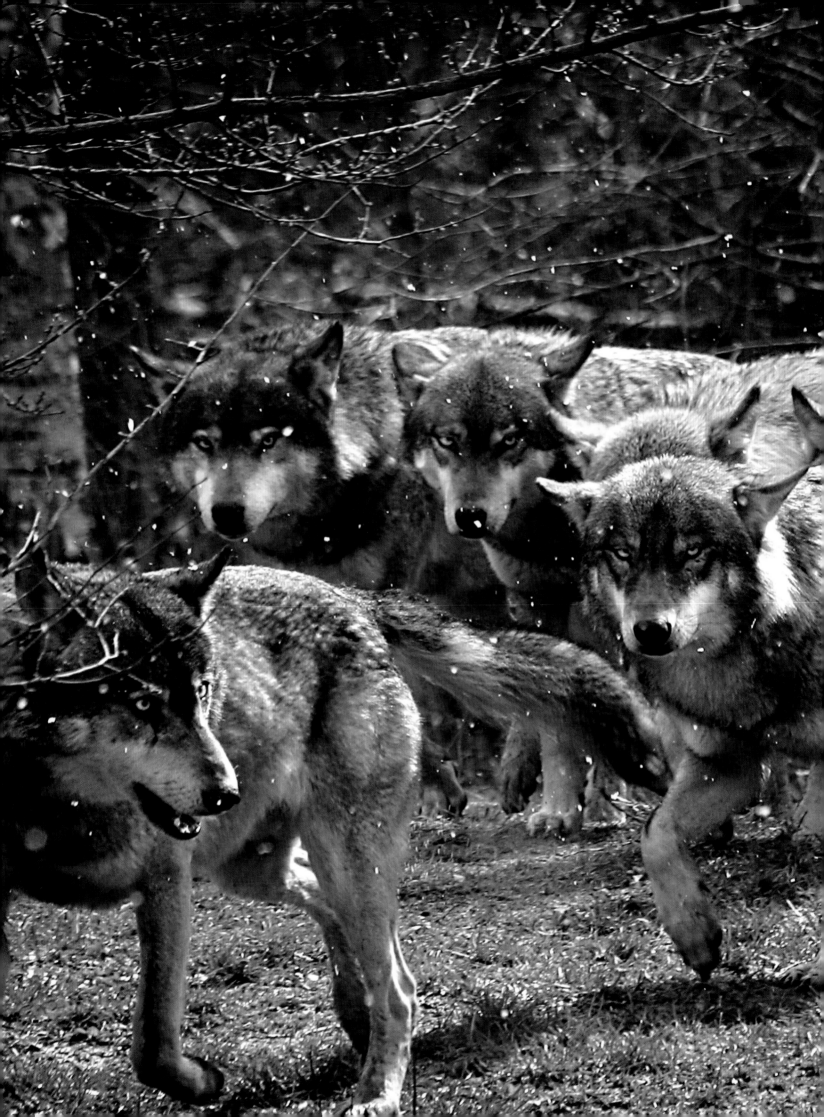

*The most common structure
is the so-called nuclear family,
consisting of parents and their
offspring.*

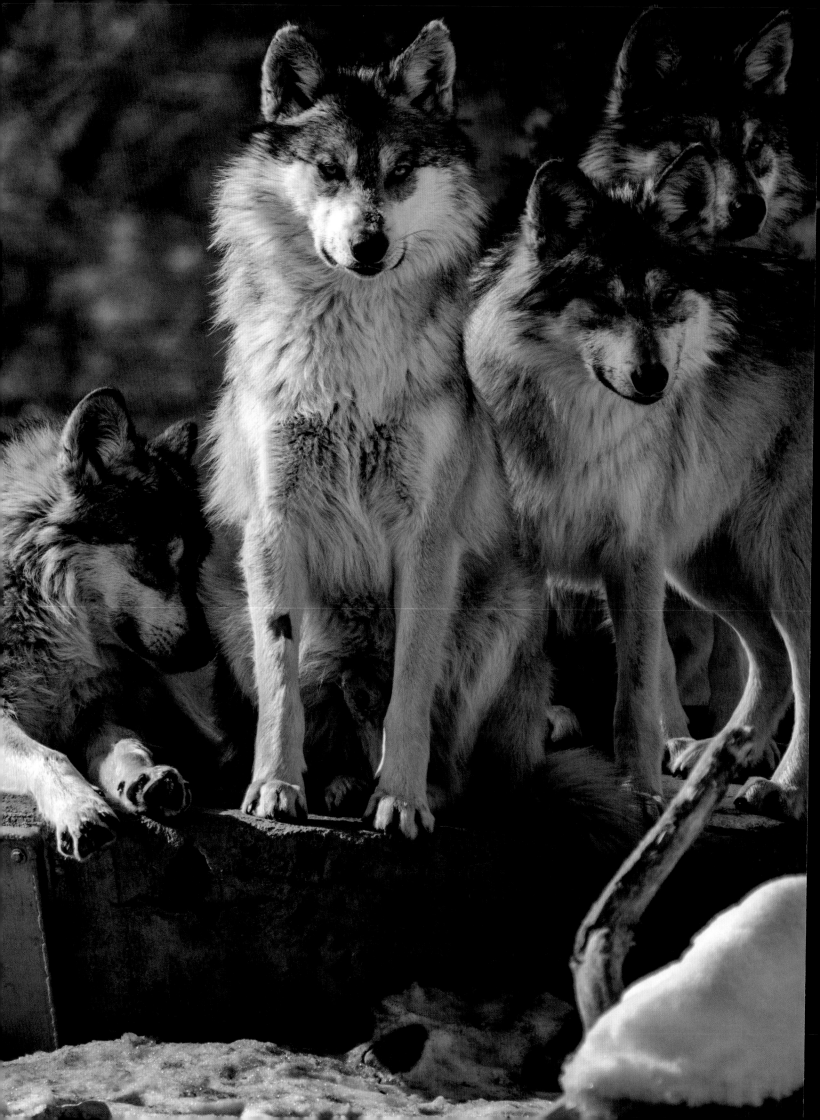

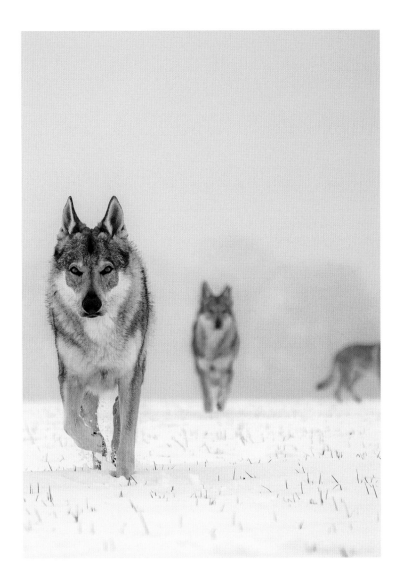

Social Organization

Traditionally, the social organization of wolves has been depicted as a pair of dominance hierarchies, or pecking orders, within each sex. In this scenario, the most dominant male wolf is called the "alpha" male, the second most dominant the "beta," and the one that is least likely to win any confrontation is the "omega"; the female hierarchy mirrors this same ranking. It was at one time thought that the alpha wolves were the biggest, strongest, breeding wolves that led the pack and ensured its survival, and that constant testing and even small battles determined this order. Also, it was most often presumed that this dominance was genetic and revealed itself fully in the course of interactions among pups, and then within the entire pack.

It turns out, however, that this is a simplified version of what really goes on in a pack. First, there is no good evidence that leaders of wolf packs are destined from birth to take on this role. There may be nutritional advantages that help a certain pup grow bigger faster, and this in turn may help secure a dominant role among siblings. Perhaps other, more dominant wolves leave the pack or even get killed, thus opening up an opportunity for another wolf to assume a dominant position. Or it may turn out that a wolf with the social skills to best maintain pack cohesion turns out to be the pack leader.

Second, dominance hierarchies do exist in packs, but they are mostly the result of natural family relationships, as we have seen. Therefore,

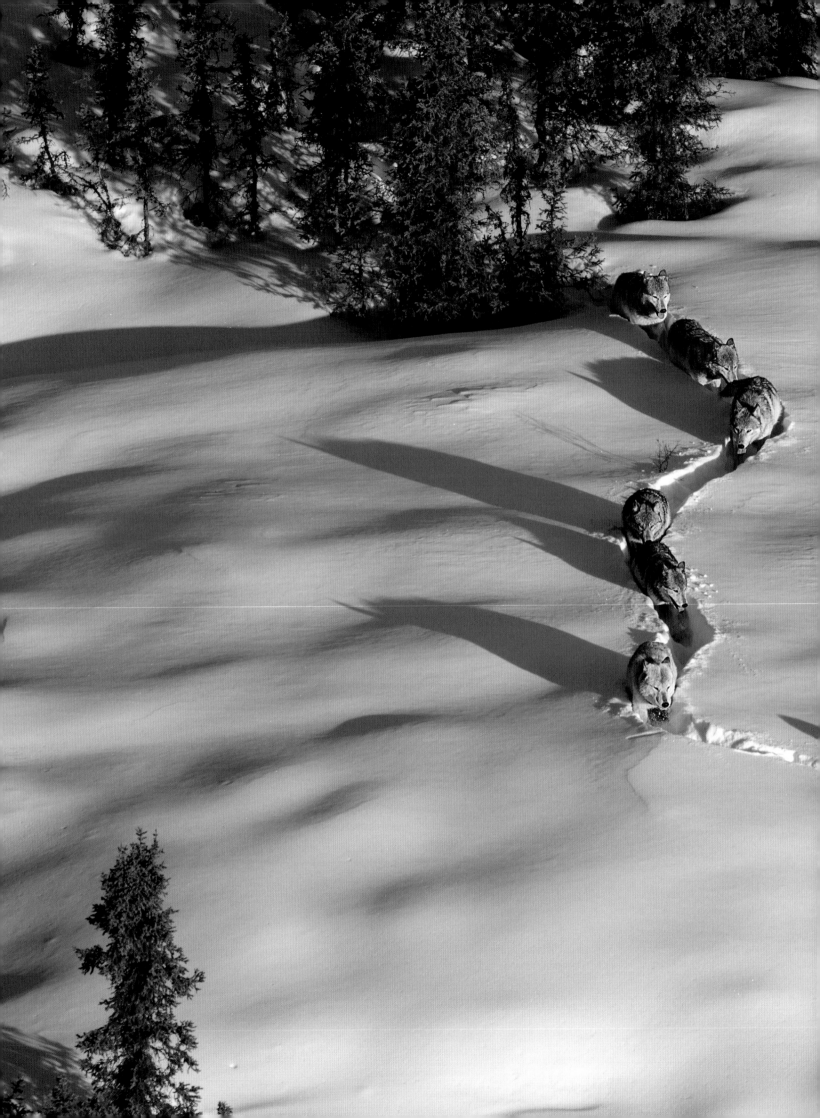

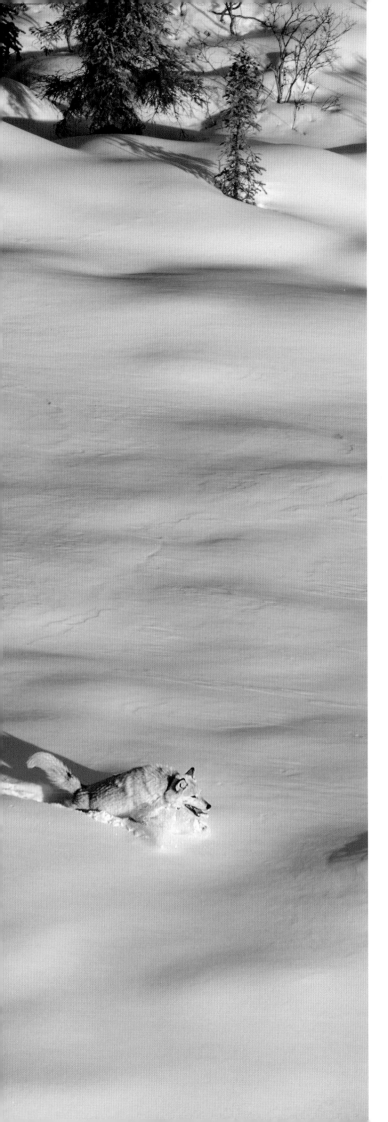

The relative dominance of wolves can change with circumstance over time and is not predestined.

the hierarchy is really a result mostly of age; it hasn't been determined only through tests of will and strength.

There are, of course, packs that have not resulted from successive production of litters of a pair of wolves. These stepfamilies include an "immigrant" breeder that must establish a social position without the benefit of a long-term relationship with pack members. In these circumstances, it might take more obvious and more numerous aggressive interactions to maintain their status.

It has been captive packs formed under these, or even more complicated, circumstances that, in the past, led scientists to emphasize dominance hierarchies as an important and constant social condition of packs. Watching pack members interact in the wild, however, paints a different picture. Conflict resulting in intense interactions is very rare compared to the "cohesive" exchanges that are regularly seen.

Wild wolves are amazingly nonaggressive in their interactions, and even though there may be wolves that are followed on hunts, are first to bite into prey, and do all of the breeding, social life in a wild wolf pack seems relatively benign.

Subtle forms of communication are exchanged via vocalizations, scent, body posture, and touch, as noted earlier, and these help wolves understand whether an interaction will be friendly or not. Older wolves are also quite tolerant of younger pups and their missteps. Wolves' high amount of cohesive behavior makes sense; it is unproductive to waste time on needless conflict. The only occassions when it does make sense is when food or mates are in short supply, and then displays of dominance are important for the pack's survival.

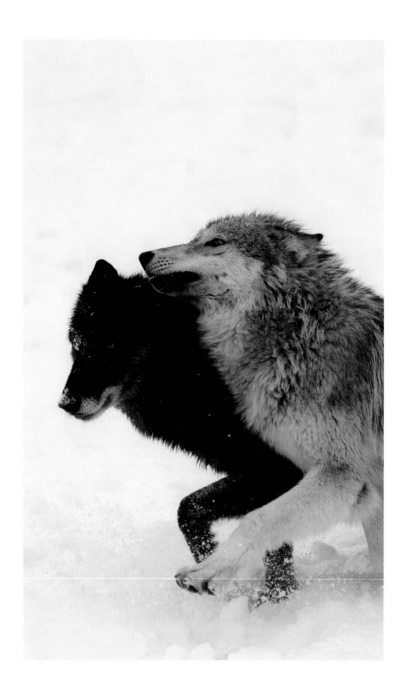

Behavior Within the Pack

What is it about living in a pack that makes it worthwhile for almost all wolves to do so, or at least want to do so? For one thing, the rate at which wolves mature varies greatly. Though most wolves seem capable of breeding at age two, some are not ready until age three, and still other wolves may not be fully mature until age five. Thus it is beneficial for "immature" wolves to stay with their parents until they are fully developed. This way, they can continue to be "subsidized" by their parents and learn the finer points of finding and capturing prey. From the parents' point of view, continued investment in immature offspring better ensures that their breeding efforts will pay off in the future (that is, their pups will have pups and continue the family line).

As might be expected, food seems to be an important factor in determining pack size. Wolves living in packs are more capable than individuals at capturing large prey, the kind that wolves typically rely on. There is also more protection for individual wolves working together in a pack.

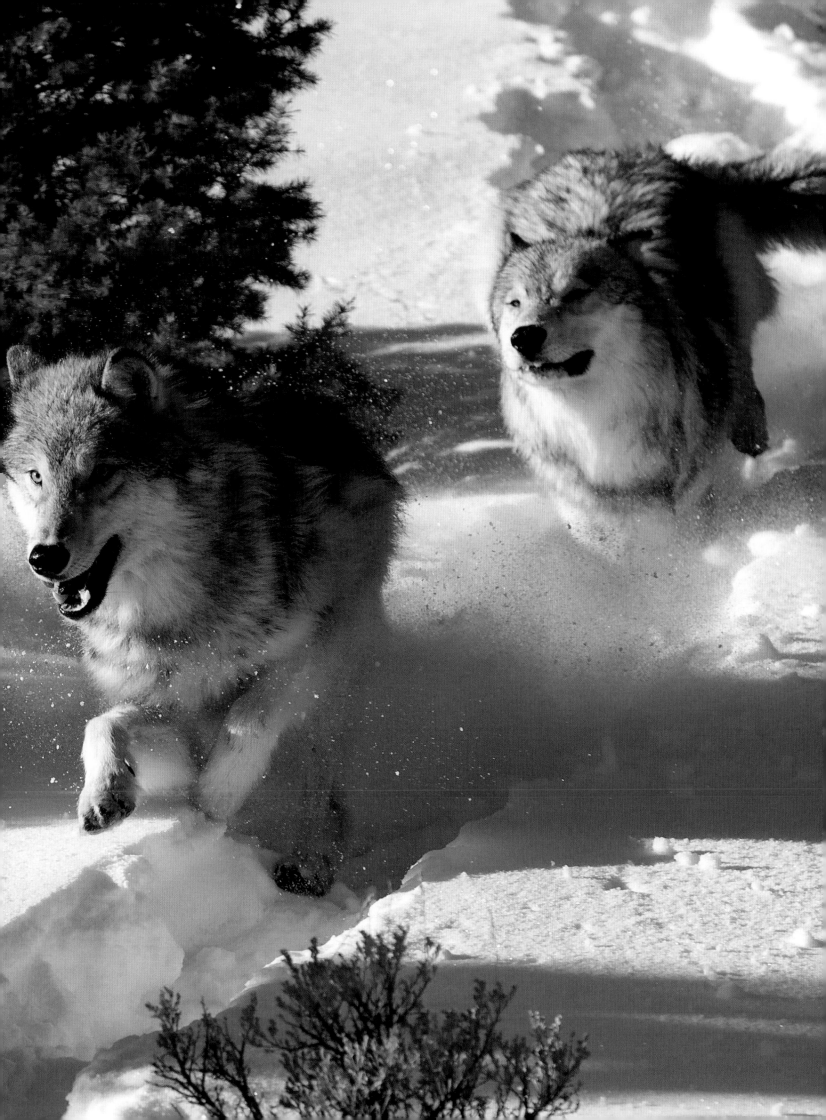

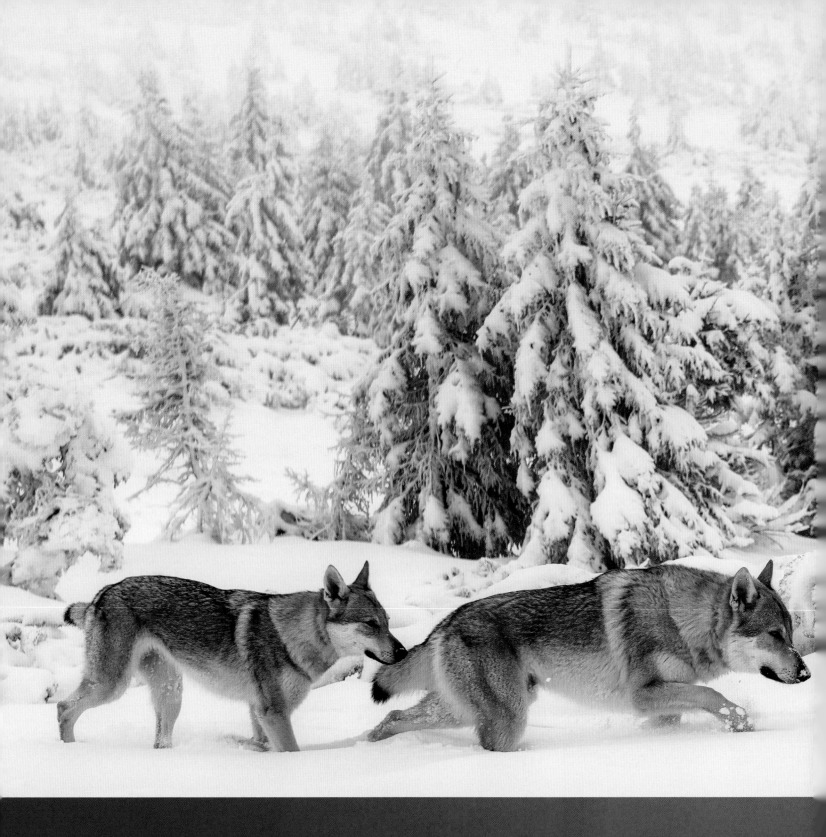

Pack sizes vary throughout the day and the time of year. Packs sometimes split up for several days and hunt as separate units; this is particularly true for large packs. In the summer, wolf packs are even less cohesive because finding and catching prey is much easier. Individual wolves often hunt on their own or with only one or two other pack mates. Still, they regularly return to the den to bring back food to the nursing female and her growing pups, so contact with pack members is fairly frequent.

How long a pack stays together varies as well. Packs with a long family line live in areas with a regularly available, predictable prey base, and where the death rate is low in any given year. The fewer disruptions there are to the pack's social structure, the longer it endures. Conversely, pack cohesion is short-lived where food is often unpredictable or in short supply.

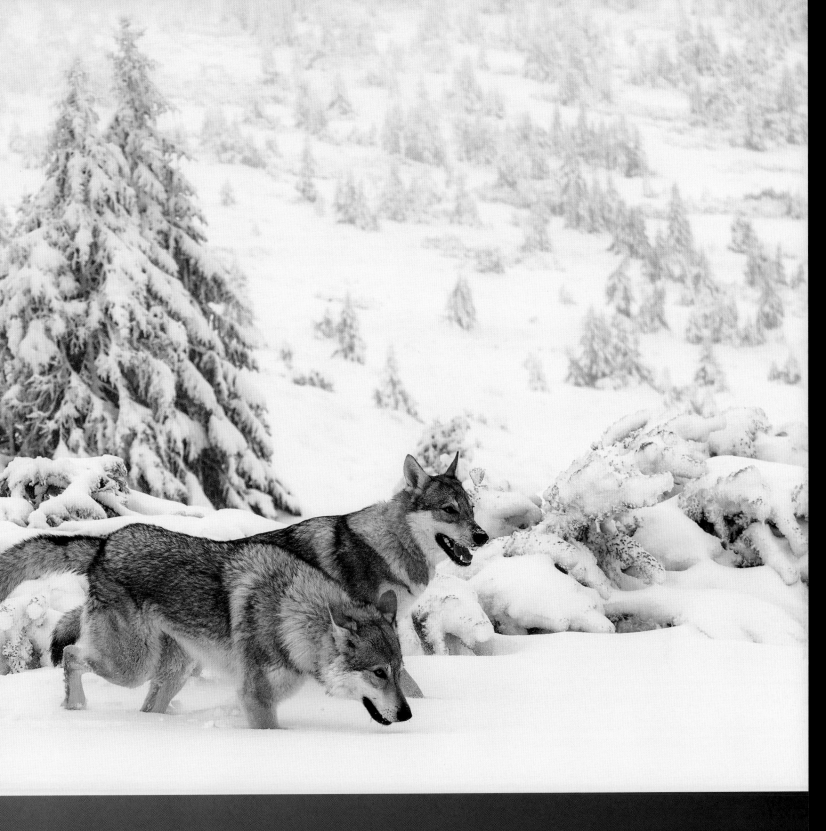

Although there are occasional interactions with competing predator species, such as brown bears, most competition comes from neighboring wolf packs.

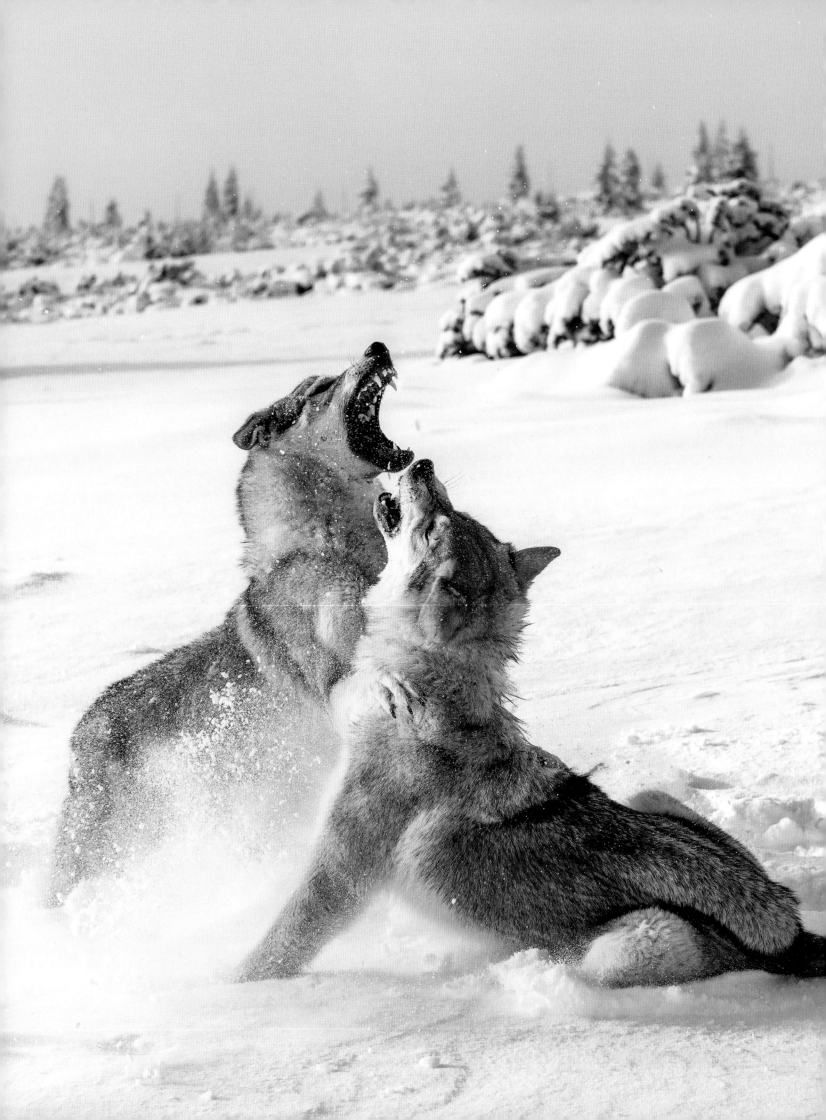

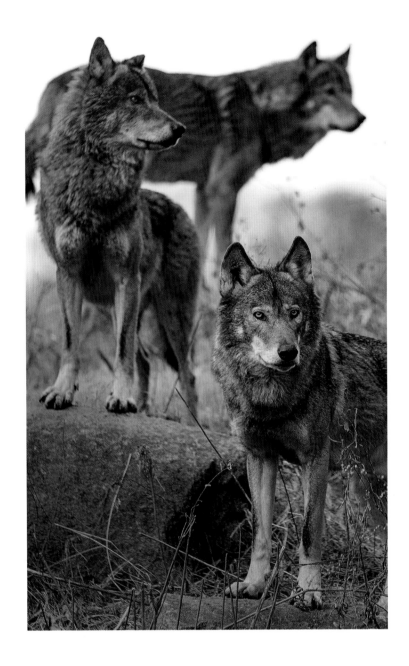

Interactions Between Packs

Wolves dependent on non-migratory prey are almost always territorial—that is, they take ownership of a particular area of land. Packs defend their home range through a variety of postural, scent, and vocal signals, and through direct physical conflict—although this is more rare.

They have their own resources that they depend on, and they don't want other wolves to have access to them. Wolves normally respect each other's boundaries, and a long-running truce of sorts typifies the wolf community. Therefore,

the boundaries of wolf territories don't often have much wolf activity in them. They are the "cushion" that allows packs to live next door to one another without constant battling.

This territorial coexistence breaks down, however, when food resources are low. Wolves need to eat to survive, and in the event that prey is so scarce that hunting becomes less and less successful, wolves will "trespass" into a neighboring pack's territory. Sometimes they are able to sneak in and "raid the larder" without alerting other

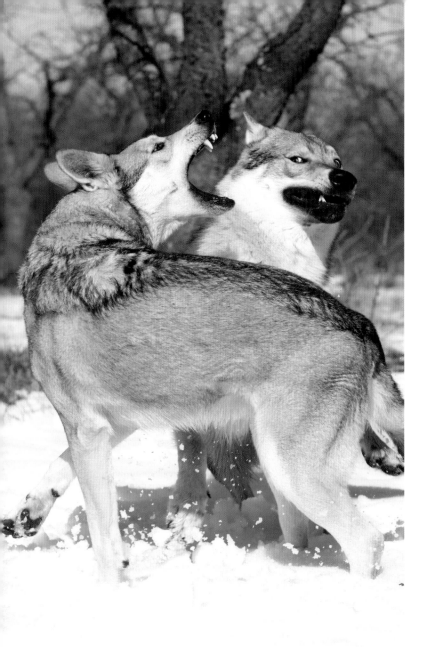

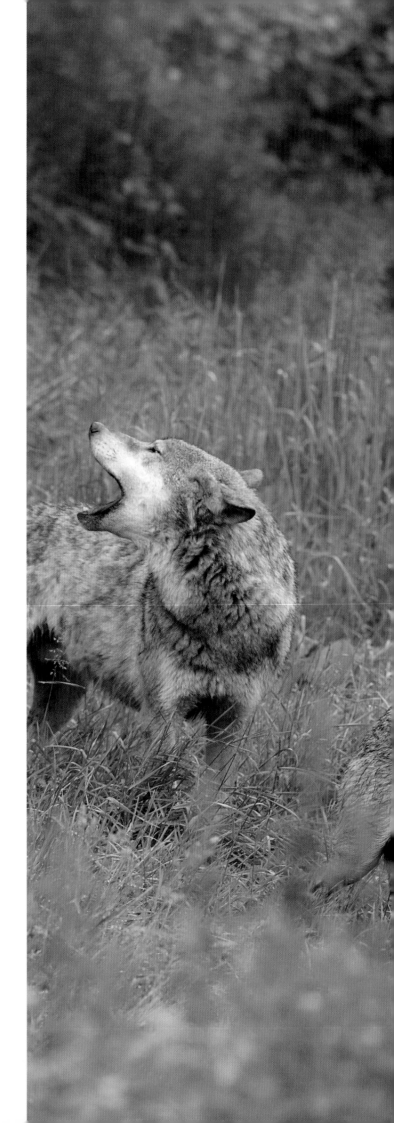

wolves. Other times, though, packs that trespass get caught, and aggressive battles then take place, sometimes to the death.

Because not all wolves are territorial year-round, some interactions between packs are certainly less aggressive. Wolf packs that follow migratory prey often find themselves in areas where just the previous day another pack may have been. When prey animals are concentrated in one region, several packs may even live in a relatively small area at the same time. Under these circumstances, packs appear to be more tolerant of one another. They keep their distance from other packs and seemingly respect the sanctity of kill sites. Such close proximity that would trigger major fights under other circumstances are normal in these places, and packs adjust their behavior to ensure survival.

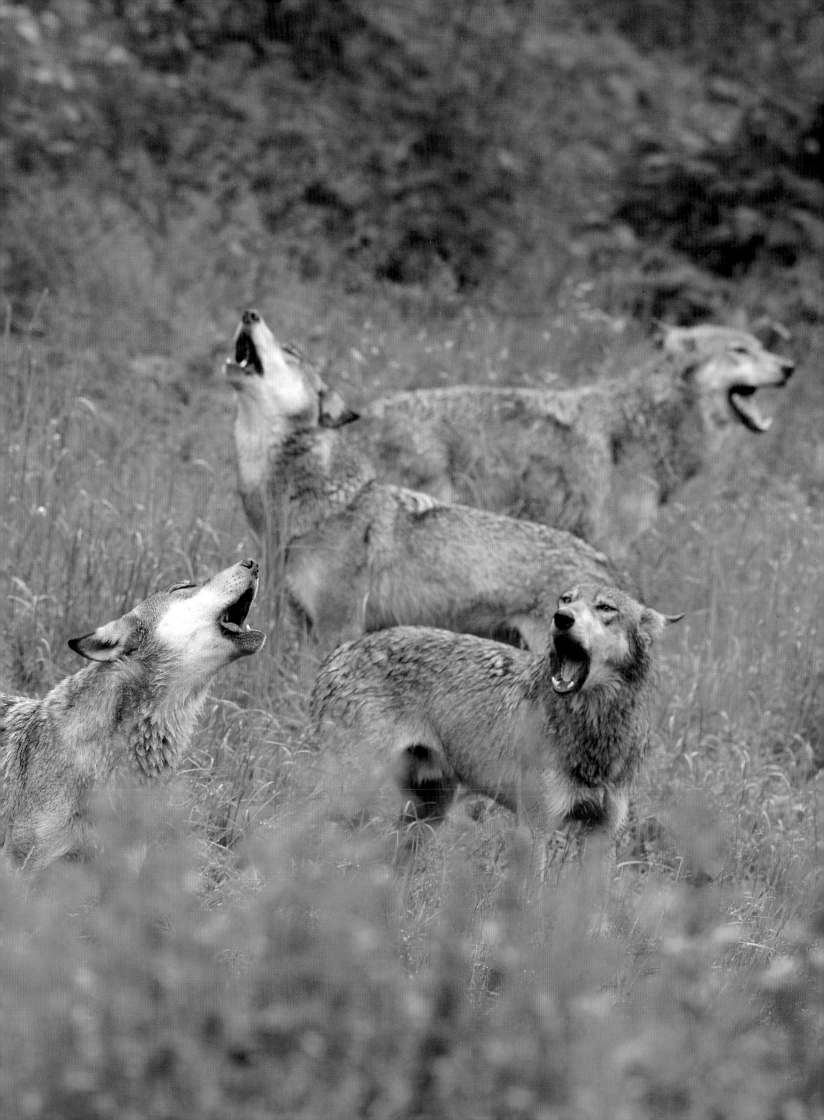

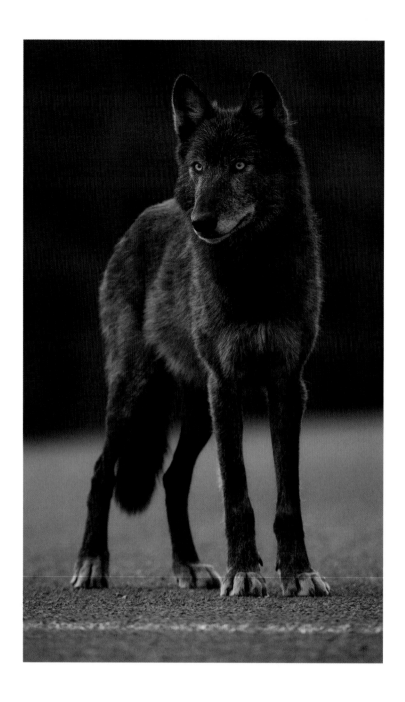

Leaving the Pack

Most wolves ultimately leave the pack they were born into when they become capable of reproducing (one to two years old) but no suitable mates are available. They leave their family and set out to find a mate in the same circumstances or to find a pack in need of a breeder (such as when the adult breeders have also left or died). Wolves most commonly leave by themselves, though they may leave with one or even two same-aged siblings.

Wolves may also leave their packs when the competition for food and other resources becomes too fierce. Wolves that recently gave birth may be more aggressive in their defense of their pups and their food resources. Females need to stay well fed in order to nurse their young, and males need to safeguard their offspring to ensure their survival. Conversely, when food supplies are relatively high, young wolves are more apt to stay in the pack longer.

Whether wolves stay in their packs or leave to join or establish new ones, they all traverse their home territories as well as the territories of other wolves, the discussion for the next chapter.

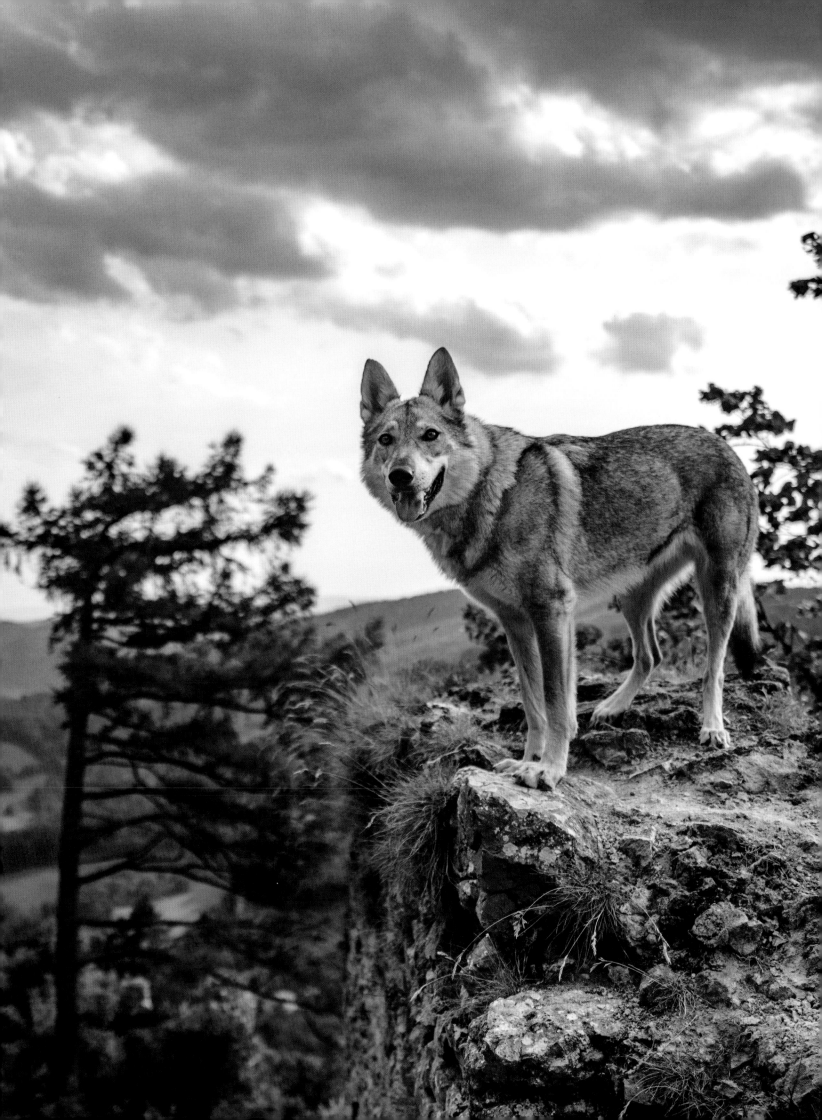

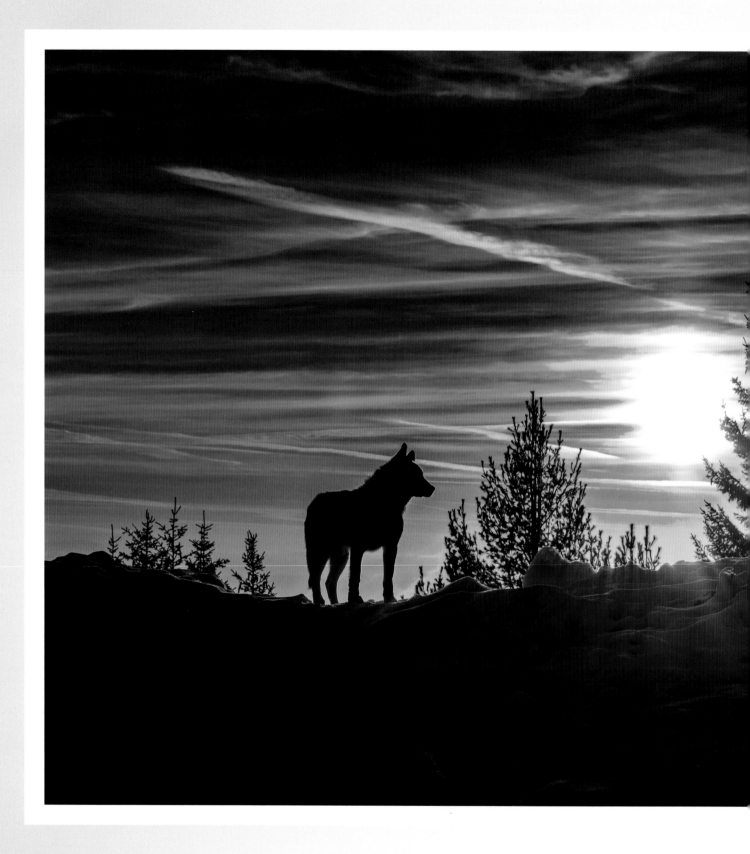

Lone Wolves

Leaving the pack is a dangerous time for a wolf. They may enter unknown regions or other wolves' territories, and may not know where and when to find suitable prey. A lone wolf is also more vulnerable to other predators and competitors for the same food sources. It's vital that they maintain good condition because if they become injured or diseased they have no pack mates to protect them.

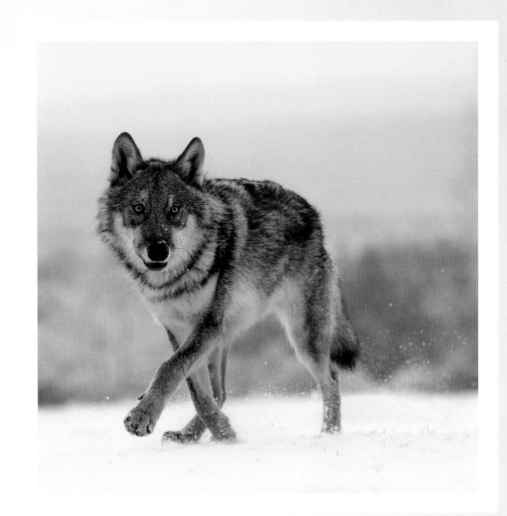
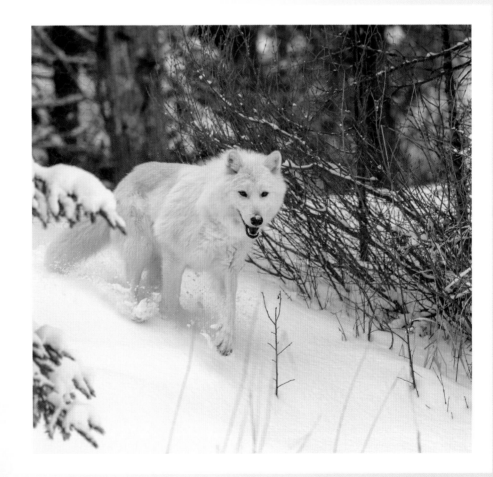

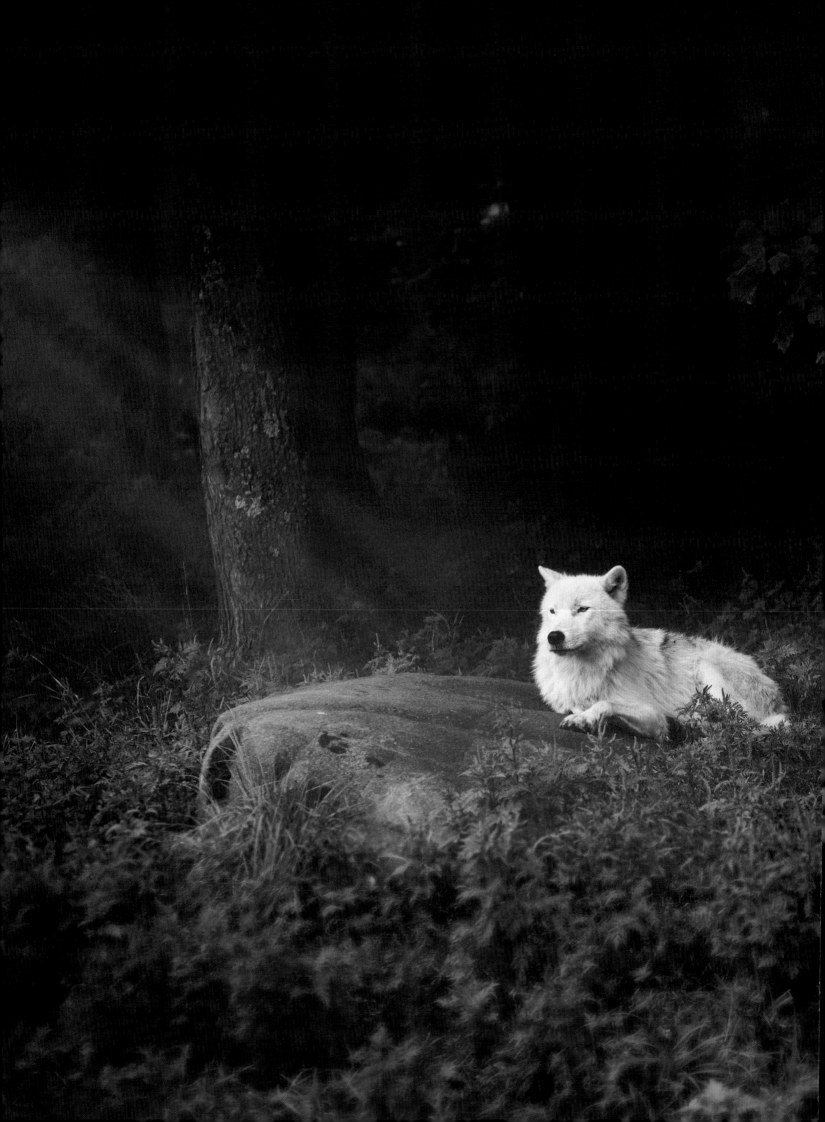

WOLF TERRITORIES

Wolves live in a wide variety of landscapes, and one might expect their uses of these different kinds of places to vary as widely. In fact, there are universal ways in which wolves have adapted to the land, no matter where they live. All wolves need to move around to find things to eat, to find mates, and to find sites where their pups can be born and raised; they also need to avoid getting in harm's way. So in order for wolves to feel safe within a large expanse of wilderness, they establish home ranges and territories for themselves and their packs.

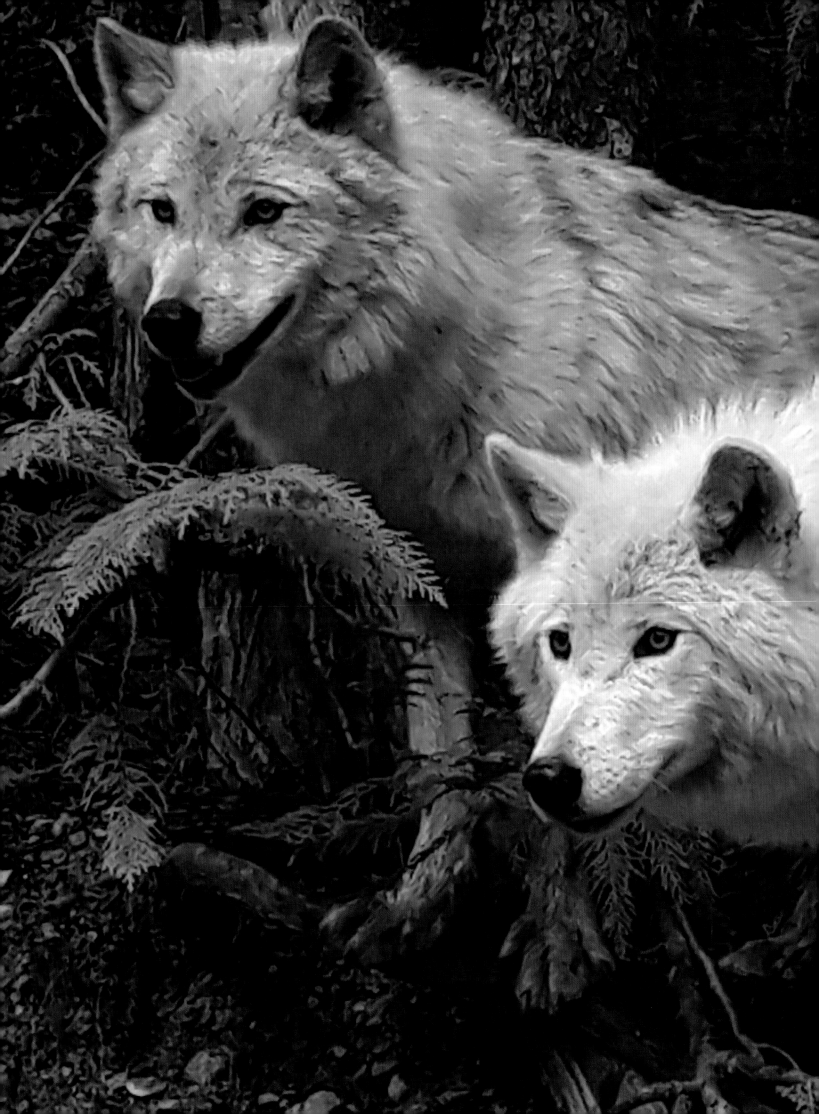

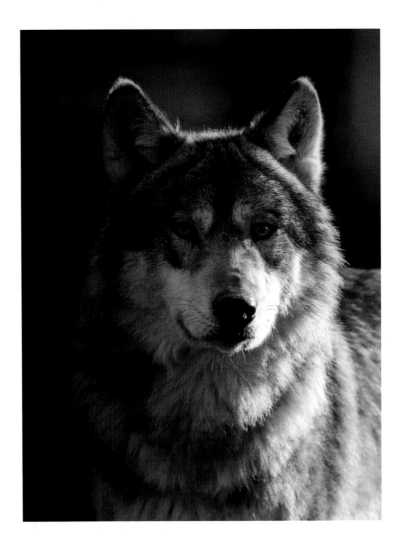

Home Ranges and Territories

A home range is the area over which an animal travels in the course of finding food, mates, rest, and safety from predators. Some individual animals are truly nomadic for at least part of their lives; that is, they travel in seemingly random directions and patterns. But most animals end up returning to the same places over and over again and have what are known as home ranges. Constantly familiarizing themselves with a particular area must also have important survival benefits, as they learn where water, food sources, shade, dens, and other important land features are located.

Some species actively defend their home range; a defended home range is called a territory.

After perhaps doing battle once or twice to defend their territory, they can expend much less energy and avoid much more risk by just leaving "signposts," such as scent marks, mostly near the perimeter of their territory, to keep other wolves out. This leaves wolves much-needed time for hunting, mating, and caring for pups.

Essentially, the boundaries of wolf territories are not places where packs seem to spend much time. If they did, they would increase the chances of physical contact with a neighboring pack, and wolves generally avoid such direct contact because the consequences can be so severe. As a result, the edges of wolf territories serve as buffer zones between packs. They are the "cushion" that allows packs to live next door to one another without constant battling. Further, both prey species and other carnivores find the edges of wolf territories better places to live because wolves are not around as much as in the middle of territories.

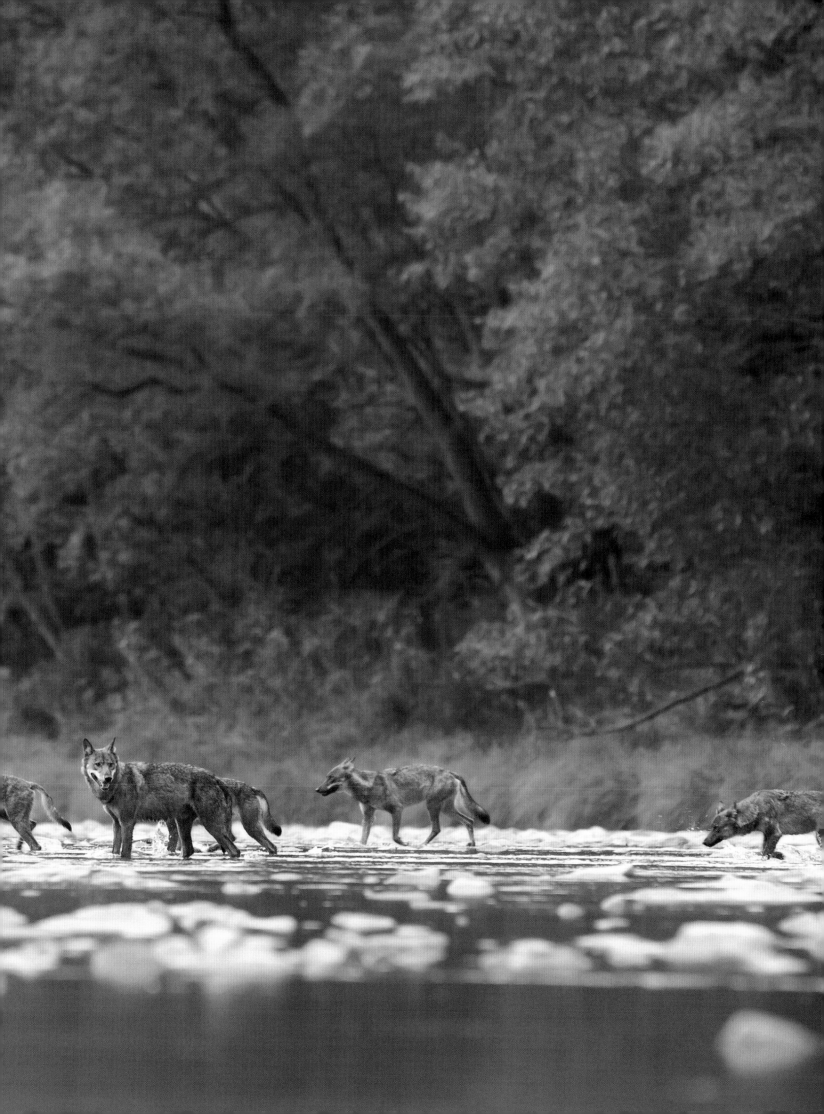

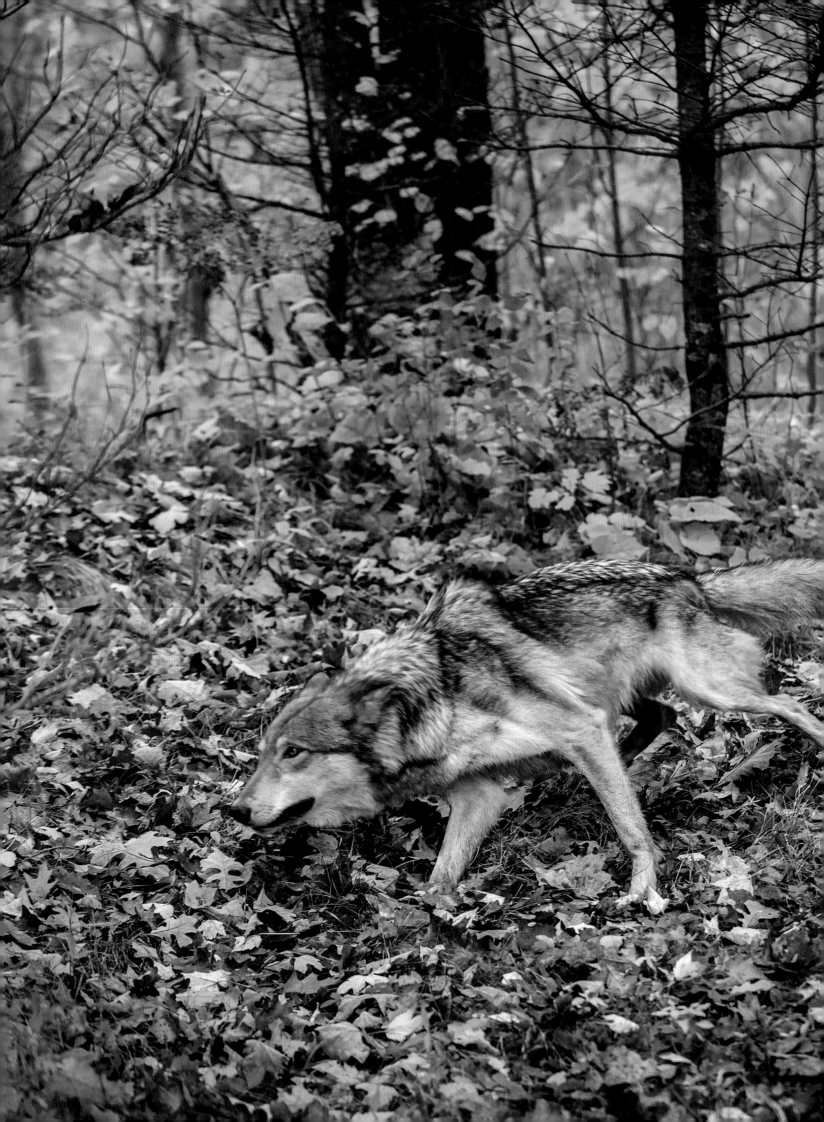

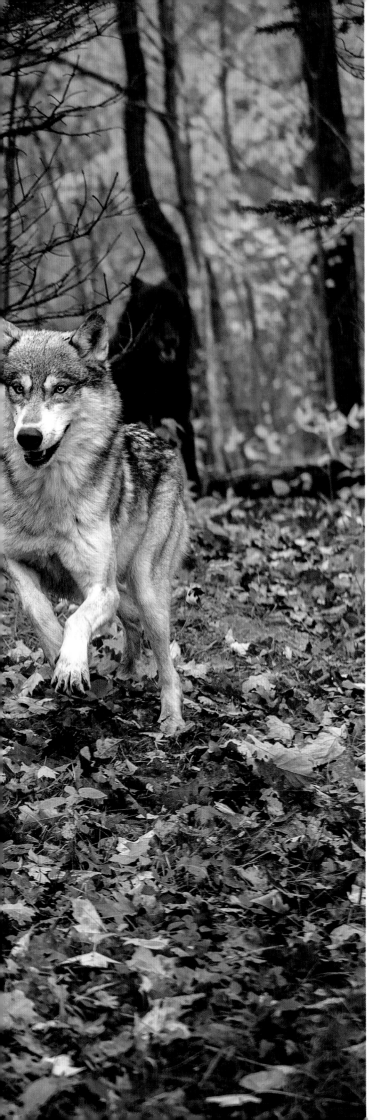

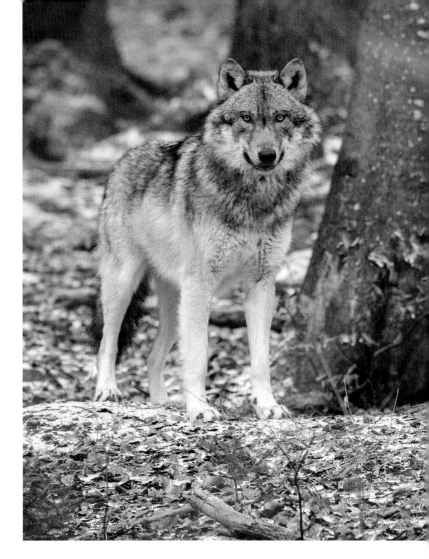

Wolves make special efforts to advertise their presence on a piece of land to other wolves, and they'll sometimes fight to the death to defend it.

This is because food is the major resource for wolves, and because wolf prey is usually hard to find and harder to catch. Most species of prey have specific habitat preferences themselves, and thus are found more often in certain types of places than in others. When wolves figure out where their prey live, they defend their territory accordingly.

For wolves that depend on prey that migrate with the seasons, the best survival strategy is for wolves to move with the prey when they can, and when they can't (during the denning season) they

*Under normal circumstances,
many wolf territories
are inherited.*

make many long trips to hunt. For a large part of the year, wolves may not defend any territory because neither the wolves nor their prey are in any one spot long enough to make it worthwhile. On the other hand, some prey move seasonally, such as when mountain sheep move up and down local mountains. Under these circumstances, wolves may remain territorial, but their territorial boundaries may shift to reflect the location of their prey.

Wolf territories are generally smaller at lower latitudes, and larger at higher latitudes. This pattern corresponds to the greater number of prey at lower latitudes and fewer prey at higher latitudes. So, in general, wolf territories are smaller where there is more prey. One might suspect that wolf territory size also varies with pack size; the larger the pack, this means the bigger the territory because more wolves need more food. However, when a pair of wolves first establishes a territory, they stake out an area much bigger than needed for just two wolves. In essence, they are anticipating the production of four to six pups, and an ultimate pack size much larger than in the beginning. Territory sizes seem to reflect not just the number of wolves in a pack at any given time, but some anticipated or average pack size. As a result, territory sizes do not differ that much among neighboring packs.

Because some pups and older animals stay with the pack throughout their lives, the territories they live in are essentially passed on to them when their parents die. Some generations of wolves have remained fairly sedentary and their territories don't really change much from year to year, or even decade to decade. Other territories are established by wolves that have left their packs to find mates and raise families of their own. Finally, some wolves acquire a territory by taking over part or all of the territory of another pack of wolves, perhaps where pack members have died, are ill, or are injured and thus less able to defend their territory.

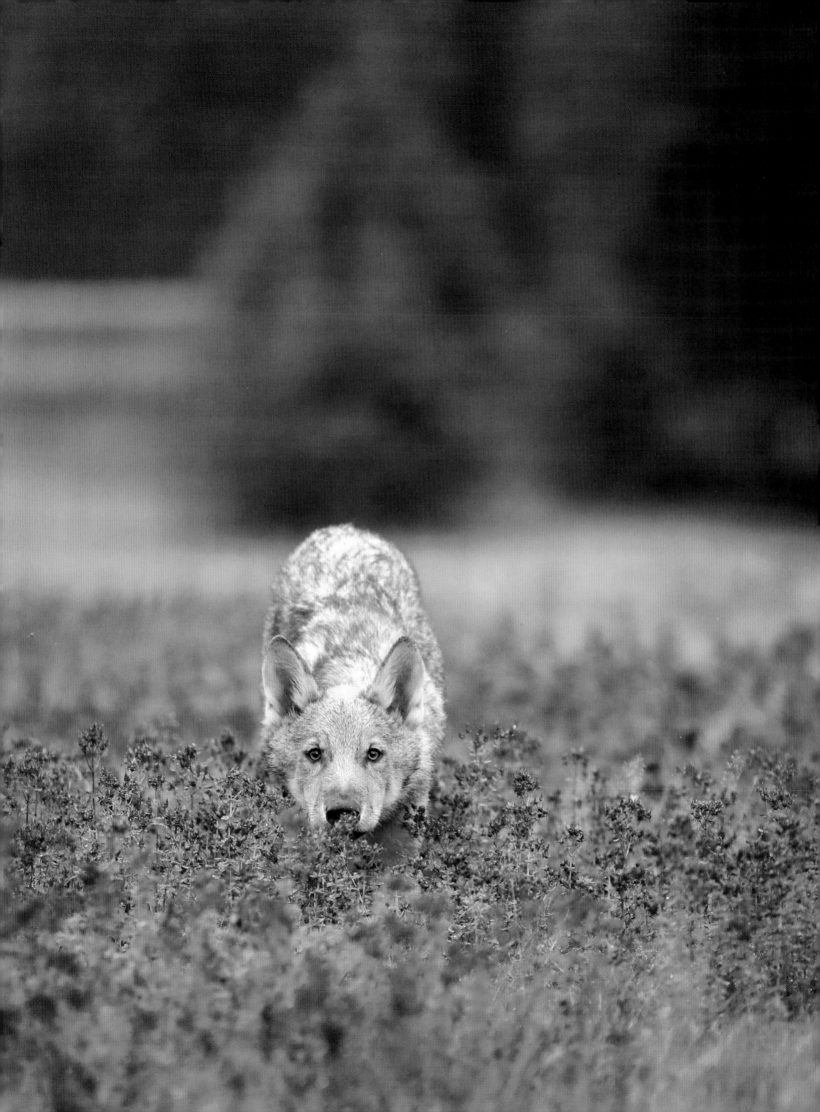

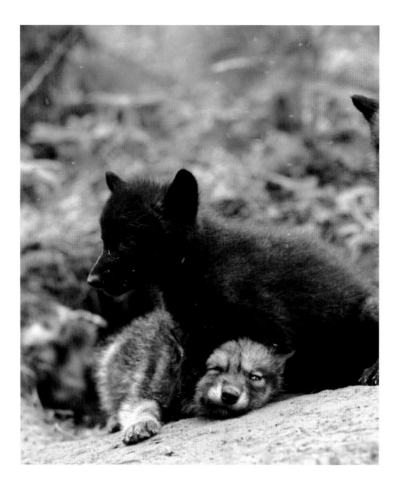

Dens and Home Sites

Dens are the places where wolf pups are born. They are usually located away from the edges of a pack's territory because this is where conflicts with other wolf packs are more common, and consequently more dangerous places to raise pups. One prerequisite seems to be relatively close proximity to open water so that females and their pups don't have to travel far to get water.

A den must provide protection for the pups, both from rain, snow, and flooding as well as from predators, so it is usually a covered tunnel and hole of some type. Wolves themselves often dig these dens, or they may enlarge burrows previously dug by foxes or other animals. It is important that the roof of the tunnel and den are structurally well supported to avoid collapse. Tunnels in the forest are dug under well-rooted trees, those on sandy bluffs in the Arctic are dug under a thick root-mat of vegetation, and in a variety of situations are dug into relatively steep hillsides. Where

the roof is not well supported and tunnels sometimes collapse, multiple entrances to dens are common. Rock caves are also common locations for dens.

Wolf pups live in and around dens for the first eight weeks of their lives. Sometimes female wolves may move their pups to a second or even third den during this time. By the time pups are eight weeks old, however, they spend most of their time above ground, and they are able to walk well enough to be moved more easily and safely than when they were younger. Thus during the next twelve weeks of their lives they are moved to different places within the pack's territory that are not considered dens, but are referred to as "rendezvous" or "loafing" sites. These are essentially wolf nursery areas where the pups stay put but the older animals in the pack all return to after foraging trips. Often these sites are near or at food sources that the pups can exploit.

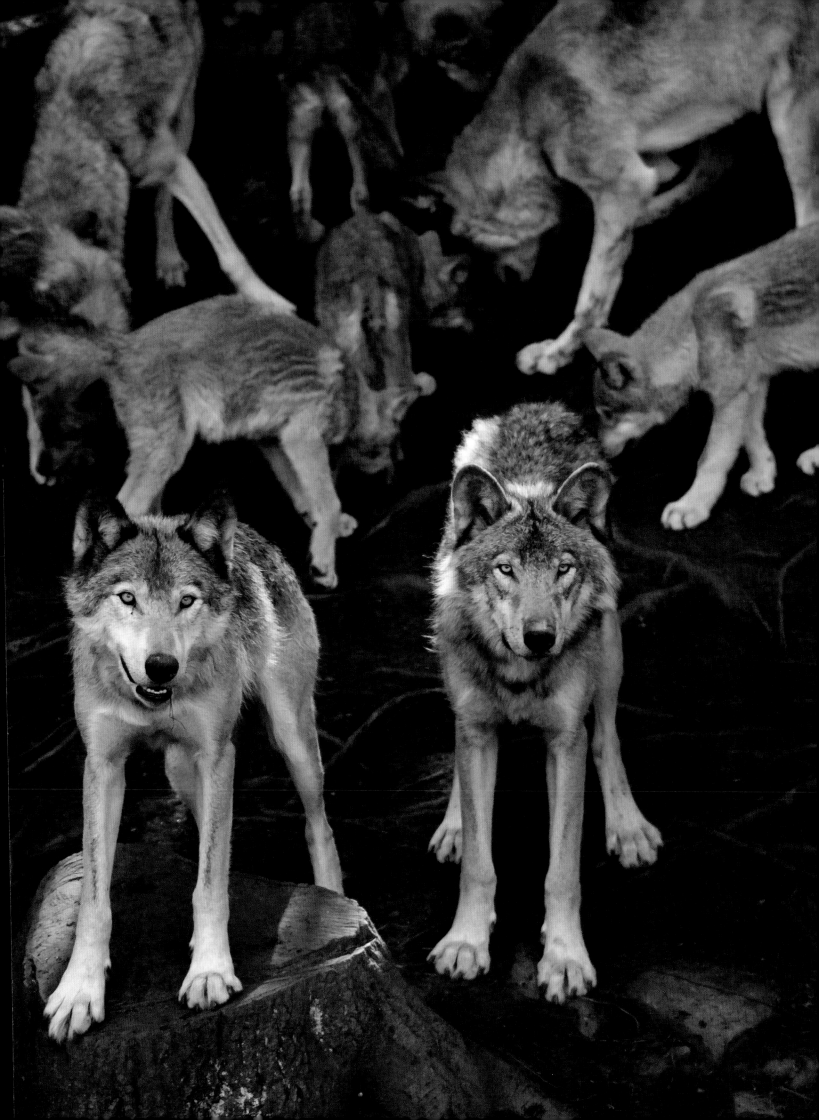

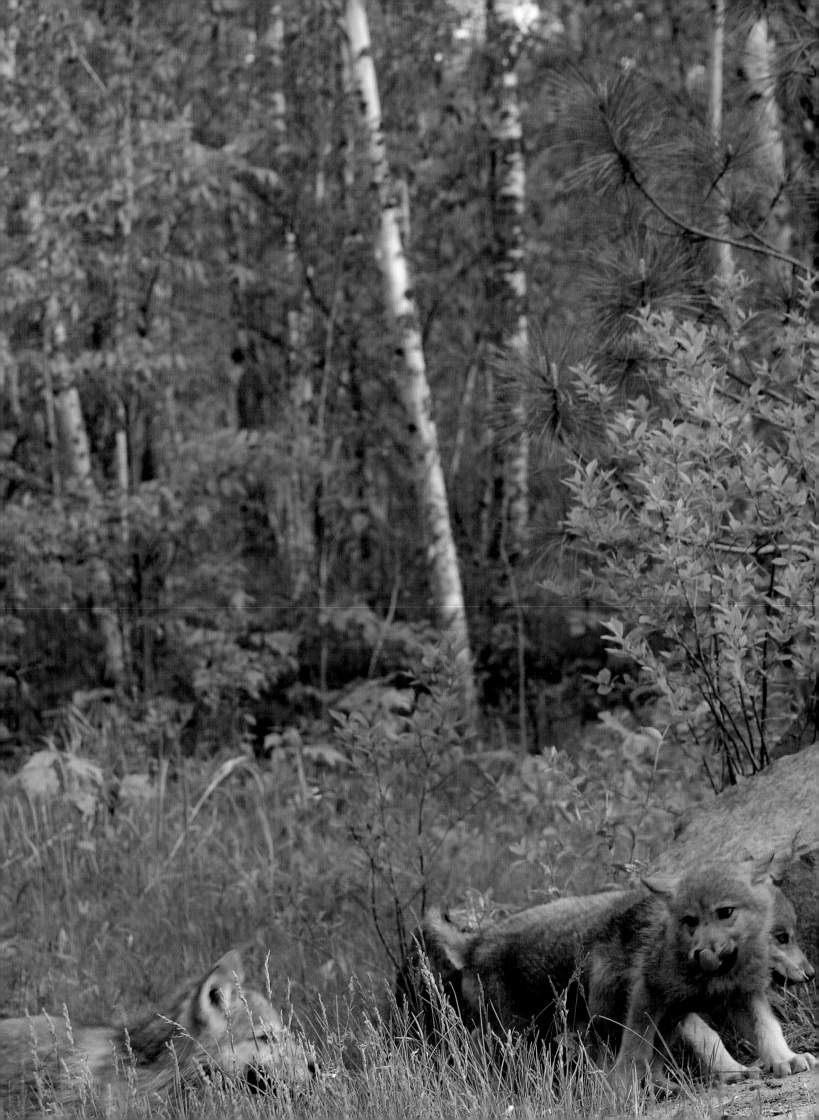

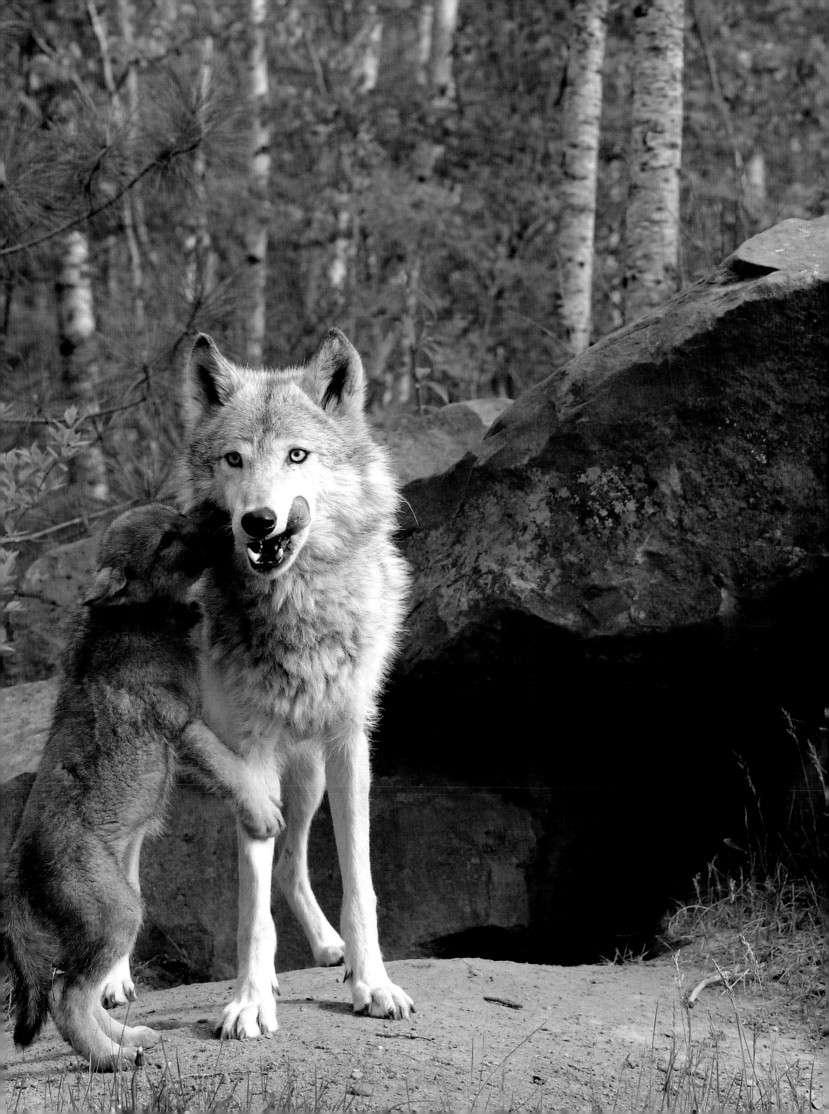

Wolves are fierce protectors
of their territories.

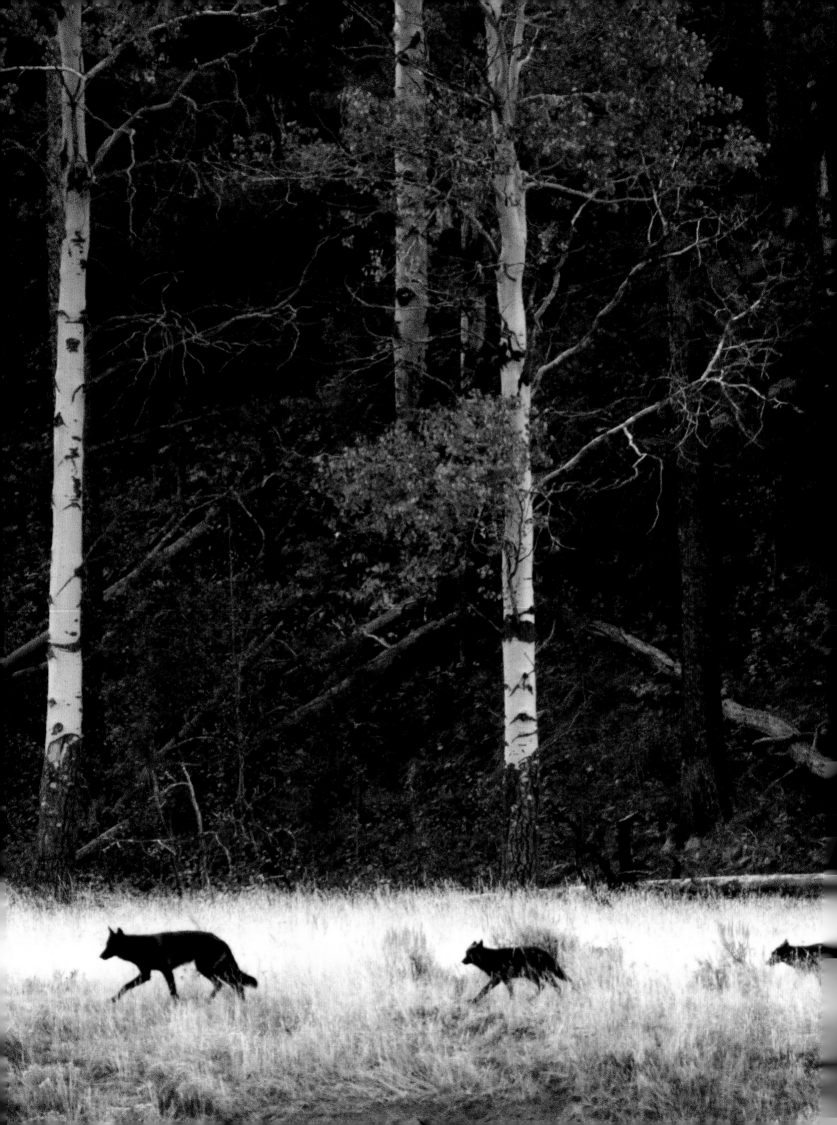

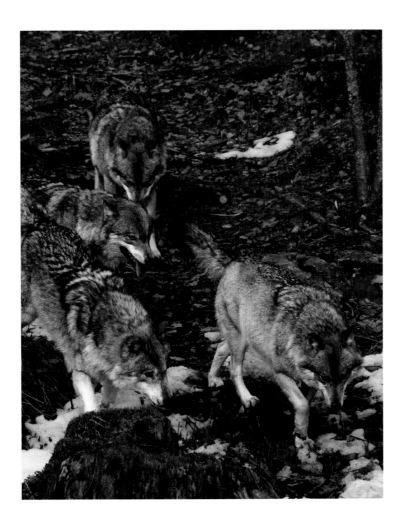

Movement Within Territories

When pups are born, the den site serves as the center of pack activity. This is because pups, as the pack's most valuable resource, require constant attention and all pack members feed the pups. Thus older wolves rest at or near the den site, and then leave in all directions to hunt by themselves or with others, returning after hours or days to bring food back to weaned pups.

As mentioned in an earlier chapter, after twenty weeks of age, wolf pups have grown large enough to travel with the other adults in the pack. The two main functions that travel fulfills are foraging (hunting and scavenging) and territory maintenance (learning the boundaries).

Most often, wolves follow trails, shores, gravel bars, frozen waterways, ridges, and roads. They also follow the trails of other animals, even if seemingly easier paths are available. They usually follow each other single file, especially through deep snow, to make travel easier, though they often spread out a bit on bare terrain. Movements within the pack's territory are seemingly nomadic, though they often pass by places where they have spent time as pups. Rest sites are most often associated with places where the pack has made kills. Resting wolves will take advantage of dry resting spots, or those free of snow in the bright sunshine, unless none is available. Then they just curl up wherever they can and wait until the next hunt begins.

In many places, wolves repeatedly travel the same routes, likely because they are easy to navigate, lead to and go through areas where prey is more concentrated, and/or are at the boundaries of territories. Actual "circuits" of travel are more common in mountainous terrain, where easy traveling is more important than in flat, uniform terrain.

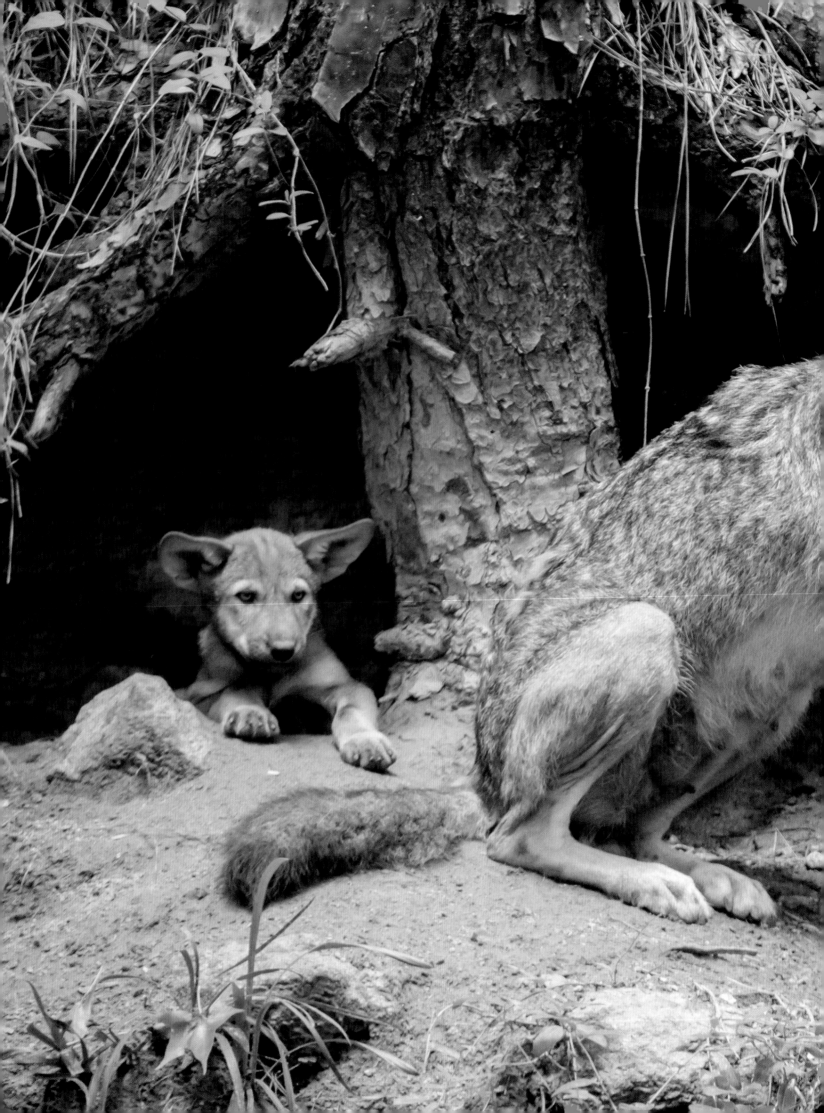

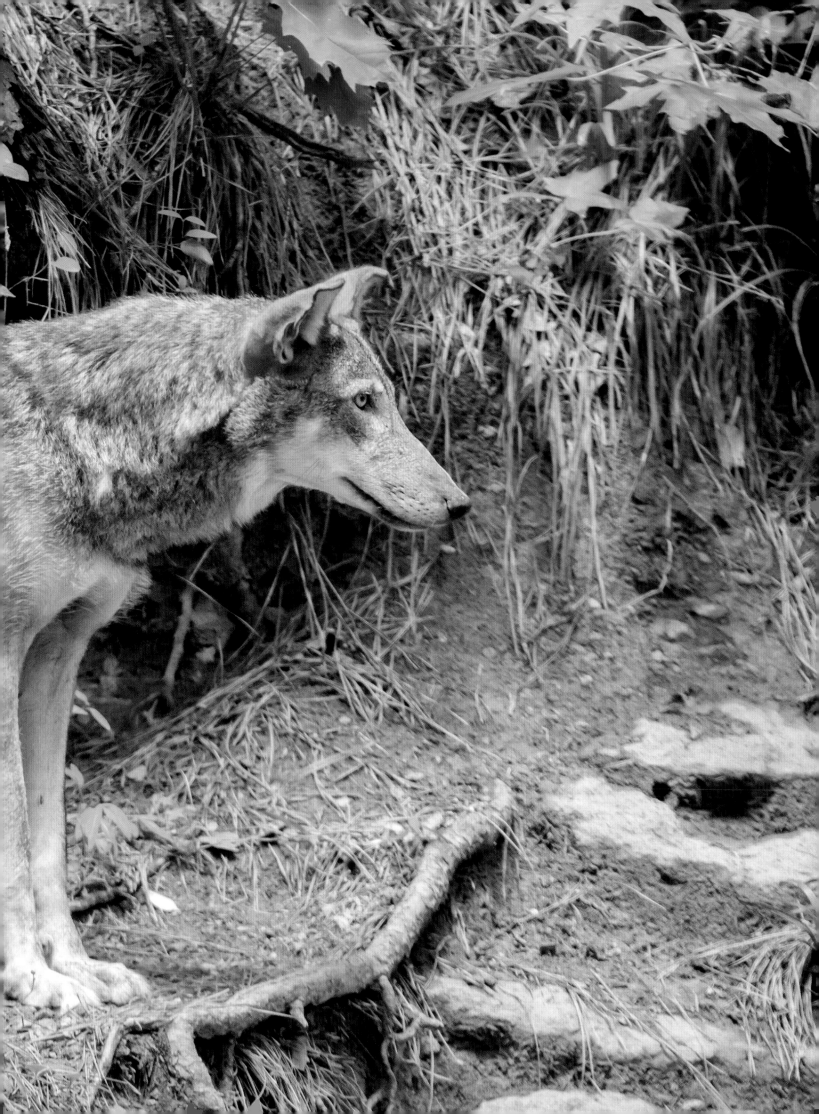

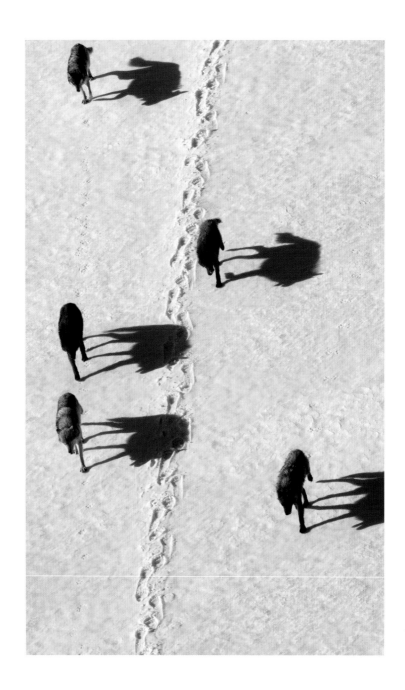

Movement Across Territories

As discussed earlier, there are several reasons why wolves occasionally travel outside of their territory. The first is to find a mate and locate a territory in which to settle and raise a family. They still follow trails and ridges, visit areas with large amounts of prey, and, importantly, respect the territorial markings of other wolves.

The other reason wolves leave their territory is to find food. This is especially dangerous when these travels lead not just along trails of migratory prey, but into the territories of other wolves. These "trespasses" are especially common when prey is hard to find or capture, and wolves are therefore desperately hungry. In almost all cases, the wolves return to their own territory relatively quickly. If not, they are usually confronted by the resident pack, and this may easily lead to deadly combat.

As wolves travel within and outside of their home territories, whether in search of food or new mates, they are bound to interact not just with other wolves but also with other species, as we will see in the next chapter.

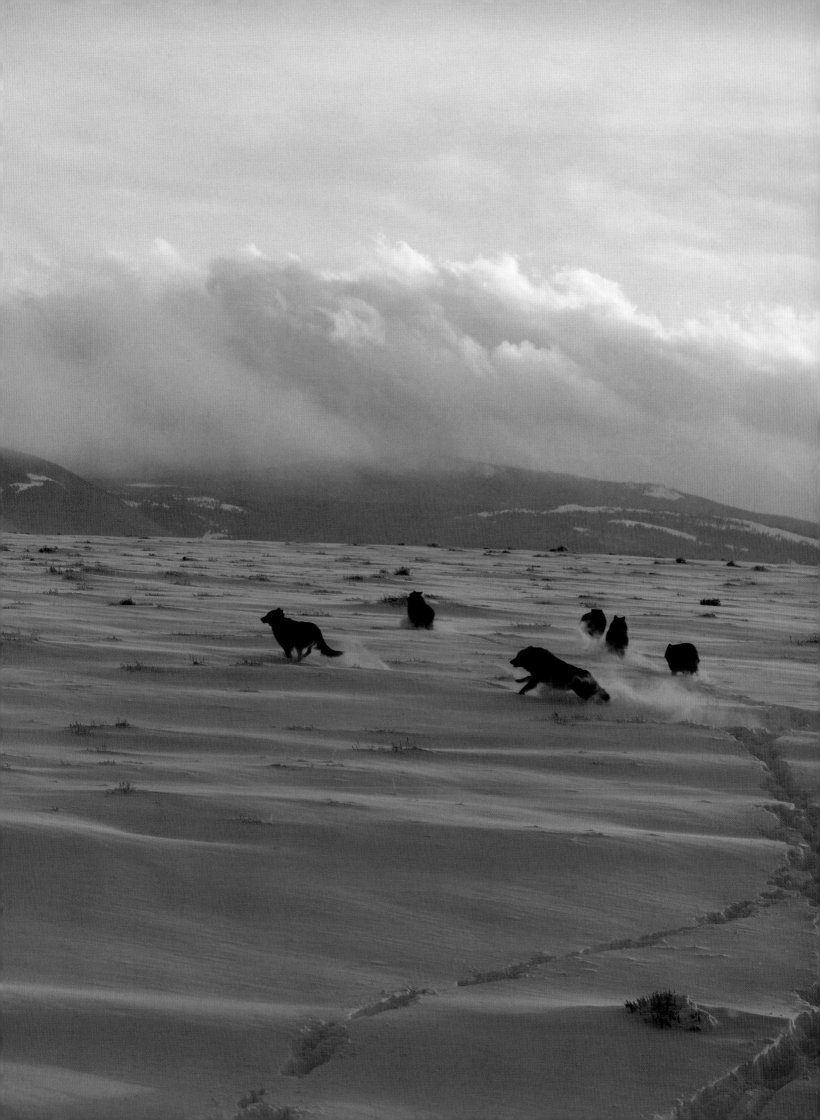

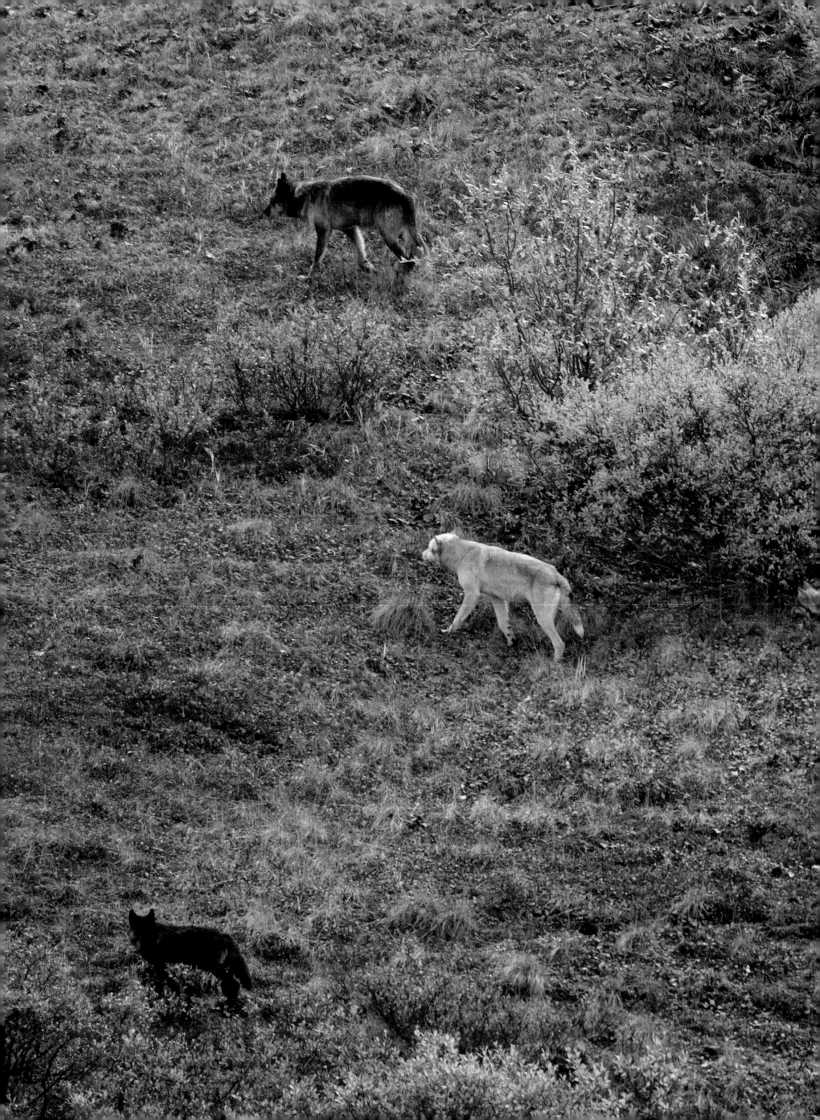

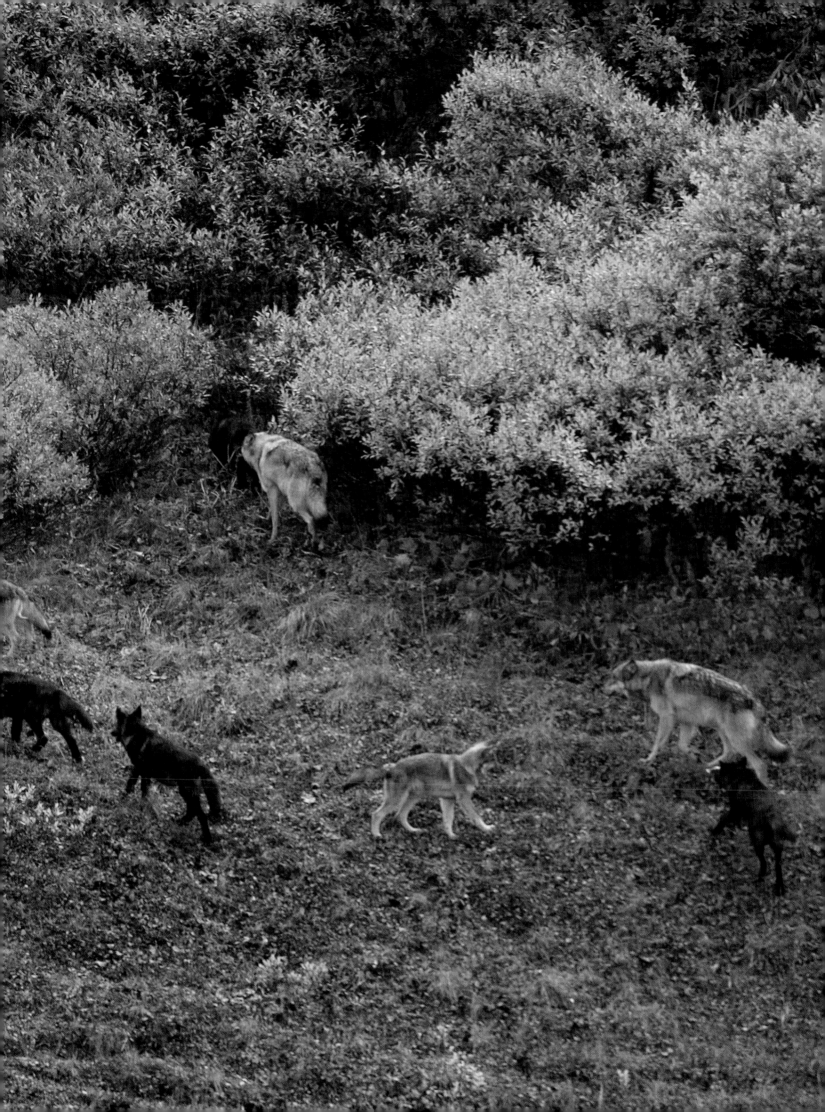

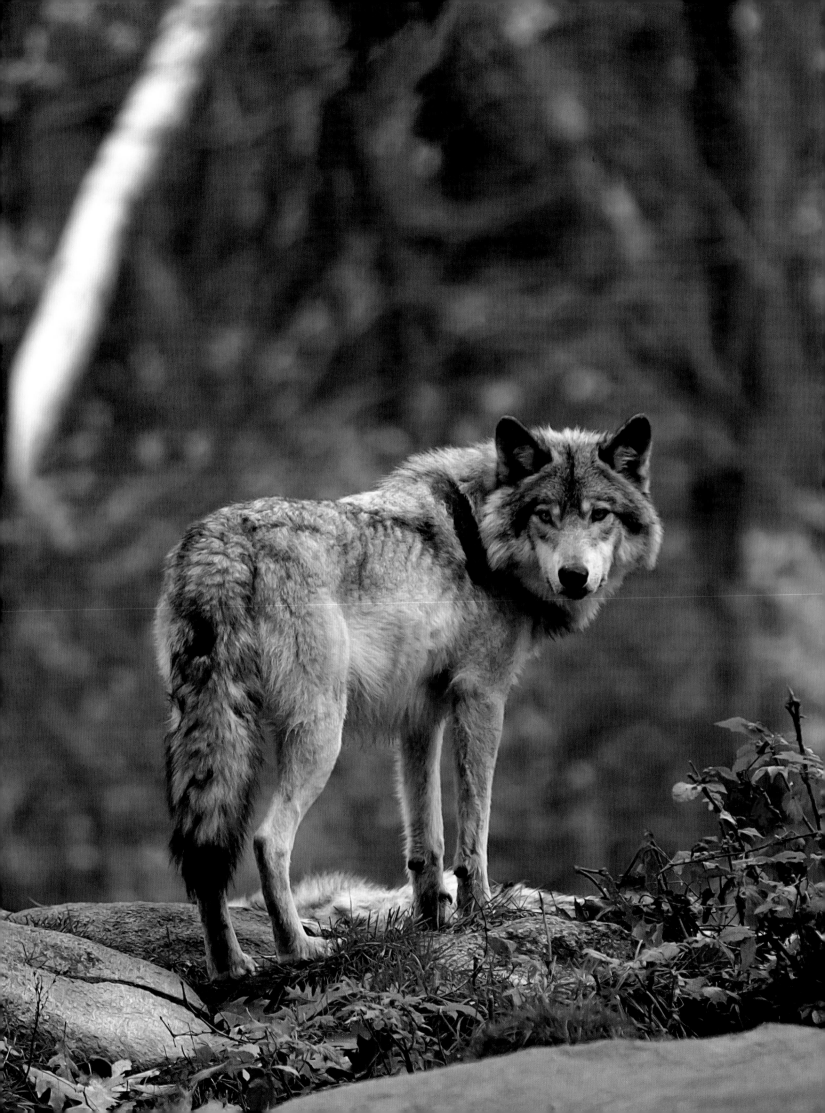

How Wolves Interact with Other Species

It is obvious that many species of animals, and particularly the ungulates, or hoofed mammals, are wolf prey. But how is it that over thousands and thousands of years, there seems to be some kind of balance among these species, and there always seems to be enough prey around for wolves to eat? Prey animals must be doing something right to avoid being wiped out by wolves, and the environment that they are adapted to, and even thrive in, must somehow mitigate the effects of wolves.

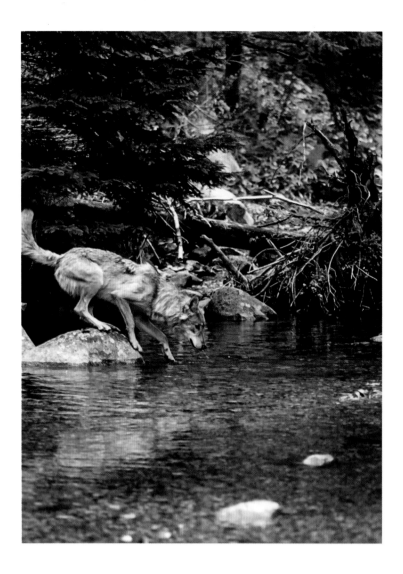

Wolves and Their Prey

Sheer size may help the largest mammals, such as bison, moose, horses, musk oxen, elk, and even wild boar, especially when combined with aggressive behavior. Antlers and horns, as well as well-aimed hooves, make good defensive weapons. Some species use their ability to run quickly and with agility to escape wolf predation. Gazelles and pronghorns on the open plains are among the swiftest of all mammals. The speed and leaping ability of many deer allow them to escape through forest cover where few other species can keep pace. The newborn young of some species have cryptic coloration, which allows them to hide more easily from predators; they also lack distinctive scents that might attract wolves to their location.

Another anti-predator strategy is to concentrate births during a short period of time. Presumably,

when highly vulnerable young are all born at once, predators such as wolves are "swamped" with prey and only have time to find and kill a limited number of calves or fawns; in the meantime, the other newborns grow quickly and are then less vulnerable to predation. As an alternative to hiding for the first several days of life, calves of some species such as moose follow their mothers closely immediately after birth and are actually able to nearly keep up with a running mother. This, in combination with defensive behavior by mothers, gives the calves enough of a head start that, if they survive the first couple of weeks, they can run as fast as any adult.

Some species are more vigilant of attack than others. Large-bodied species are generally more observant of large predators than are smaller species,

All species possess a combination of physical traits and behaviors that provide major survival benefits.

and individual animals in large herds are less watchful than when they are in smaller groups and thus have fewer "eyes" scanning for predators. Similarly, individuals in the middle of herds are less alert than those at the periphery.

Mothers with newborn young are definitely more attentive and on guard than other individuals. Ungulates in thick cover also seem to be more vigilant than those in open areas because it is so much easier for predators to approach closely where vegetation is dense. Also, prey animals seem to increase their watchfulness after wolves have hunted in an area.

Some ungulates, such as deer and sheep, may vocalize when a predator is seen and thereby alert their neighbors. Some species have group defensive behaviors that are effective deterrents. For example, musk oxen form a defensive line or ring to shield their young when a predator is detected. They press their rumps together in front of their young, the young crowd toward them, and the wall or ring of sharp horns that faces the wolves is formidable. During some seasons, antelope, elk, wild boar, and musk oxen all travel in herds, which provides more protection. Other ungulates make it more difficult for predators to find them or evade them by moving nomadically around their range.

Many species make use of escape features in the environment to avoid predation. By running into water, long-legged ungulates, aside from making wolves swim, may give shorter-legged wolves less leverage. Steep terrain clearly plays a role in the survival of sheep and goats; these species are almost defenseless on level ground, but once on rocks and cliffs it is extremely difficult for wolves to catch them. Some species, especially when giving birth, use islands, shorelines, peninsulas, and elevated sites in the forest as a way to reduce the chances of a predator sneaking up on them, and wild boars use burrows to avoid predators.

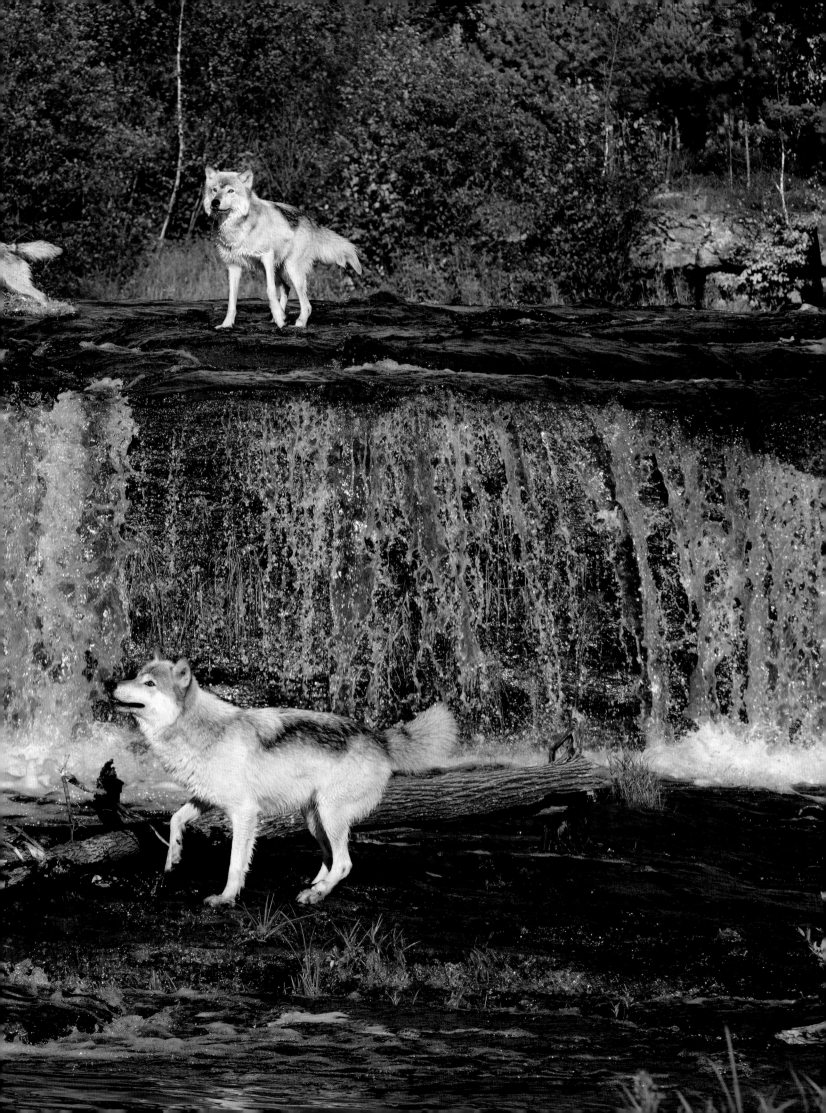

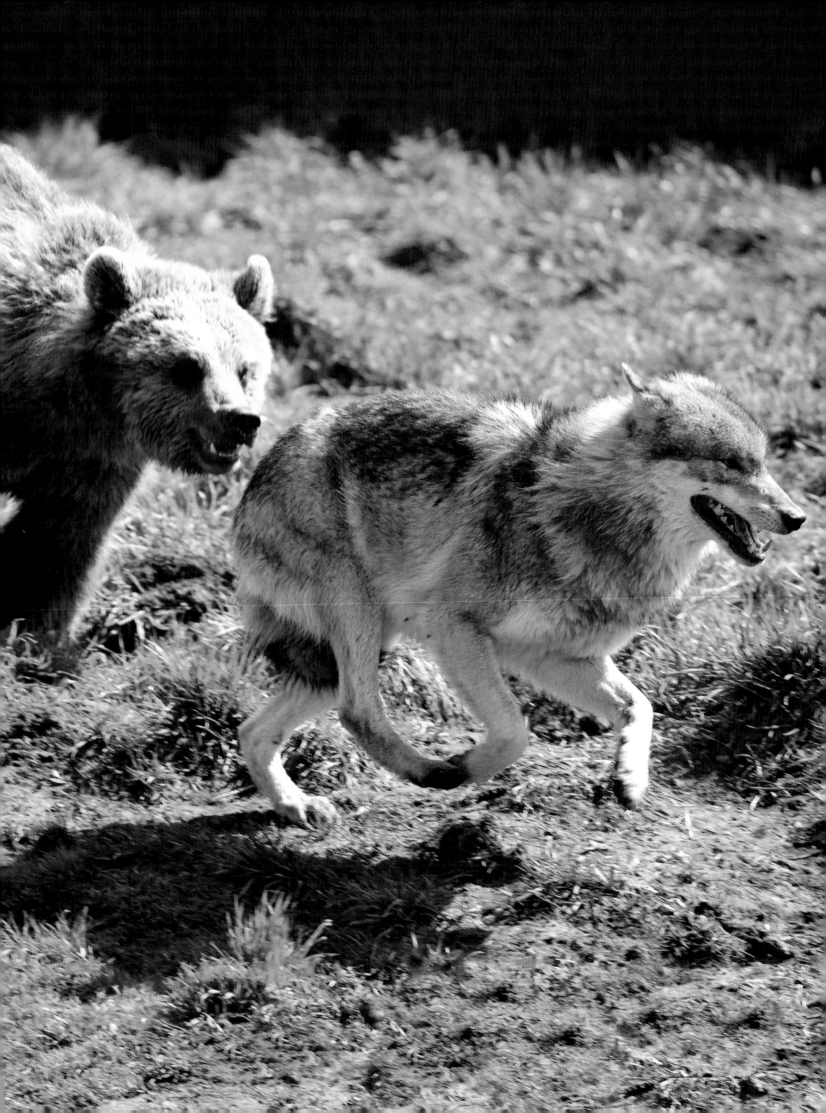

Wolves and Their Competitors

In addition to their prey, wolves interact with a wide variety of other species.

Whether this competition becomes a source of conflict depends on the availability of food and the relative size of each species.

Brown bears and wolves live together in many parts of the world. Brown bears are omnivorous—they eat plants and insects in addition to meat—but they are very effective carnivores as well. Most of the wolf–brown bear interactions take place at kill sites, mostly those of wolves where the bears are scavenging, but also those of bears where wolves are scavenging. Usually, bears win these encounters. Bears also investigate wolf dens in the spring and sometimes kill pups.

Wolves and North American black bears also have overlapping ranges and directly interact with each other. Some interactions occur at kills made by wolves, and wolves usually win these encounters. Interestingly, wolves may also seek out black bears in dens.

Wolves and cougars, or mountain lions, in North America both live primarily on ungulates, but the two species hunt in very different ways. Unlike wolves that chase down prey, cougars hunt by stealth, stalking and ambushing prey animals in relatively thick cover and rough terrain. To some extent, these different techniques may provide some "separation" between the species. In winters when snow forces most ungulates into mountainous river valleys, however, the two species do interact over kills.

Tigers and wolves are known to eat the same species of prey, but direct interactions are rare. In many places, coyotes are able to live at the boundaries of wolf

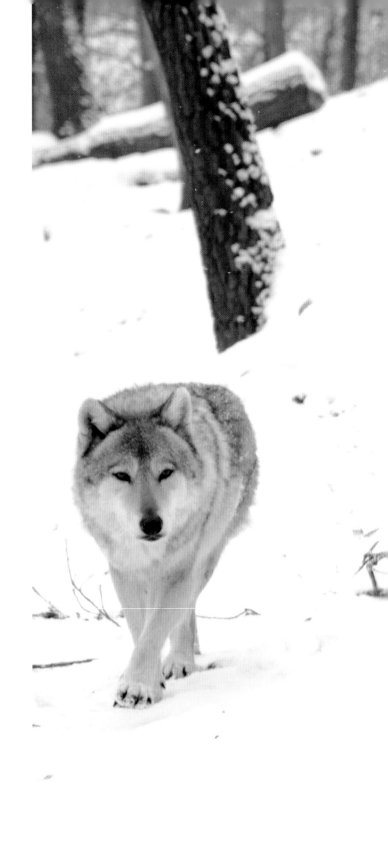

In the wolf's role as predator and scavenger, there is ample opportunity to have overlapping food preferences with other species.

territories, but coyotes trying to scavenge carcasses of prey killed by wolves are most often killed.

Wolves kill and sometimes eat red foxes, usually when foxes are attempting to scavenge from wolf kills. In the long run, however, it may be better for foxes to live where wolves do. Coyotes are actually stronger direct competitors with foxes than are wolves, so when wolves reduce the coyote population, red fox populations may actually increase in comparison to when only coyotes are present. Wolf and coyote numbers seem to be inversely related to one another, indicating that wolves displace or kill coyotes in many instances. Coyotes certainly try to scavenge carcasses of prey killed by wolves, and that is where they are most often killed. In many places, however, coyotes are able to live and successfully breed at the boundaries of wolf territories, where the chances of encountering packs are less likely.

Eurasian lynx and wolves live in the same areas across much of their range, and they often feed on the same species, usually roe deer. However, when wolves are plentiful, lynx seem to eat relatively fewer roe deer and more hares, leaving the deer for the wolves and thus reducing potential deadly interactions.

Dholes, also known as Asiatic wild dogs or whistling dogs, apparently can displace wolf pairs from prime habitat and those wolves will be forced to subsist in less optimal circumstances.

Ravens in North America seem to interact with wolves more than any other non-prey species. In particular, ravens focus their activity at wolf kill sites, though they are sometimes caught and killed by wolves while scavenging.

There is one species left to consider–humans. Wolves and humans do indeed interact, as we will discover in the next chapter.

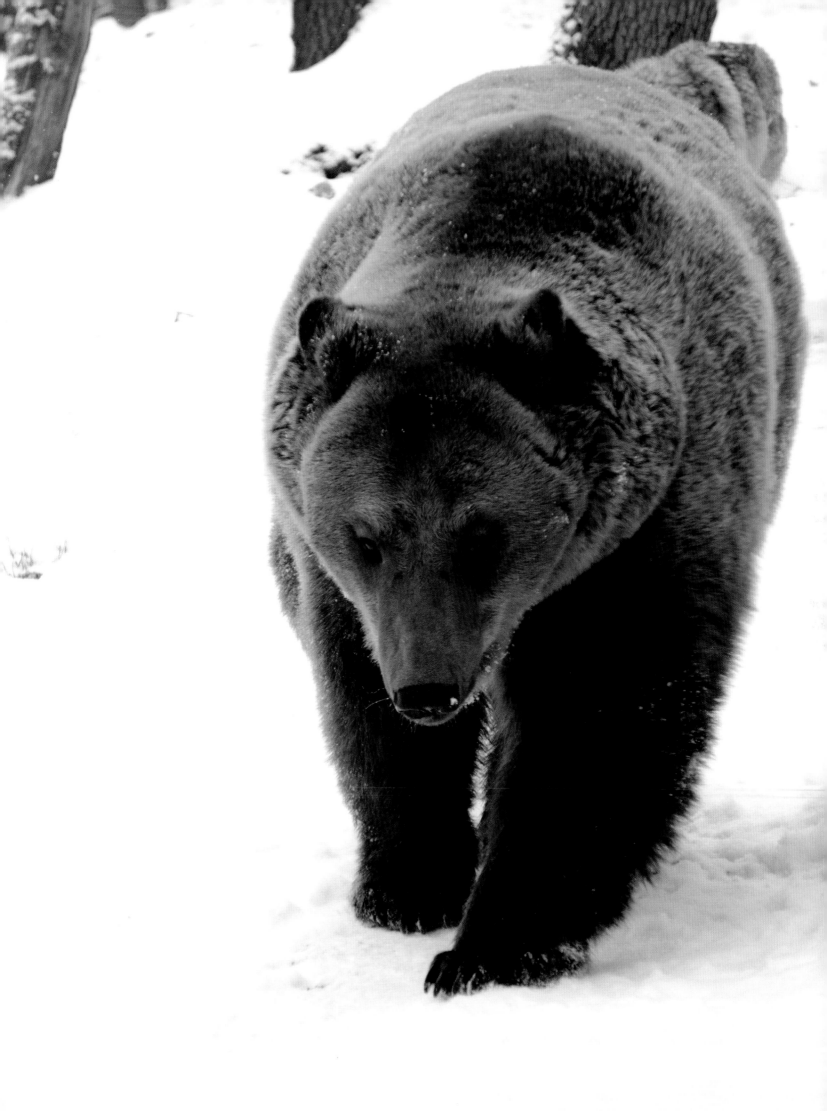

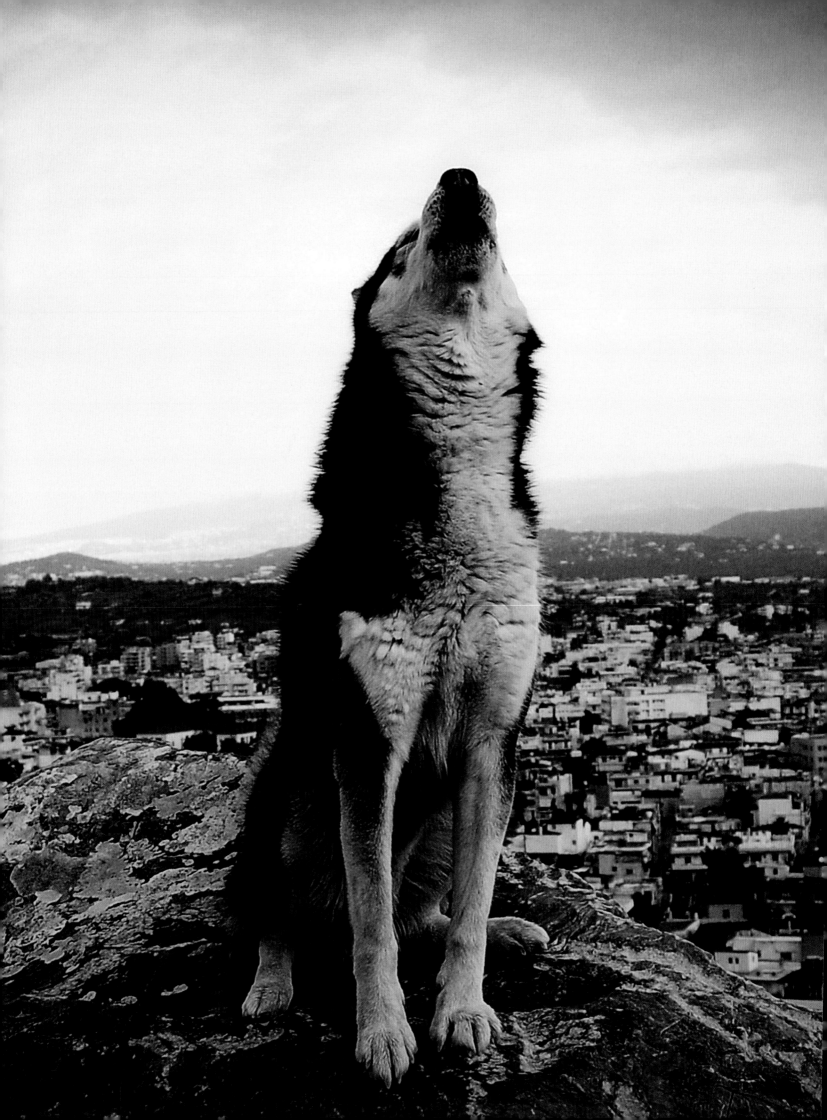

How Wolves and Humans Interact

Wolves and humans historically have competed for the same kinds of food, and as a result there were likely always some wolves killed. In addition, some wolves were killed to be eaten and for their fur to serve as clothing.

The biggest motivation for killing wolves, however, was for the protection of domestic livestock. As human populations spread, they took their livestock with them.

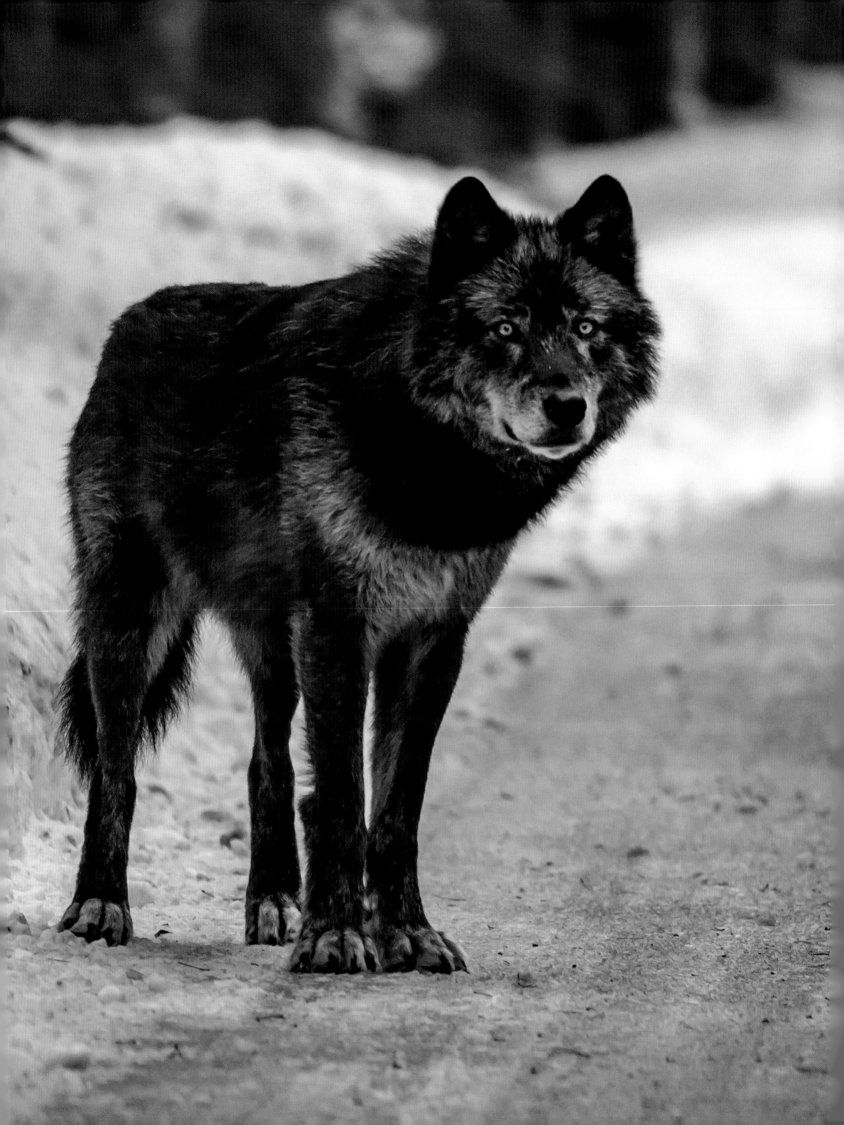

During the past ten thousand years, and mostly in the past five hundred years, the wolf population has declined, almost entirely as a result of human activities.

The selective breeding that made domestic animals easier to herd eliminated much of their natural defensive behavior and made them easy prey for wolves. Wolves soon started killing cattle, sheep, and goats, putting people's livelihoods and ability to survive in jeopardy.

In large part, the increase in domestic livestock paralleled the decrease in wolves' natural prey. The longer humans and their livestock remained in an area, the greater the chance that every last wolf in the region would be killed. Areas inhabited by humans that were isolated from larger populations of wolves, such as islands or peninsulas, were the first to have their wolf populations completely eliminated.

Over a hundred years ago, the U.S. government authorized the elimination of wolves in Yellowstone National Park in order to protect big game species, and by the 1920s the government trappers had finished their job. Even in the sparsely populated western half of the country, wolves were eliminated some sixty years ago. Wolves hung on along the southwestern border with Mexico until late in the twentieth century; in the western Great Lake states, and particularly the remote, unpopulated northeastern part of Minnesota, wolves were never completely eliminated.

At the turn of the twenty-first century, wolf populations in most areas were no longer declining as precipitously as they had in the previous century. In fact, many were increasing and expanding their range because of legal protection and purposeful reintroductions.

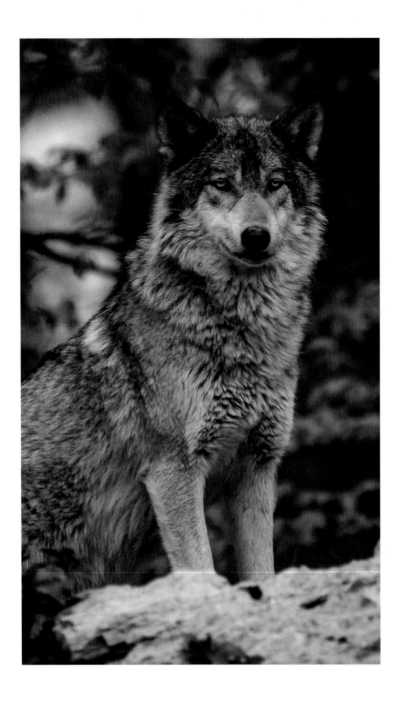

Wolf Reactions to Humans

The behavior of wolves encountering humans seems to depend in large part on their previous experience and the current conditions. Wolves without any experience with humans often approach them with curiosity, and no doubt with some uncertainty as to whether or not humans might be prey. Wolves that attack people might be doing so for defensive purposes, such as when pups are vulnerable or they perceive themselves to be in danger. In some instances when food is scarce or children are unprotected and far from other people, it appears that wolves kill humans, but this is quite rare and has occurred mostly under special circumstances. Historical records of wolf attacks on humans appear to involve tame wolves, wolf-dog hybrids, or rabid wolves. In some instances, the killing could be blamed on wolves that had been raised in captivity and then released.

Where wolves have had little contact with people, or where they are used to humans providing food for them, they show little fear. Prior to the advent of

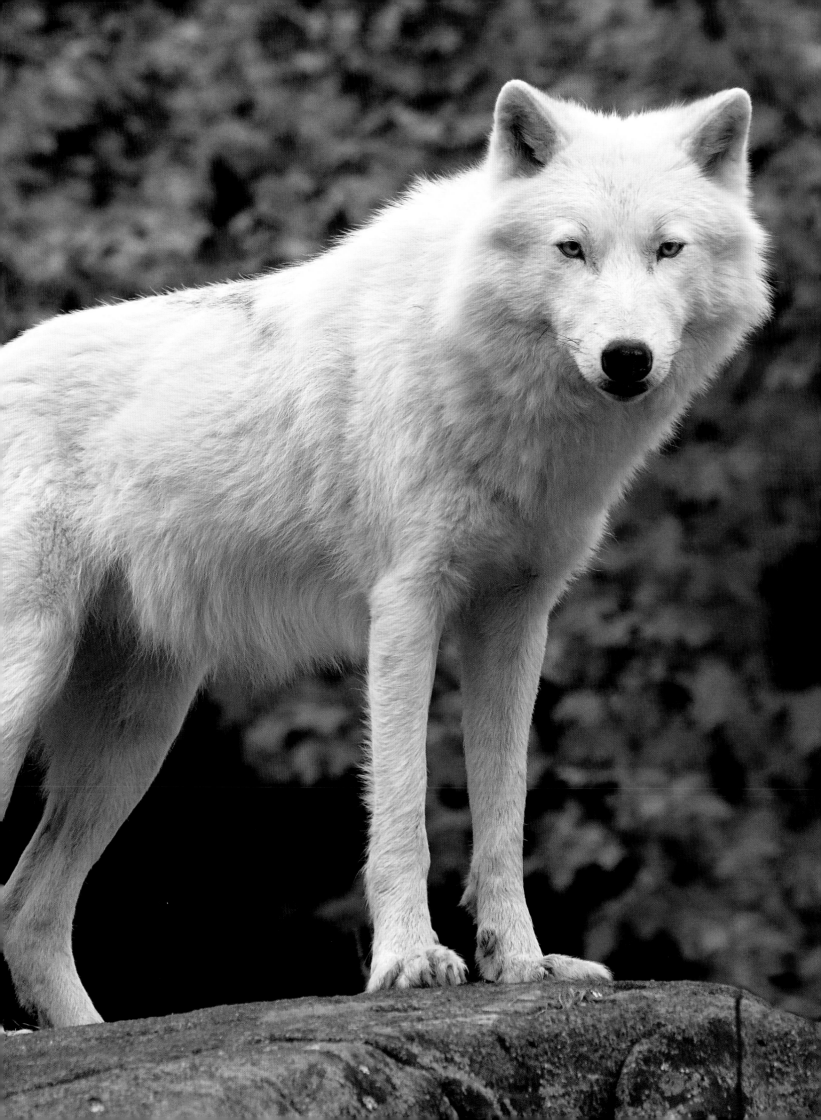

The reason why some people believe that wolves in North America are wilderness animals is not because they require wilderness, but because that is the only place where they have remained after persecution by humans.

rifles that could injure or kill them from a distance, or vehicles that could chase them, wolves on the open grasslands seemed relatively indifferent to humans. This behavior is unlike that of wolves in forested areas, where they may have been more wary and secretive because they cannot see as far, and thus have to be more vigilant than grassland wolves.

Like many other animals, wolves become conditioned to activities in their environment, and they soon learn to avoid those that are harmful or lethal. For example, airplanes are not inherently dangerous to wolves, but wolves in northern Minnesota soon learned to run for cover when a plane approached because pilots or their passengers routinely shot wolves from the air when there was a bounty for them.

Indeed, in parts of Europe wolves do live among humans, even foraging on the outskirts of or passing through villages, towns, and cities. Usually, however, such activity occurs at night when the chances of direct contact with humans is low. Where wolves are not specifically protected, they have learned that many encounters with humans are not positive, so they avoid places and times when human activity is high. Where they are protected, however, they may be seen and even observed for long periods of time, acting as they do when no humans are around. In such areas, they have been known to den near logging activities, pass near hikers, and even reside on military bases.

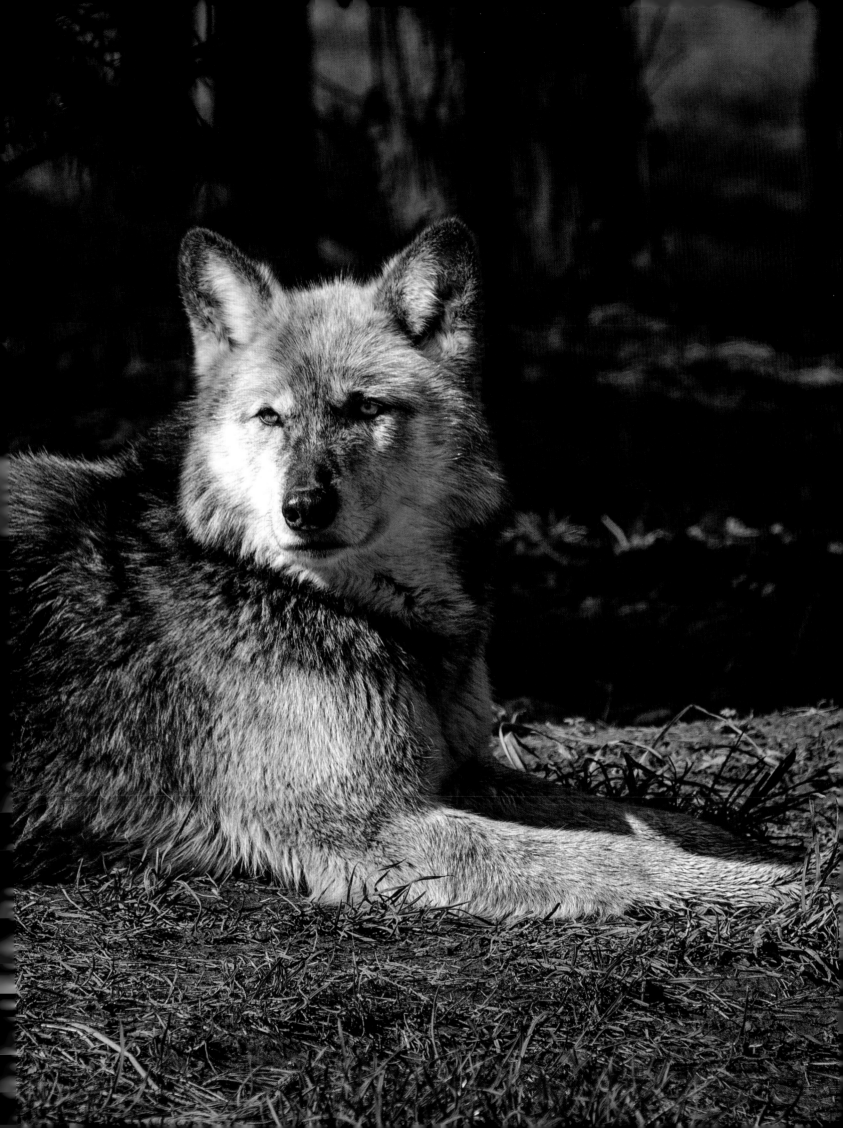

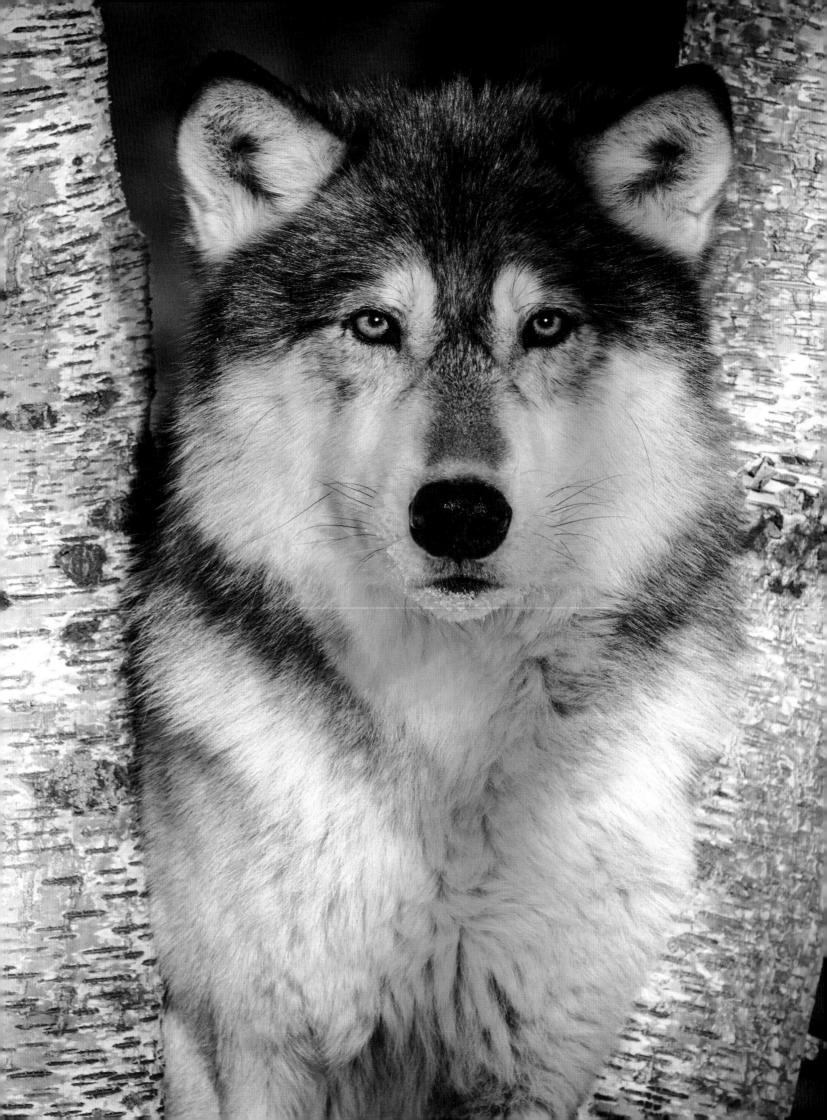

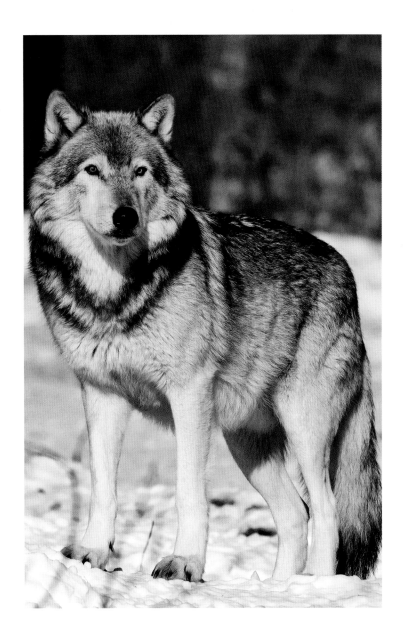

Human Reactions to Wolves

Contemporary human attitudes and values concerning wolves run the gamut from adoring to hostile. But one has to wonder why it is that some people believe wolves are the ultimate symbol of wilderness and environmental completeness, while others are convinced that wolves represent nature out of control, wreaking havoc on humankind. Many negative feelings are clearly reactions to the practical problems that humans must face when living with wolves. Most farmers would be angered when discovering a wolf standing over a dead, pregnant ewe. But just as many urbanites, few of whom have ever walked in wolf country, would be

enraged when viewing a videotape of wolves being shot so that an elk population could increase for hunters.

Humans kill wolves for a variety of reasons. Understandably, wolves have been killed in self-defense, but probably more often they have been killed in defense of livestock, especially sheep and cattle, as well as pets, particularly dogs. Wolves have also been killed for their fur, which is used for clothing and sometimes blankets. Plains Indians of North America wore wolf skins as disguises in order to be able to sneak up on bison they were hunting. In addition, wolf meat is a prized part of the diet in

some parts of the world. Wolves also have been shot for sport. They are valued as trophies that can end up as rugs or wall hangings.

Humans and wolves have always competed for ungulate prey. Logically, to some, any deer that wolves killed was one less available to a hungry hunter and his or her family. The fewer wolves there were, the more opportunities there were to kill a deer. Thus, wolves were speared or shot, and

wolf dens were occasionally raided to kill pups to keep the wolf population "under control."

The wolf–game animal issue is still important and has become especially contentious where wolf reintroduction has been proposed. After decades of being able to hunt big game in wolf-free environments, hunters continually question scientists as to the effect of reintroducing wolves to an area and, more specifically, how much it will reduce

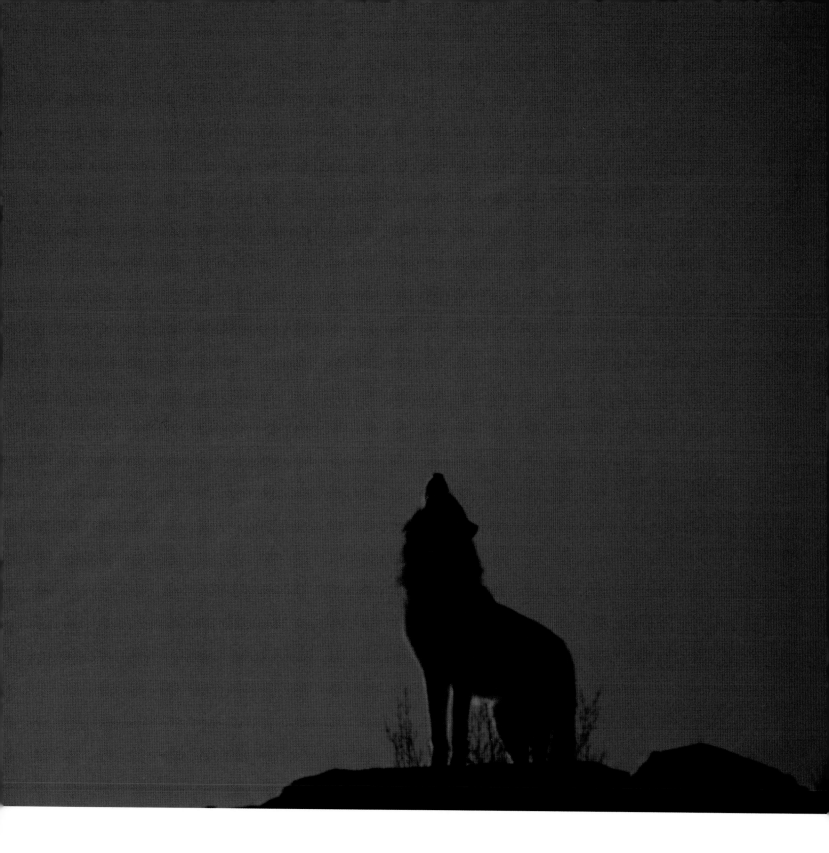

the legal harvest of game by hunters. Where wolves are common, they often are legally killed (such that their populations will remain viable) in order to maintain sustainable hunting by humans.

Given the inherent demands of both wolf and human populations, how can these two species ever hope to coexist safely? That is the subject of the next, and final, chapter.

In the United States, most of the wolves were gone from the eastern half of the country two hundred years ago, though some hung on until late in the nineteenth century.

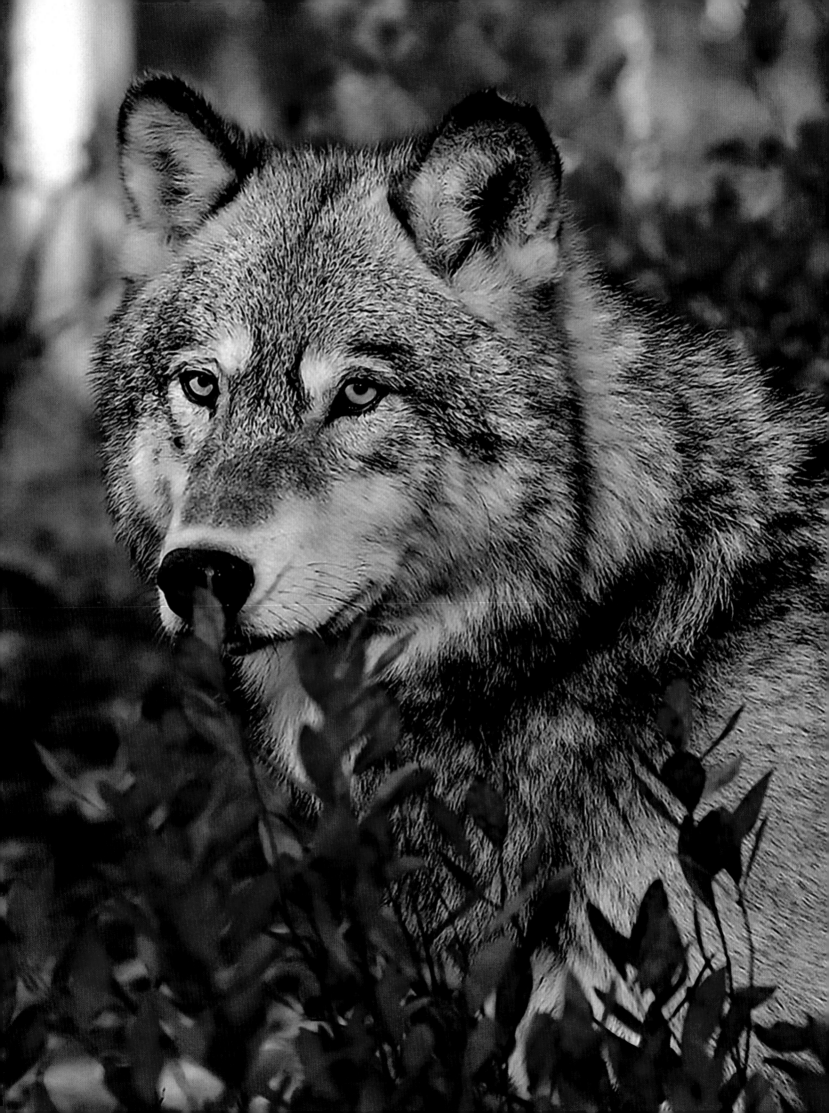

Conservation and the Future of Wolf Populations

Human attitudes and traditions have played a major role in determining the locations of wolf populations, because in the past, unrelenting hunting of wolves has resulted in their complete elimination from some areas. In post-colonial America, taming the wilderness was no less a passion than was eradicating wolves, and both seemed essential to advance civilization.

Even in places where humans are more common, wolf populations can exist if hunting is regulated and illegal or accidental killing of wolves by humans is low.

Currently, wolves thrive in very remote areas where few humans reside, or in designated wilderness areas, national parks, and wildlife refuges where wolves are protected.

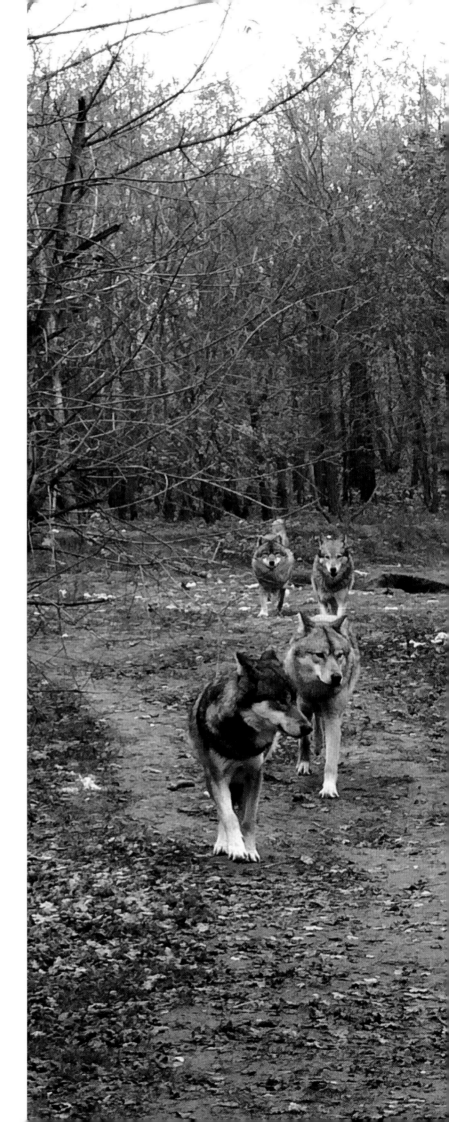

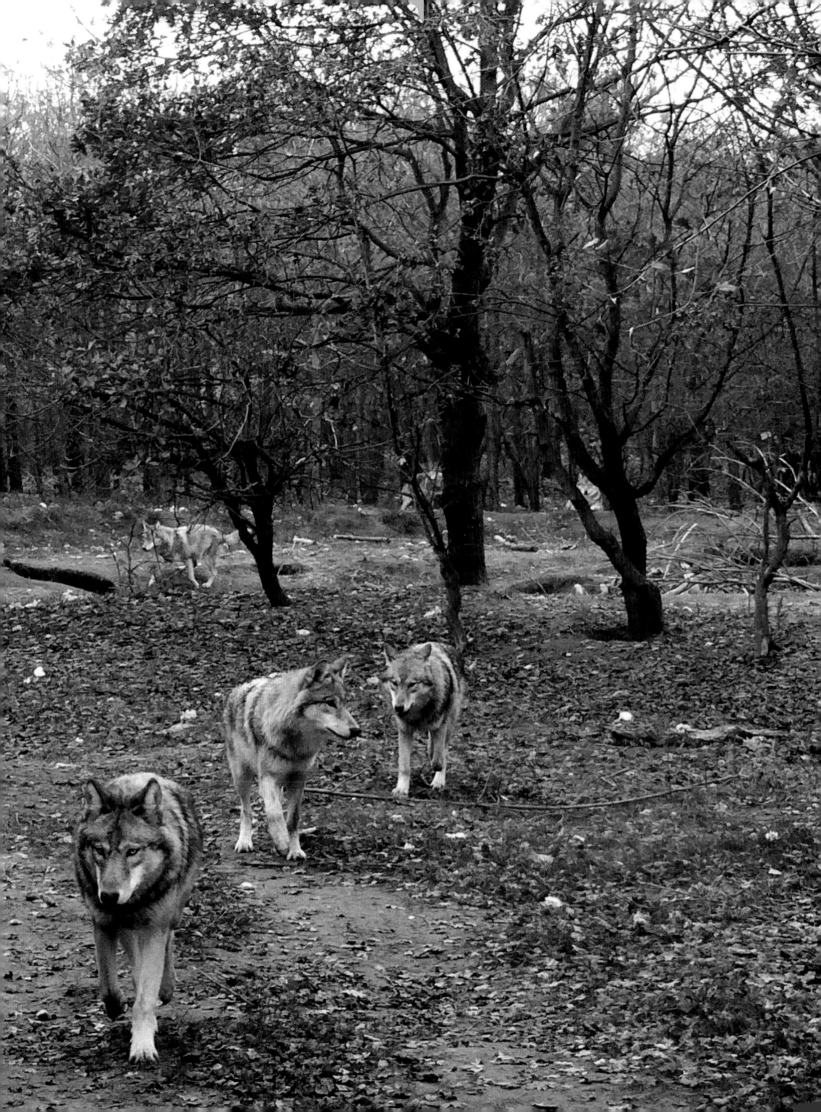

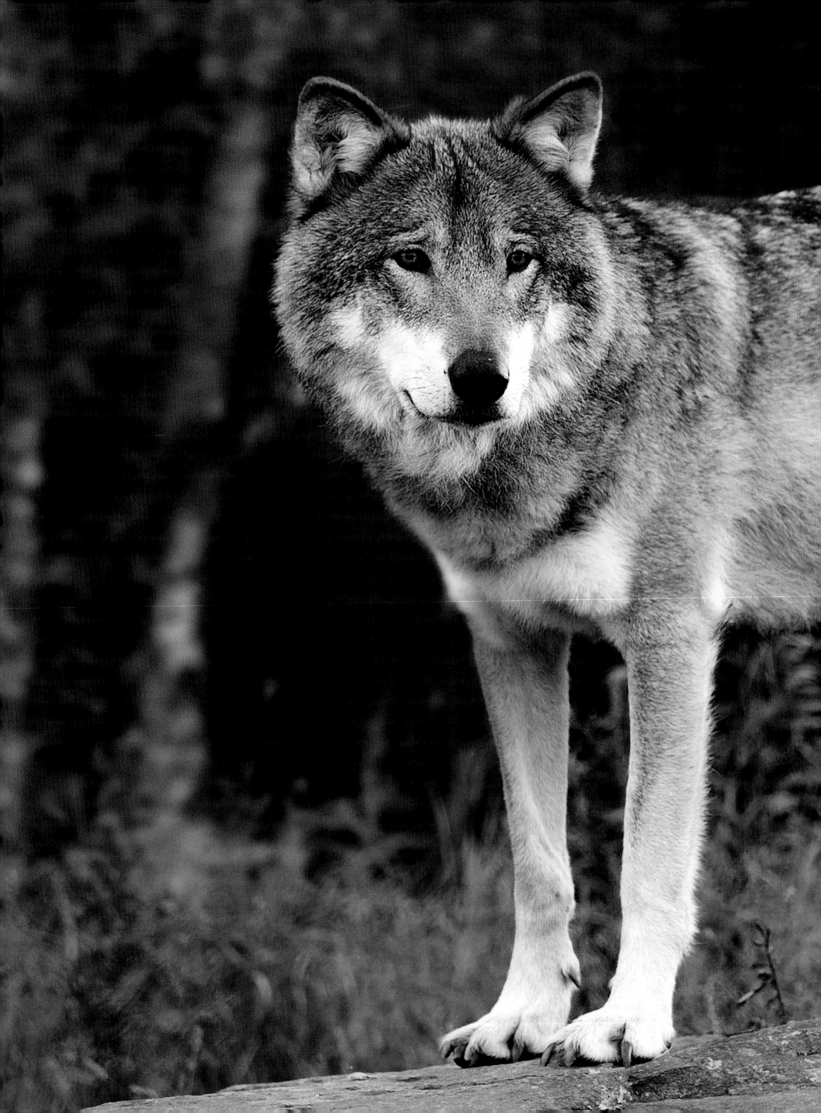

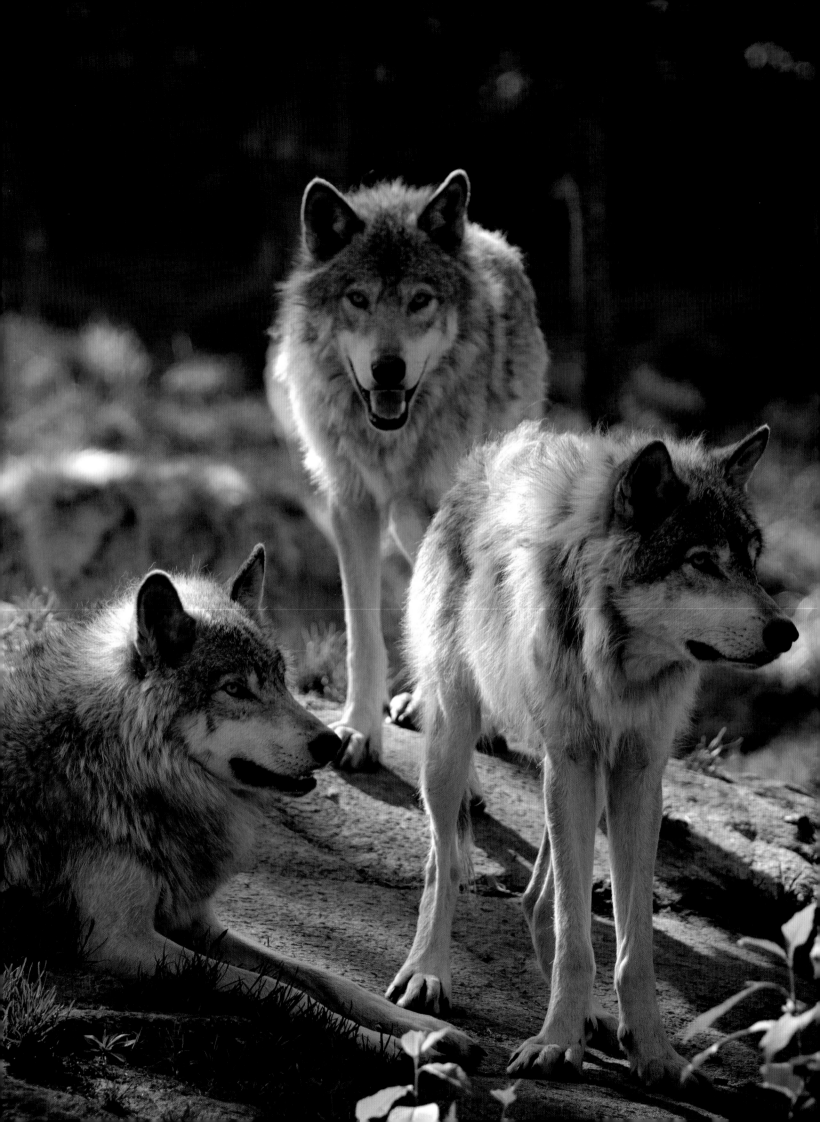

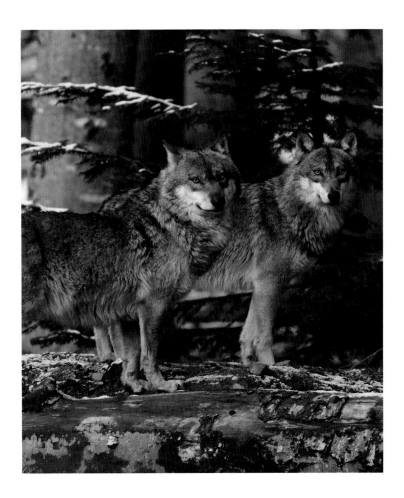

Changes in Attitudes and Knowledge

Some of the long-held values we humans have had about wolves persist. We still believe, or at least are subtly influenced by, the myths and stories that have been passed on for generations. Yet many people are questioning or opposing the historic persecution of wolves, and even the regulated harvest, and directed control, of wolves. This change in attitude is due in large part to increased knowledge of wolves. Wolf conservation has become an ecological and ethical concern, and much time and effort has gone into trying to figure out how wolves and humans can continue to coexist.

Wolf advocacy has come about as the result of several key events. The change in our perception of wolves had to do with the advancement of scientific management of wildlife, with the development of a land ethic, and with the discovery that humans were having self-destructive effects on the environment. Not until the 1930s and 1940s were wolves even deemed worthy of scientific study, and not until the environmental movement of the 1970s did the public's attitude toward wolves begin to change in the United States. With these actions, the historic fate of the wolf and many other species was reconsidered, and conservation efforts were begun to counter the harmful practices of the past.

The pace of wolf science also accelerated in the 1960s, particularly with the advent of radio telemetry (small transmitters on collars that allowed scientists to locate wolves). In the 1970s, knowledge of wolves increased rapidly, as did the number of biologists studying these wild animals.

Wolves became one of the first species to receive federal protection under the Endangered Species Act of 1973.

In the past fifty or so years, millions of dollars have been spent on wolf research, management, promotion, and recovery.

In order to change opinions, a new mythology of wolves evolved in which the evil, overabundant wolf was transformed into the unfairly persecuted, endangered wolf. Wolves evolved into symbols of wilderness, of nature at its best, of an environment that was functioning as it was meant to. To be sure, there is a cultural value of wolves as symbols of hunting prowess and family life. Wolves are respected as a species of survivors with many valuable abilities and traits. Many people have an affinity for wolves; this is not surprising, given the number of dog as pets that live in the world.

Now people recognize that removing major parts of ecosystems significantly disrupts their balance. One of the most persuasive arguments for restoring wolves to Yellowstone National Park was that wolves were the only species that was present at the time of European colonization of North America, and that reintroducing them to the park would restore the "imbalance" of the rest of the plant and animal community.

Wolves recently have been marketed as a draw for tourism and recreation. Economic analyses suggest that millions of new dollars have flowed into the economies of the American Rocky Mountain states where wolves have been reintroduced because of the appeal to tourists of being in "wolf country" and maybe even catching a glimpse of a wolf. Alaska has drawn tourists by advertising itself as the "Serengeti of the North," offering views of majestic and abundant wildlife, including wolves, interacting as they have done for thousands of years.

Finally, wolves have been valued in a cynical

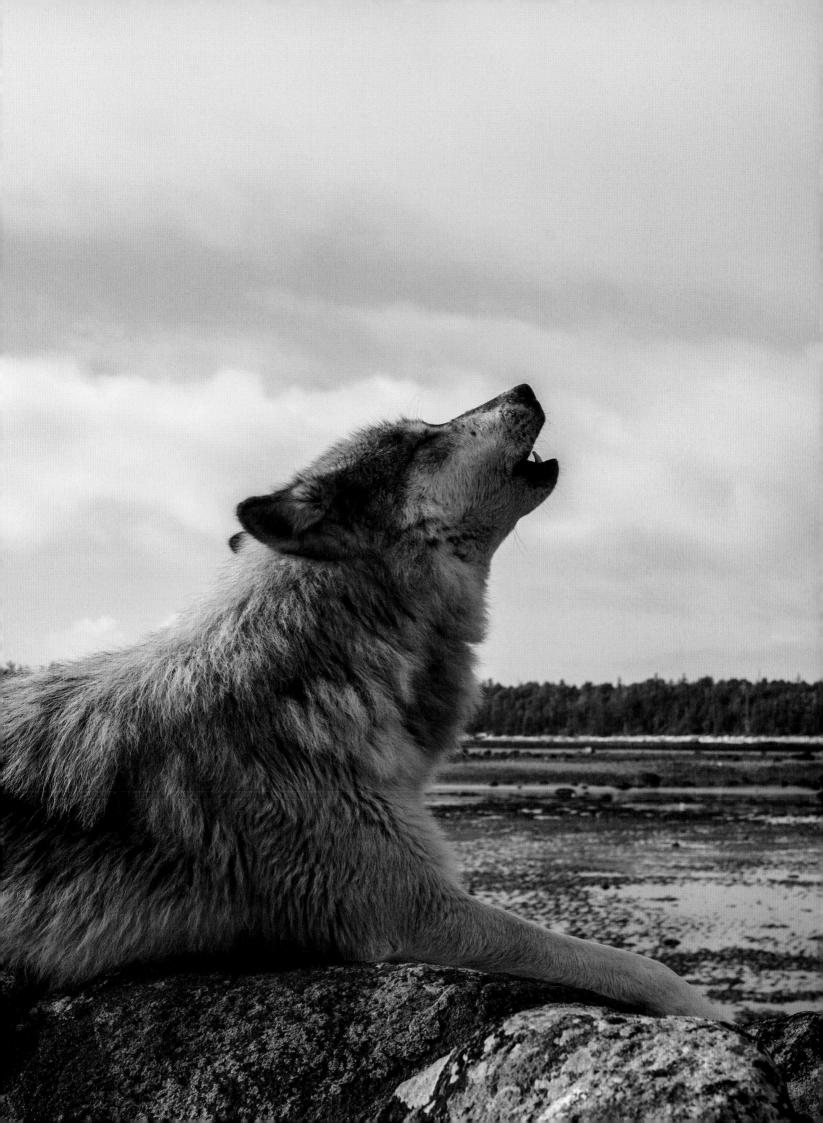

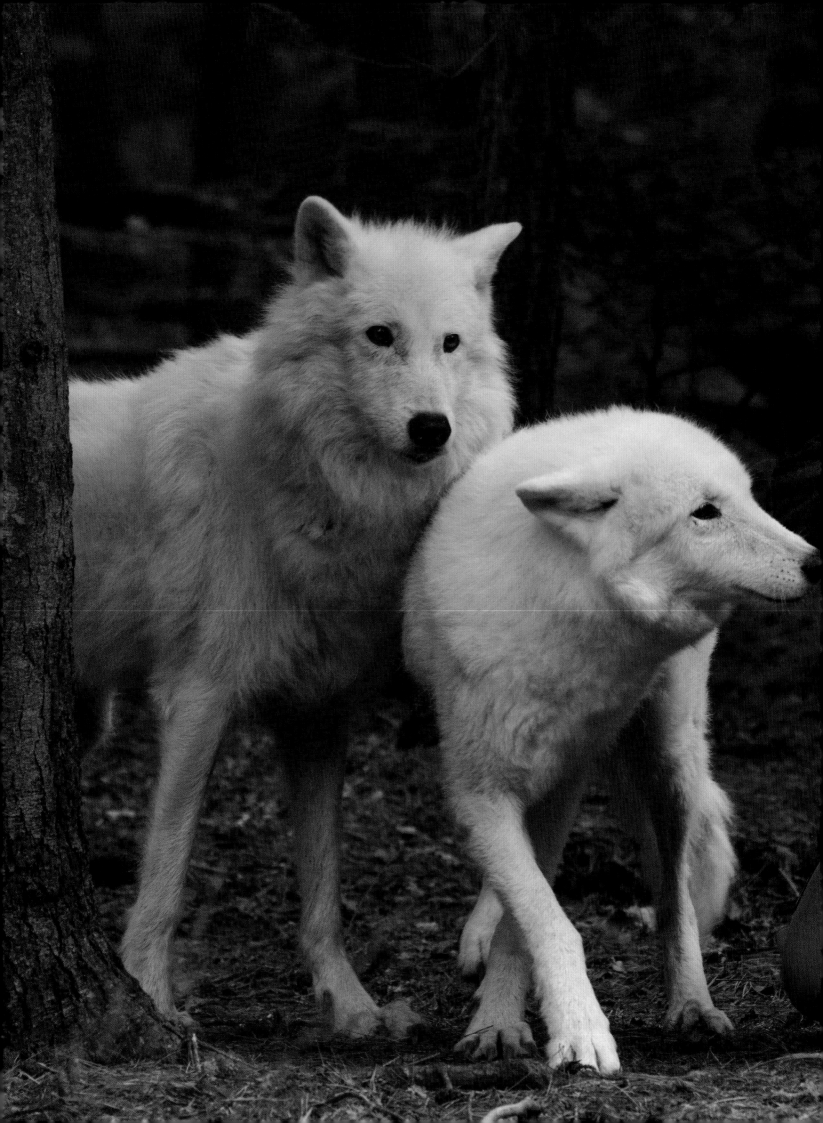

*Wolves became valued as an
essential part of the ecosystem
and a symbol of righting the
wrongs of the past.*

sort of way as a political and strategic tool. As an endangered species, wolves have been used to protect areas from timber harvesting, development, aerial over-flights of military planes, noisy recreational uses, and more. Often wolves themselves are not the focus of a given environmental protection effort, but a means to achieve some end other than conservation of wolves. For example, people who don't like military aircrafts flying over their cabins may claim that endangered wolves are being disturbed by these flights (but they're not) and ask the military to change the flight paths. Wolves are also used extensively in fundraising for environmentally oriented organizations and groups, some of which actually do a tremendous amount to help conserve wolves, but others that just know a good marketing tool when they see one.

Understandably, these efforts have not been without backlash. One relatively new fear is that of land-use restrictions resulting from the legal protection of wolves. If logging or even recreational hiking can't go on in some areas because wolves are denning nearby, if livestock grazing on government land is restricted because of the potential presence of recolonizing wolves, or if areas are closed to big-game hunting because they are deemed necessary to ensure wolf reintroductions, then many people see wolves as the cause of unnecessary and undesirable change.

Another unintended consequence of conservation efforts has been what some people consider the "over-promotion" of wolves. Some who embraced wolf conservation were quick to portray wolves as good, not bad, and the problems they caused were due to people, not some inherent trait of wolves.

However, wolves did cause some problems, and dealing with them was difficult. In places where wolf recovery seemed to be gaining success, wolf conservationists realized that, in the long run, a more balanced view of these animals was essential.

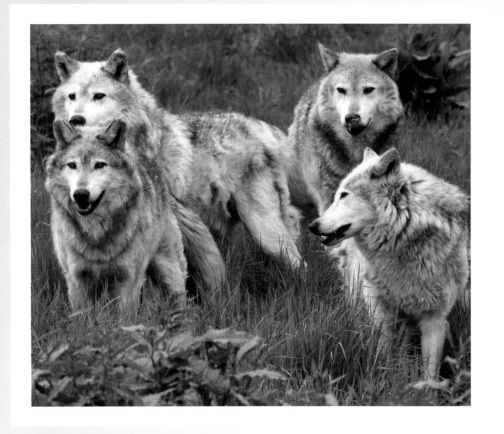

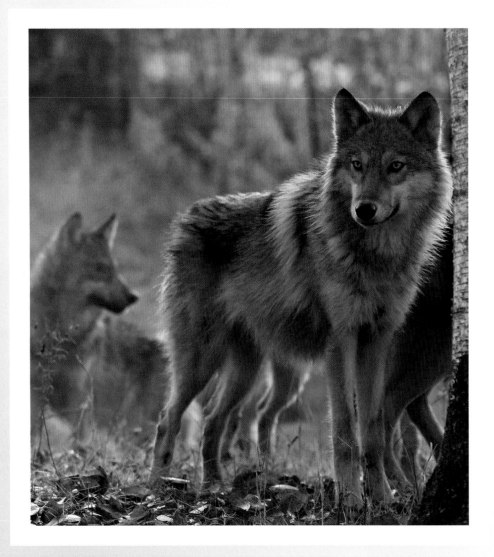

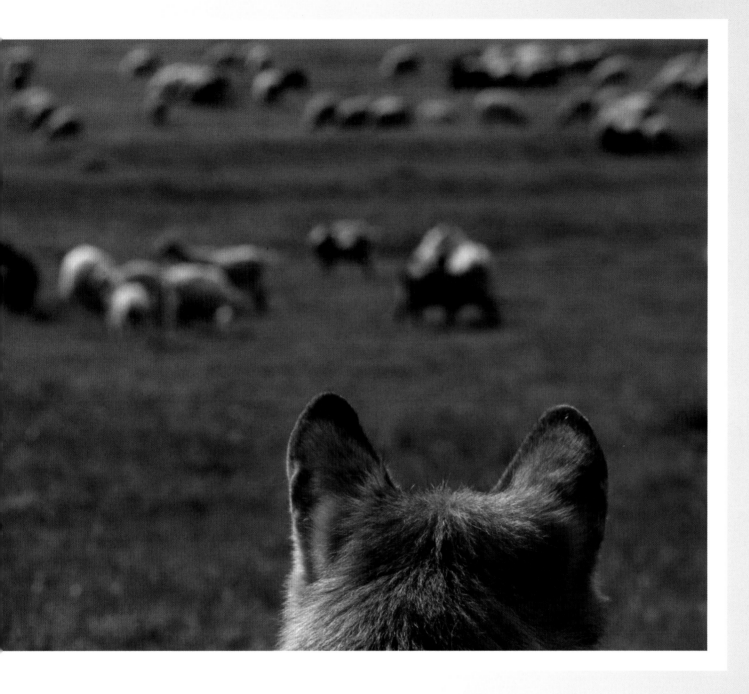

Wolf Control and Livestock

A variety of nonlethal control methods have been tried and are being used to help prevent wolves preying on livestock. One of the oldest and most effective means is the use of guard animals, particularly dogs, but also llamas and donkeys. Dogs are most beneficial when used in combination with shepherds, and are common in parts of Europe, especially with flocks of sheep. Other techniques have been tried and used with some success, but none is consistently effective; these include the use of lights, sirens, propane exploders, and fireworks. Livestock have been fitted with collars filled with foul substances; the idea is that any wolf biting into such a collar and receiving a mouthful of sickening liquid will not do it again, regardless of whether an animal has a collar or not. Wolves are also trapped or captured from helicopters and relocated to new areas, but such animals usually roam widely and have been known to continue preying on livestock even years later.

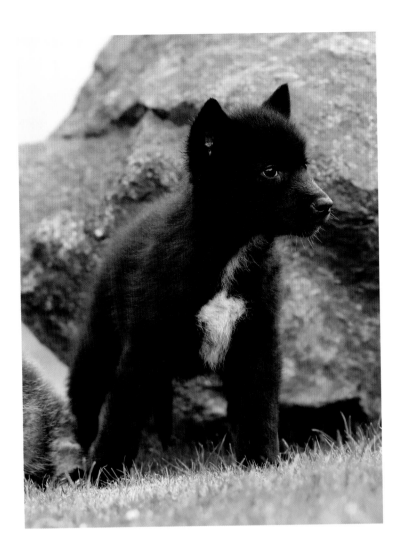

Conservation Needs

Human attitudes and traditions have played a major role in determining the locations of wolf populations, because in the past, unrelenting hunting of wolves has resulted in their complete elimination from some areas. In post-colonial America, taming the wilderness was no less a passion than was eradicating wolves, and both seemed essential to advance civilization.

Even in places where humans are more common, wolf populations can exist if hunting is regulated and illegal or accidental killing of wolves by humans is low.

There are few places on Earth, however, where humans do not affect wolves (and vice versa) in some way, and thus wolf-human interactions are a principle focus of wolf conservation. To address these interactions, conservation must build on what we already know about wolves and humans to achieve the goal of long-term coexistence.

Wolf conservation is necessarily a complicated endeavor and involves the careful and long-term coordination of expertise from a variety of sources.

Because of the resilience of most wolf populations, exact counts are not as important to conservation as is consistent monitoring to assess presence and trends. The relatively new field of molecular ecology will, in time, allow more specific assessment of the genetic status of populations. The results can tell the degree of inbreeding in a population, and, along with geographic analyses of wolf distribution, help identify places where conservation efforts can be made.

Assessing habitat suitability for wolves is an ongoing process because changes in the landscape

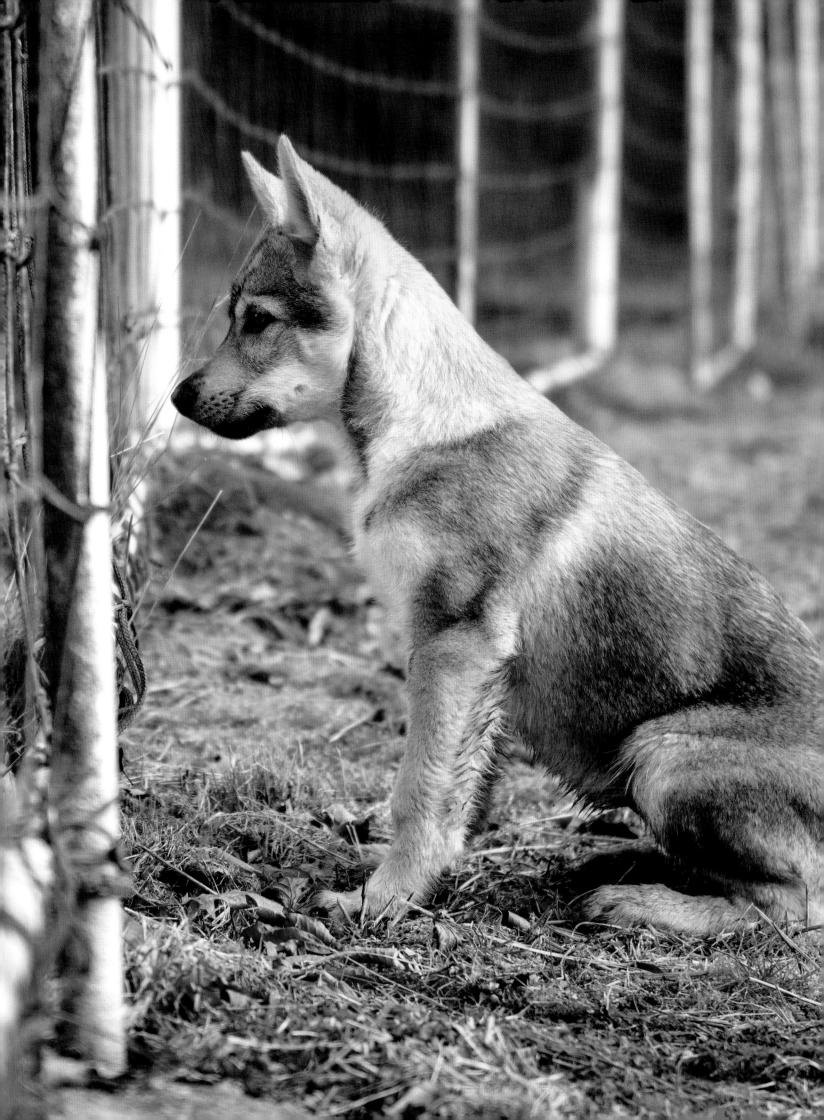

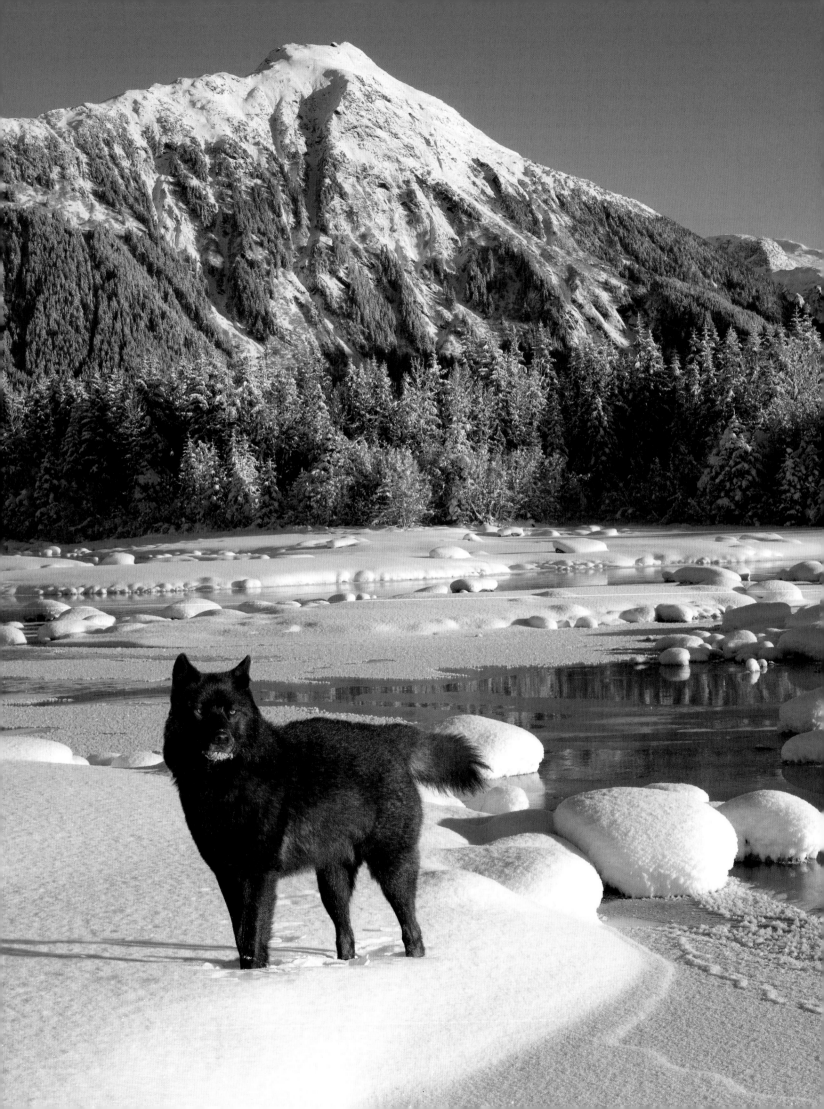

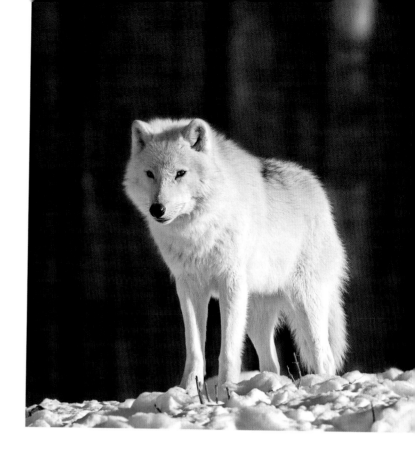

The basic principle of wolf conservation is that wolves have a right to exist in a wild state in viable populations.

will continue to occur. Monitoring the number and distribution of prey is a primary focus because, in some circumstances, prey can be reintroduced to ensure that wolf populations remain sustainable. Human activities also affect the distribution and abundance of wolves, whether directly by killing wolves or indirectly by eliminating prey. New models of wolf habitat quality incorporate these and other factors to derive maps of suitable landscapes for wolves as well as the places that can serve as corridors connecting wolf populations.

The legal status of wolves varies among countries. Many countries, such as those in Europe and North America, have signed international agreements related to wolf conservation, and have drafted local, national, and/or collaborative international plans and treaties to ensure coordinated management of wolves. Such management usually involves zoning areas for national parks, refuges, and wilderness areas.

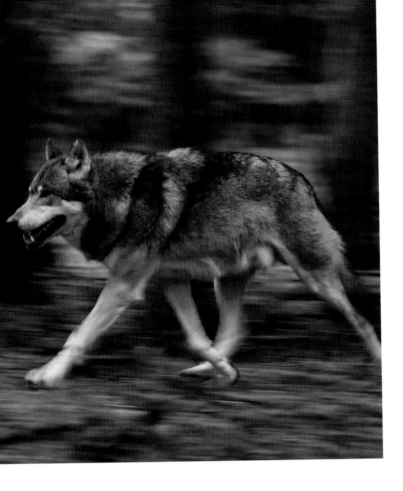

Any assessment of wolf population viability needs to include some estimate of population size and change.

In many areas, legal harvesting of wolf populations is an important component. If properly planned and regulated, legal harvesting rarely has long-term negative effects on a wolf population, and it can provide an inexpensive means of keeping wolf numbers, and thus wolf conflicts with humans, from escalating. Where such public harvest is socially unacceptable, government agencies often play the role of wolf population managers.

Wolves have found many ways to exist in environments as different as the desert and the Arctic tundra. They are resilient, adaptable, resourceful, and capable of coexisting with other competing predators. Perhaps we should reflect on their abilities a little more often, then roll up our sleeves and get to the business of taking care of ourselves and of one of the most charismatic creatures that has ever lived, to the betterment of both.

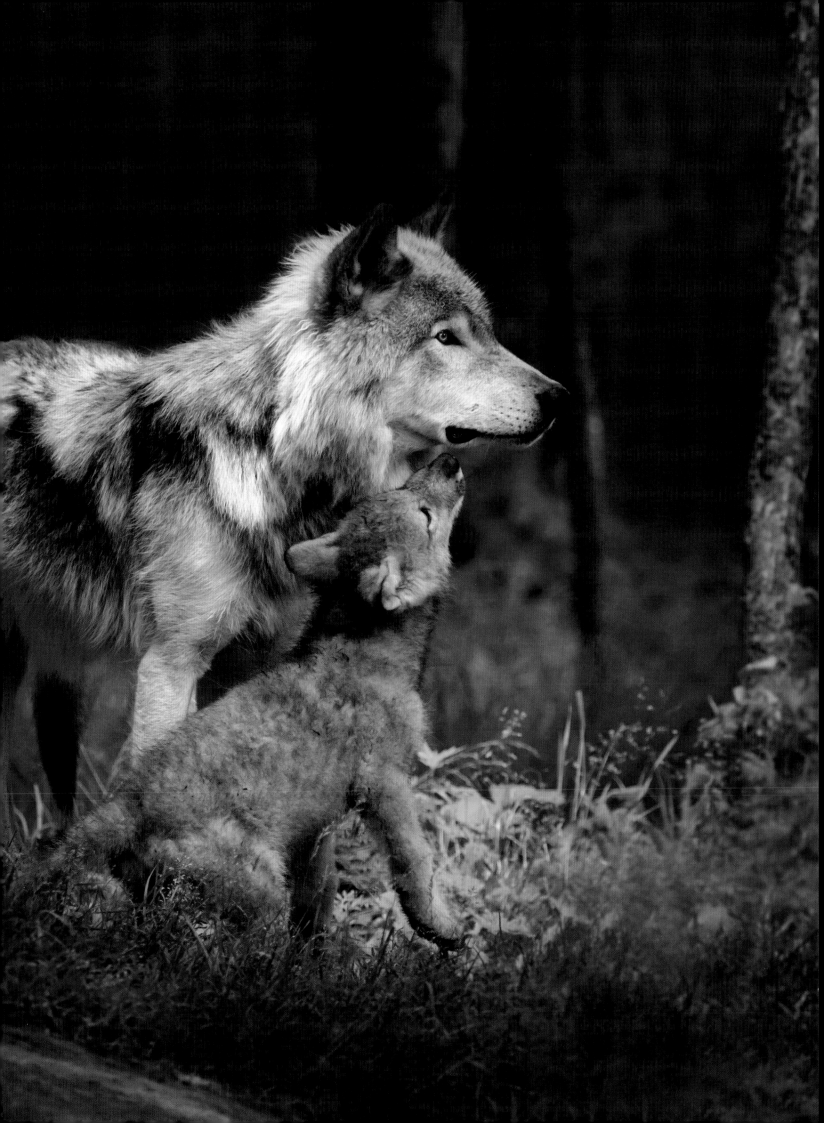

Brimming with creative inspiration, how-to projects, and useful information to enrich your everyday life, Quarto Knows is a favorite destination for those pursuing their interests and passions. Visit our site and dig deeper with our books into your area of interest: Quarto Creates, Quarto Cooks, Quarto Homes, Quarto Lives, Quarto Drives, Quarto Explores, Quarto Gifts, or Quarto Kids.

© 2019 Quarto Publishing Group USA Inc.
Text © 2019 Todd K. Fuller

This edition published in 2019 by Chartwell Books,
an imprint of The Quarto Group
142 West 36th Street, 4th Floor
New York, NY 10018 USA
T (212) 779-4972 F (212) 779-6058
www.QuartoKnows.com

Chartwell titles are also available at discount for retail, wholesale, promotional, and bulk purchase. For details, contact the Special Sales Manager by email at special-sales@quarto.com or by mail at The Quarto Group, Attn: Special Sales Manager, 100 Cummings Center Suite 265D, Beverly, MA 01915, USA.

10 9 8 7 6 5 4 3 2 1

ISBN: 978-0-7858-3738-1

Printed in China

Group Publisher: Rage Kindelsperger
Editorial Director: Michelle Faulkner
Creative Director: Laura Drew
Managing Editor: Cara Donaldson
Project Editor: Keyla Pizarro-Hernández
Cover Design: Laura Drew
Interior Design: Beth Middleworth

Library of Congress Cataloging-in-Publication Data

Names: Fuller, T. K., author.
Title: Wolves : spirit of the wild / Todd Fuller.
Description: New York : Chartwell Books, [2019]
Identifiers: LCCN 2019015205 | ISBN 9780785837381
Subjects: LCSH: Wolves. | Wolves--Behavior. | Wolves--Adaptation. |
 Wolves--Conservation.
Classification: LCC QL737.C22 F854 2019 | DDC 599.77--dc23 LC record available at https://lccn.loc.gov/2019015205

MIX
Paper from responsible sources
FSC® C016973